Infiltration
1997
Butterworth Hall,
Warwick Arts Centre
See pp.92–96

This book is about the ephemeral in art. It explores documentation, memory, anecdote and the broader context which frames them. It begins in 1969. A good year. It set the scene and started my ball rolling and the inflation of my particular balloon.

Documentation has been an unresolved and untapped mystery to me. *Enhanced performance* is a personal approach to befriending and exploiting it. The evidence and recollections that remain when an artwork has disappeared are lasting and tantalising. What to do with them? This is not the quest to manufacture a marketable object but to 'fix' time passed. And to create a continuity and equality of status across art disciplines. Robert Rauschenberg's work in performance is as valuable as his paintings. Laurie Anderson's live performances are more valuable than her CDs. The market does not have ultimate control. We have. Along with our recollections.

The featured works in *Enhanced performance* are a selection made partly in response to the available documentation. *Fingers and Fathers*, *Dark Angels* and *No Hamburger Uniform* don't get a look in. Up to this point my documentation has been quietly contained in box files and filing cabinets.

Deborah Levy encouraged me to talk straight, fill in gaps and list materials. It was her suggestion that I focus in detail on a few chosen photographs, which speak for that particular moment in time. Seven of these appear as picture captions. Short intermittent comments taken mainly from notes and diaries appear vertically on the page. Selected reviews occasionally surface. A framing commentary comes and goes.

R L, London April 1998

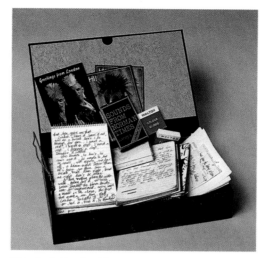

**Documentation box file
for *Long Done Crazy*, 1988**

Enhanced performance
Richard Layzell

edited by Deborah Levy

firstsite, Colchester

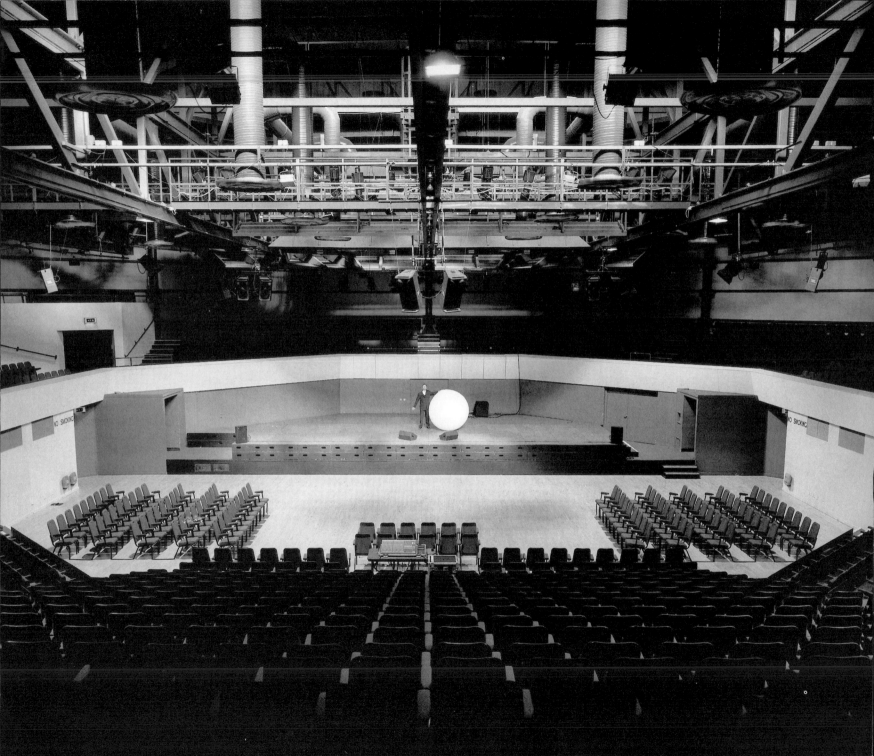

The Slade School of Fine Art is part of University College London and lies off Gower Street mid-way between Euston and Warren Street stations. It was founded by Felix Slade in 1873 and has a long unbroken tradition of Life Painting combined with a libertarian approach to students (the first art school for young ladies) and contemporary art. When I started there in the late 1960s you could do whatever so long as you weren't in the Life Room. My personal tutor was Sam Carter, the world authority on perspective. We didn't have a lot to say to each other. So I got on and grew weirder.

It's 1969. Stuart Brisley has become the 'staff/student advisor', moving between students and staff. He is presumably appointed to stave off student unrest but he brings fresh input and a budget for every kind of radical visiting artist. Stuart subsequently gains international recognition for a long series of durational and physically punishing performances involving vomiting, fasting, self-imposed imprisonment and encounters with offal. Maidstone School of Art has a sit-in. Marc Chaimowicz begins a postgraduate course in painting. I'm in my first year but connected to Marc through the same grim home suburb in West London, the same Foundation Course in Art & Design in Ealing and the shared 'z' in our surnames. Marc moves from painting to performance, although in 1969 the category is called Events. Performance Art isn't adopted for a few years yet. Derek Jarman and Robert Medley (painter and theatre designer) run a project for first year students in the university theatre, later called the Bloomsbury Theatre. They work in the Theatre Design Department at the Slade. This is our introduction to 'theatre'.

Yellow (Man)

1969, a first performance

I'd been waiting for something to happen, frustrated by feeling more affinity with the postgraduate students than my own year group. Arrogance maybe. Or I was missing my elder brother who'd emigrated to Australia. I set up a system where, in pairs, they introduced us kids to their work; Maggi Hambling describing her (then) electronic gizmos, Gerald Newman using the I Ching. They had a lot more to offer than good old Sam the perspective man.

The theatre project was straightforward and open-ended. But what an opportunity. Do what you like with this space and we'll have a performance at the end of the week with lights and all. This project contributed to my complete change of direction. I'd already been closely involved in Marc Chaimowicz's epic *Random Landscape Approximation* where several performers behind white masks uttered scripted streams of consciousness for ninety minutes. And then a guerrilla event with him on tube trains sitting among passengers, again wearing the white masks. I'd also arranged a welcoming event for the visiting striking Maidstone students with substances rolling down the stairwell. But this was an opportunity to do it yourself. Total immersion. I remember walking along the Tottenham Court Road with images and ideas coming at me, no holds barred. It was a new intuitive level of involvement.

I had four performers apart from me. Most memorable was Keith Trussell who later went on to play the zob stick for Mungo Jerry and had two hit albums. I played the spoons for them one Sunday afternoon at a folk club in Charing Cross Road, wearing a women's navy greatcoat. Keith's orange pullover was covered in fish and feathers. He walked slowly to the front of the stage (it was his round shoulders I went for), tipped out a bag of bones and walked off. That was the closing moment. Bones. Chucked. I'd collected these bones from Smithfield Meat Market a few days before and kept them in my locker. The smell wafting up from the basement had caused a stir. I had the key.

They called it a 'Happening'. I called it a 'Theatrical Event'. Derek Jarman took a few photos and suddenly they became fanatically precious. Week after week I reminded him to bring them in for me. Eventually three slides arrived and I pored over them trying to regain the stardust.

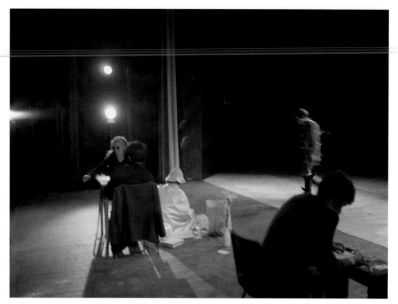

Yellow (Man)
1969, performance
Bloomsbury Theatre,
University College
London
Five performers, fish,
feathers, bones and
various materials

Iceland

That summer I worked in Clarks Shoe Factory in Somerset shifting little shoe boxes containing bright shoe jewels for small feet. 'Don't work so fast. Slow down mate.' Then I hitched to Scotland to take a boat, the *Gulfoss*, to Iceland. It looked interesting on the map and not too far, just north. The *Gulfoss* boasted as much food as you could eat included in the ticket price. A couple of hours after setting sail from Leith we all knew why. Nautical stabilisers became the main topic of conversation for the few who left their bunks. I was sharing a room with Dean from Chesham. He'd re-named himself Dean (previously John) after reading Kerouac's *On the Road* and spending summers in post-beatnik St Ives. We found a place to stay in Reykjavik then hitched around Iceland together. I was staggered by the landscape and by Dean's self-taught knowledge of hip literature. The whole environment was like land art, one perfectly formed near-symmetrical crater after another. There were huge solidified lava flows of rope-forms and expanses of all-black with a few grass tufts. On the second day I stripped off and walked naked into black virgin wilderness. Irresistible.

The Icelandic landscape was an art experience and I was hungry for it. The rolls of slide film I took are still precious images. This was the life/art overlap I'd been waiting for. And I'd make use of it back in the classical building off Gower Street.

Black Room 1

1969, an environment

One of Stuart Brisley's innovations at the Slade was the Black Room. An empty room that could be booked out for whatever. It would now be called an installation space. I'd just got back from Iceland and reserved a slot in December.

From notes made at the time:

```
NOTES RELATING TO ENVIRONMENTAL WORK OF DECEMBER 1969

formaldehyde
candle holders
groups of candles
graftings
the animal works and produces, this is his home
eggs and nuts
fish hung at eye level
string tension guy ropes but not tent-like
environment

PUBLICITY
DAY (1) positioned at 15.43 hours
COMMON ROOM
BASEMENT - GENTS DOOR

DAY (2) positioned at 15.43 hours
GROUND FLOOR
BETWEEN WINDOW AND DOOR OF ROOM 3

DAY (3) positioned at 15.43 hours
1ST FLOOR
BY STAIRS
TOP CORNER OF CUPBOARD

DAY (4) positioned at 15.43 hours
GROUND FLOOR
NEAR FILM NOTICE BOARD

SETTING UP FOR THE EVENT:
Saturday 28th November 1969
Beautiful weather, very elated. Bought a lot of stuff.
Discovered some good cheap candles. Asked for some
feathers and the butcher picked them straight from the
tail of a pheasant, including pink flesh.
```

Marc Chaimowicz

Dec 69 'You think it's a Flanagan (*ie* a sculpture by Barry Flanagan) and it turns out to be a shopping bag.'

Perfect snow.
Hung gable-shaped beams, very pleased.

Monday 1st December
Could be my most exciting day.
Tube to Tottenham Court Road.
then 1) Russell & Chapple for hessian and string
 2) Goodge Street for fish, crab, cabbages,
potatoes,
 parsnips, seeds and eggs.
 3) College:
 BEAM SUSPENSION
 HOMESTRUCTURE
 LIGHT BULB
 MORE INSIDE GRAFTINGS
 OUTSIDE GRAFTINGS
 BUNDLE
 ROCKBOXES
 EARTH PILES (CRATERS)
 LEAVES
 EGGS
 ICELAND BELLOWS
 LOOPS
 ONE CORNER COLOUR INTENSITY
 GRASS
 NUTS

Tuesday 2nd December
VERY GOOD ALL ROUND PERHAPS
Achieved
Bought eggs and crab + 3 mackerel.
Went to Berwick St Market for crab - great place -
inspired to buy 'one corner colour intensity' in
ORANGE - oranges, mandarins, big and small carrots,
peppers
Arrived in Black Room at 08·45.
Given up with light bulb.

Assembling the work: not in order
Formaldehyde made dizzy and eyes water
Hung inside graftings higher
Hanging hessian really good -
1) Pussy grass [shim]
2) Brown eggs + walnuts [hessian]

3) Rockboxes [hessian]
Iceland bellows with crab
Crater candles on earth - used crater-shaped earth and
only candles on some piles
One outside grafting - cabbage
Parsnip and potato candleholders: v. pleased with.
Displayed ordinary grass in drawer at angle to wall -
not happy with
One corner colour intensity - quite successful

So good to improvise on the spot - notably with brown
paper and hanging hessian.
14.00 - 16.00: Card on door. Lights out. Candles on.
Put on my anorak and tied string round my legs

Black Room 1
1970, environment
Slade School of Art
Hessian, soil, sculpted
candles, vegetables, string

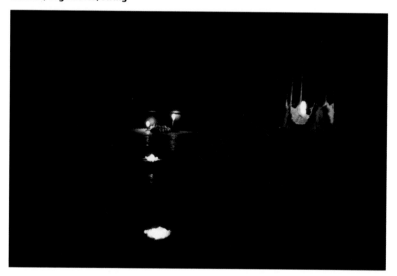

Encouraged by visiting lecturer Malcolm Hughes I spent weeks
analysing and documenting *Yellow (Man)* and *Black Room 1*. The result
was a hand-crafted book (see p.98).

The rockboxes were individually made from hardwood to fit volcanic rocks brought back from Iceland. One rock per box. I made them at home in Crouch End on the kitchen table with a portable vice and a small hacksaw. I worked obsessively and into the night. We were evicted from the flat three months later. As we were moving out the downstairs neighbour, who'd complained about us to the landlord, said in passing, 'It wasn't the parties it was the late-night sawing I couldn't take.'

Black Room 1 was the next stage on from *Yellow (Man)* and as important. The first serious ventures into a new medium can be so formative. This one was. I didn't quite know what had hit me. And I was getting a lot of attention. Marc Chaimowicz introduced me to Peter Carey from the Camden Arts Centre and Sigi Krauss from the Sigi Krauss Gallery. He told me if I was nice to Sigi he might give me a show. I wasn't quite ready to handle an East European minor celebrity. Peter Carey was an easier prospect and I was included in *The Human Presence: Live-action Structures* at the Camden Arts Centre in 1970. It was my second year at the Slade. Stuart Brisley was one of the other exhibitors.

NNYN (No no yah no)

1970, a second performance

Still using material from Iceland I start work on a second performance, *NNYN*. It's less exuberant, more carefully planned, probably more interesting, but harder to get an audience. A tramp-like figure carries his home/sculpture on his back with bags and bits hanging off him. He was my flatmate Nick. I was in a supportive role wearing muslin bandages over head, wrists and feet, and a sheath of brown paper bags. Nick's first speech is a catalogue of indecision. [It's spoken as an internal dialogue, accompanied by foot stamping, differences in volume and emphasis, always ending on No]:

NO, NO, NO, YAH, YAH, NO, NO, YAH, NO, YAH, YAH, YAH,
NO, YAH, NO, NO, YAH, NO, NO, YAH, YAH, NO, YAH, NO,
NO, YAH, YAH, NO, NO, YAH, NO, YAH, NO, NO, NO, YAH,
NO, NO, NO, NO, YAH, YAH, NO, NO, YAH, NO, YAH, YAH,
YAH, NO, YAH, NO, NO, YAH, NO, NO, YAH, YAH, NO, YAH,
NO, NO, YAH, YAH, NO, NO, YAH, NO, YAH, NO, NO, NO,
YAH, NO, YAH, YAH, NO, NO, NO, NO, NO, YAH, YAH , NO,
YAH, NO, NO, YAH, NO, YAH, YAH, YAH, NO, YAH, NO, YAH,
YAH, NO, NO, YAH, NO, NO, YAH, NO, NO, YAH, NO, NO,
NO, YAH, YAH, NO, NO, YAH, NO, YAH, YAH, YAH, NO, YAH,
YAH, NO, NO, YAH, YAH, NO, YAH, NO, NO, YAH, NO, NO,
YAH, NO, YAH, NO, NO, NO, YAH, NO, NO, NO, NO, YAH,
YAH, NO, NO, YAH, NO, YAH, YAH, YAH, NO, YAH, NO, YAH,
NO, NO, YAH, YAH, NO, YAH, NO, NO, YAH, YAH, NO, NO,
YAH, NO, YAH, NO, NO, NO, YAH, NO, NO, NO, NO, YAH,
YAH, NO, NO, YAH, NO, YAH, YAH, YAH, NO, YAH, NO, NO,
YAH, NO, NO, YAH, YAH, NO, YAH, NO, NO, YAH, YAH, NO,
NO, YAH, NO, YAH, NO, NO, NO, YAH, NO, YAH, YAH, NO,
NO, NO, NO, NO, YAH, YAH , NO, YAH, NO, NO, YAH, NO,
YAH, YAH, YAH, NO, YAH, NO, YAH, YAH, NO, NO, YAH, NO,
NO, YAH, NO, NO, YAH, NO, NO, NO, YAH, YAH, NO, NO,
YAH, NO, YAH, YAH, YAH, NO, YAH, NO, NO, YAH, NO, NO,
YAH, YAH, NO, YAH, NO, NO, YAH, YAH, NO, NO, YAH, NO,
YAH, NO, NO, NO, YAH, NO, NO, NO, NO, YAH, YAH, NO,
NO, YAH, NO, YAH, YAH, YAH, NO, YAH, NO, NO, YAH, NO,
NO, YAH, YAH, NO, YAH, NO, NO, YAH, YAH, NO, NO, YAH,
NO, YAH, NO, NO, NO, YAH, NO, NO, NO, NO, YAH, YAH,
NO, NO, YAH, NO, YAH, YAH, YAH, NO, YAH, NO, NO, YAH,
NO, NO, YAH, YAH, NO, YAH, NO, NO, YAH, YAH, NO, NO,
YAH, NO, YAH, NO, NO, NO, YAH, NO, YAH, YAH, NO, NO,
NO, NO, NO, YAH, YAH , NO, YAH, NO, NO, YAH, NO, YAH,
YAH, YAH, NO, YAH, NO, YAH, YAH, NO, NO, YAH, NO, YAH,
YAH, NO, NO, YAH, NO, YAH, NO, NO, NO, YAH, NO, NO,
NO, NO, NO, NO.

He puts down his backpack/shelter and sets up home. His second speech is a list of British grasses [spoken with a stuttered relish for the language]:

CREEPING BENT
BIG QUAKING-GRASS
SHORT-AWN FOX-TAIL
SAND BENT
SCUTCH
NARROW-LEAVED MEADOW-GRASS

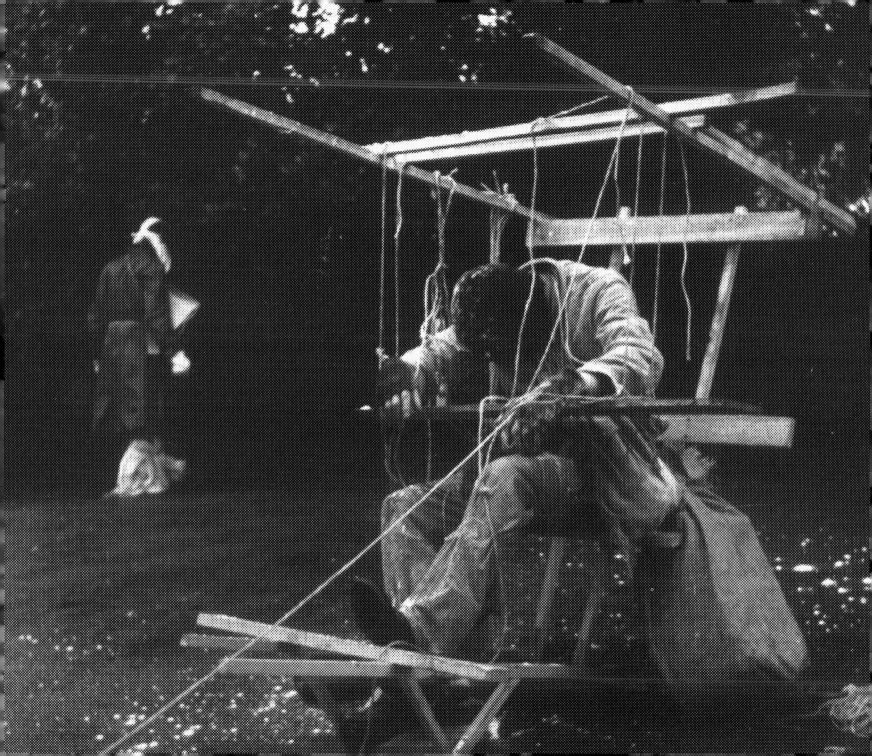

```
VIVIPAROUS FESCUE
TOTTER GRASS
UPRIGHT ANNUAL BROME
RIPGUT
HAIRY CHESS
GIANT FESCUE
DOOB
VELVET BENT
PURPLE-STEM CAT'S-TAIL
DON'S TWITCH
EAVERS
NODDING MELICK
GLAUCOUS BRISTLE-GRASS
DODDERING DICKIES
DARNEL
CREEPING FINGER-GRASS
DROOPING BROME
SOFT BROME
CREEPING FESCUE
HAIRY BROME
FIORIN
NEW ZEALAND BENT
CHALK FALSE-BROME
HASSOCKS
LOP GRASS
QUACK GRASS
QUICK
BLEWGEIRCH
ANIMATED OATS
COW QUAKES
```

Opposite
NNYN
1970, performance
Regents Park, London
Timber, sacking, string,
brown paper bags, flour,
canvas

Culture

In 1971 I took a year off from the Slade, knowing I was returning to start a two year postgraduate course. I worked for six months as a messenger for a picture framers in Covent Garden called Blackman Harvey in Earlham Street. They occupied the building where Boxfresh, Detroit, Mambo, Quicksilver, High Jinks and Spice NK are today. It wasn't great money but I made a bit on expenses and saw a lot of London. I was saving with a frenzy to go travelling later in the year. Food became expendable. I started reducing the filling in the lunchtime sandwiches; go easy on the margarine and just a smidgen of marmite. A little run down, one Saturday night I took the train to Chesham for one of Dean's parties, with a heavy cold. I landed up in Casualty at University College Hospital later the same night with pneumonia. They admitted me for a week or so. The hospital is on the opposite side of Gower Street to the Slade. I was in the men's chest ward. Whenever liver was on the menu someone died, that was the ward folklore. The words of some of the ailing aging old boys stayed with me:

```
I like tea and I like soup

Whenever you're ready darlin'
(any time you like)

Easy come, easy go
```

We all wondered if we'd get out alive.

I survived and travelled alone in the USA for four months. I finally got the money together. Bullet holes in the wall of my New York YMCA room. Always carry your camera in a brown paper bag (helpful advice). Tentative trips to the Eatery. Didn't speak to a soul for eight days. Bus Station on 34th Street. Chicago then Memphis for a taste of the novelist William Faulkner but not a sniff of him. Met Ron from Baltimore in a park in New Orleans. I'm talking to someone. We travelled together to Mexico City, Guadalajara and Acapulco in his Volkswagen bus. He was looking for Carlos Castaneda's Yaqui Indian guru Don Juan; like most of the other Americans travelling in Mexico in VW camper vans with homemade shelves behind the driver's seat filled with Castaneda's books. If we met Don Juan by the side of the road then it was meant to be, no pressure. We didn't. Ron implicitly blamed me for this. 'You're not a believer, man.' We went on a fruit fast for several days. 'Just oranges man. I do it all the time man. My guru in Baltimore, he recommends it man.' I was losing weight. By the end of it we were in a hallucinating orange haze of paranoia and truly detested each other. Why did we stay together? Some strange loyalty. We separated as soon as we crossed the border back into Texas.

Things started improving. I wanted an easier time so I took the bus to Santa Fe in New Mexico with an address and phone number from Peter Snow (theatre design lecturer at the Slade). I phoned and was invited to stay with a gentle gay man called Jim McGrath and his lover, Tom. They both worked with the American Indians. This was a passport to normally closed ceremonies and dances by Apaches, Hopis, Navajos and Zunis. I was experiencing in depth a culture I'd hardly thought about. No photos allowed. I'd anticipated going to America to see cities and art museums, not columns of fully masked men naked to the waist filing out of prayer chambers chanting and stamping in unison. 'Heyey hey. Heyey heyey hey.' I couldn't get enough of it – the squirrel kachina dance, the velvet shirt kachina dance, the Mescalero Apache coming-of-age ceremony. It became my cultural highlight. I wanted to be up there/down there with them, stamping

and shaking the bells strapped to my legs, looking out from inside my spirit mask. When we dance we *are* the squirrel and the audience knows it. This was not theatre. But perhaps Henry Mayday was.

With his colossal head, thick neck and resonant mesmeric voice, Henry Mayday led the 'UFO Watch' on a mountain top in the Arizona desert. I went with Jim and a cluster of adoring middle-aged lady followers who hung on Henry's vocal chords and masculine determination. We sat in a circle. Henry stood before us. It was a clear night. This was a good sign. He paused. 'We welcome you.' 'Great forces from the outer cosmos, we welcome you.' 'We await you.' We concentrated and awaited a 'sign' for an uncomfortably long time. Then Henry announced that it wasn't a good night after all. Jim and I slept on the mountain top under his Indian bearskin blanket. I thought he expected to have sex with me but he said he didn't. No UFOs just stars.

1972–74 Serious business

The preceding year had been strong medicine and dominated the postgraduate course for me. It also informed the work I then produced. Photographs taken on the travels were at the heart of almost everything. Text and image experiments for a self-produced magazine (with Ron Henocq) were based on my time in hospital and experiences in America. I was slightly withdrawn. Art had become a serious conceptual business. I spent most of the two years working towards one installation called *Support*. It combined photography, drawing, and video within an elaborate post-Constructivist framework. I also made a 60 minute experimental film about Walthamstow Marshes in the tradition of the Canadian experimental film-maker Michael Snow (see p.35).

Left
**Text and image works
1974**

Right
***Support*
1974, environment
Slade School of Art
Photographs, photocopies,
fibreboard, timber, video
tape (not shown)**

1975–76 The real world

I'd had my fill of art school and there was no obvious follow-on. The postgraduate course had not been easy. There was a strong message at the time to get out there, off the pedestal and into the real world not the art world. I took a job as a labourer with Hackney Parks Department and was sent to the high-walled Haggerston Park, a former gas works. 'You can still smell the gas if you put your nose to the grass at the far end over there.' 'Slow down mate or he'll give us something else to do.' When it was quiet we were told to remove the moss from between the cobbles with a hoe. It felt like being banged up. In the late autumn we moved on to planting the bulbs. I looked forward to this, but it transpired that it was the foreman's job to 'place' them. We just dug 'em in. One of my workmates was Maltese Charlie. He quietly told me stories of seeing men thrown to their deaths into vats of boiling sugar at the Tate & Lyle factory. I was sworn to secrecy. We'd sit huddled around the coke-burning stove in the wooden shed and he'd say 'It's cold, dampy in ee Ricky?' I was asked to think about promotion, they offered to send me on a course. 'You've got an education, you should move up son.'

Instead, I went to work as a part-time teacher at Woodberry Down School in Hackney. The head of the Art Department, Mr Freeman, was an ex-policeman. He was good at crowd control. The kids loved him for it. 'Please Mr Freeman can you do mine for me. I can't do faces.' 'Give it *here* then.'

The art store cupboard was full of his geranium cuttings. He talked insultingly about Alison, the asthmatic young teacher in the next room – always referring to her by surname or 'her'. Is this how he talked about me? He wanted to tell everyone I'd been to the Slade. The ex-policeman's reflected glory. He'd given me the job after all. Alison took a lot of time off. She offered me a share of her studio in Old Street, a quarter floor subletting from a famous furniture designer called Floris. I went there two days a week, started to produce drawings that people later thought were made by computer and always fell asleep at least once, head on folded arms over drawing board.

All was revealed when it came to marking the CSE examinations. Mr Freeman was in league with the examiner and my kids were marked down. His kids got higher grades than mine. Simple as that. Mine were penalised by having me as their teacher. I was dumbstruck and would have resigned over it but had already done so. I'd decided to go and visit my family in Australia. They'd all emigrated by now. Before leaving I heard that I'd been selected for a show at the Acme Gallery.

Acme

The Acme Housing Association started housing artists in London in 1975. The founders, Jonathan Harvey and David Panton, managed to access short-life housing stock from the London boroughs, particularly Tower Hamlets. The houses were below normal habitable standards and offered to artists as part studio and part living space at low rents. Artists are strangely adaptable. I was allocated a derelict house in Bow, opposite the Gas Works, a window-free zone. When the number of houses under their management had reached about 100, mainly in the East End, they began to look for a gallery space as an obvious outlet for the many young artists they were providing for. Jonathan Harvey took on the role of gallery director and the housing association offices moved in to the floor above the gallery, a former banana warehouse in Covent Garden. It opened in 1976.

Breaking Down ... Finding New Paths

1977, an installation at The Acme Gallery London

The title *Breaking Down ... Finding New Paths* came partly from a state of mind, transferring mental states into the visual. This had not been an easy period for me. I was signing on, living opposite the gas works in Bow, spent up and working solely on this exhibition. I was gradually and painfully coming out of a 'real world' wilderness and back into the art world. There was a clear six months in which to prepare for the exhibition.

For the Lower Gallery I used grids as a means of visually 'breaking down' imagery and objects, finding an equality through fragmentation. Photography, drawing and construction were brought together under low formal structures. The converse of this took place in a separate and more improvised, installation in the Upper Gallery. Here physical contact with materials was forced upon the spectator and it became the *Finding New Paths* of the exhibition title. The title was also reflected in sequences of photos of aborigines. Going Walkabout represented the culmination of breaking down or out through the pressures of western culture.

Colour slides I'd taken in 'the bush' did not recapture its wild intensity so back in Bow I projected and re-photographed them again and again; not just moving towards abstraction but also to a closer representation of the landscape of New South Wales. Detail into smaller detail. These were fragmented still further by masking bits off and projecting them in quarters and sections of the film frame size. A desperate attempt to regain lost landscape and an aboriginal relationship. They were the final destination of *Finding New Paths* in the Upper Gallery, bright colour following the mainly monotone up to this point in the journey.

The sculptor Richard Deacon was then writing occasional reviews for art magazines:

> Various and complex relations are alluded to or established between discrete items; the degree to which items are viewable as dependent or independent within the particular context is crucial.

> The installation is split into two parts, one in the upper and one in the lower gallery, this split being marked by one word 'RIGID' in a prominent position downstairs and the word 'LOOSE' equally prominent upstairs. The core of the information organised around this opposition is contained within a quantity of photographs and slides. The images, with the exception of one group, are all of Australia – of the landscape, of aborigines, of the towns. The separate group contains pictures of

American blacks as well as photographs of the stages of the incorporation of those photographs into the piece of work.

> Downstairs the remnants of a grid is marked in tape on the floor. There are partial actualisations of that grid in eight modular cubic structures two of the largest of which cover groups of photographs. Small parts of (the same?) photographs are displayed on the end wall of the gallery, each mounted on a square of black card. On one of the side walls there is a series of five drawings, each a combination of marks relating to grids overlaid by/overlaying non-systematised marks. A similar drawing is underneath a third of the cubic structures. The clustering of marks in these drawings possibly maps the combination of grid and structure on the floor or represents an abstraction of particular information from the photographs, although these are by no means the only alternatives.

> In the upstairs gallery one enters a maze and passes through layer after layer of stuff. Materials are stretched, tied, suspended; placed or laid on the floor; a barrier to progress or to be pushed aside. The light level reduces through the upper gallery and haptic perception becomes increasingly important. Progress is slow and one is invited to contact the variety of things that are present; the experience is intimate and highly sensitised. At the far end of the gallery, behind a screen stretching from floor to ceiling one comes across a large wooden structure – a bit like a piece of rough staging. This is placed against the end wall of the gallery. Mounted above it there is a large picture of three aborigines sitting in the desert amongst the roots of a tree. Each has his back to the camera and appears to gaze off into the distance. Above this photograph a series of slides are being projected. Some of these images have previously been seen downstairs.

> In retrospect the experience of passing through the gallery is seen as a preparation for this slide show. Roughly speaking it is as if the slow progression and sensitising that have gone before provide a location and a sense of place: one has been climbing a hill and reaches the top, revealing the view, the preceding effort and arrival serving to locate oneself and, reflexively, to contain and anticipate the view. The richness of this experience is marred by the sound of the projector.

> Having seen the slides upstairs one's appreciation of certain images in the photographs downstairs is significantly altered. The relation of the aborigine to his landscape – the kind of marking and signification that that involves – is certainly invoked and possibly paralleled by this kind of working with materials and systems (as tangible stuff and organisational procedures) that Richard Layzell has gone in for.

Richard Deacon *Artscribe* No.7

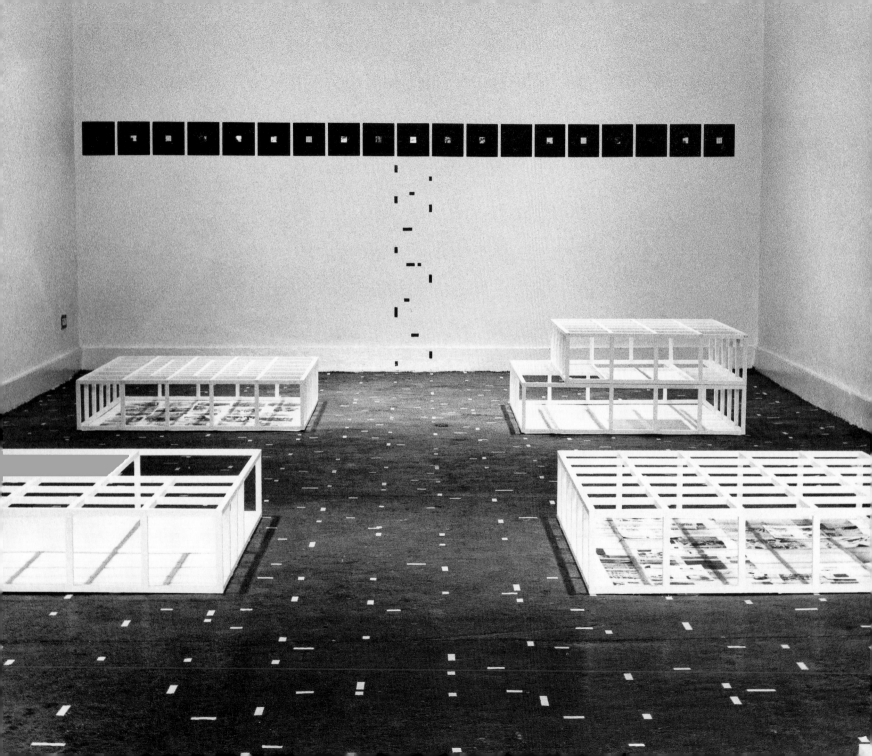

Opposite and above
Breaking Down
1977, installation
Acme Gallery
Timber, fabrics, polythene,
slide projections,
photographs, glass
fragments

I became the invigilator of my own first one-man show because they were short of staff and I was short of money. This job became a salutary experience. I witnessed every conceivable response to *Breaking Down … Finding New Paths* while I sat behind the imposing gallery desk and its magazines. More than half the visitors did not go upstairs. I was mortified by their lack of adventure or interest. I had counted on complete consumption. You couldn't experience the work without seeing both floors and extending the experiential framework; one floor cold the other warm, one of intellect one of emotion, one cerebral the other physical. I felt the need to control people more but couldn't force them. I took it personally and was distressed that so many visitors were having an incomplete experience. Do you realise this is my work you're skimping through? But I was now representing the gallery more than myself and was understandably compromised through the role of an invigilator.

An outcome was my beginning to pursue performance again. In part I became aware of the high level of interest in Performance Art in London at the time through my (now continuing) job with the gallery. Performance presented an opportunity to have more control of the audience through a time-based experience. More significantly, I could be sure of giving them the whole picture rather than a fraction of it. No danger of them missing the Upper Gallery and half the story.

2B Butler's Wharf

2B was a studio space amongst many others at Butler's Wharf, which became the second major Thames-side low-rent studio development after St Katherine's Docks (by

Tower Bridge) turned into a luxury hotel and tourist complex. Butler's Wharf is now developed but was then almost exclusively studios. Derek Jarman was a tenant and made one of his first films here. 2B was rented by a group of artists: Alison Winckle, Kieran Lyons, Dave Critchley, Kevin Atherton and John Kippin amongst others. On Saturdays their shared studio was used as a performance space, a generous initiative. Participating artists produced their own publicity and the Collective helped to raise an audience.

Opposite
Line Flying
**1978, performance
Slide projections, paper,
timber, cigarettes, Bengal
matches**

Line Flying

1978, performance, 30 minutes, 2B Butlers Wharf

I've been working at the Acme Gallery for six months. There's a lot of performance going on there and in general. Perhaps the adoption of the American terminology (Performance Art) gave a fresh impetus. I'd stopped performing eight years before (see *NNYN*, p.9), having lost interest in anyone actually seeing the work. It began to feel like complete indulgence, a circular relationship which excluded the audience. But I'm forced to think again. Performance could be a way to activate an installation, to create a more direct relationship with an audience. I take part in a few movement and improvisation workshops run by Shape in Covent Garden. This is enough. It offers another approach to performance, one that includes the spectator. I book a slot at Butlers Wharf.

Line Flying becomes an energising way of working with drawings, projecting them in negative, white lines in space, then adding to this linear theme with light, movement and sound. These drawings were the only thing I'd been able to produce in two years. This was a way of exploiting them, shouting back, drawing in space. Several people came along to see it. The Butlers Wharf group were mainly from Newcastle. I felt like a poncey Southerner prancing around but it didn't stop me going for it. I'd even rehearsed.

Afterwards, racking my brains, testing responses to find out if it had succeeded on any level. Something had shifted. There was a lightness of touch and a gap bridged. And I wanted more.

The image which is literally line flying. Figure and lines in movement chucking it around. The space had been available for just the day of the performance. These installed arrangements of timber, paper and projector had been assembled in a few hours, a very different story from *Breaking Down*. But the projected drawings in negative had been painstaking. Two years in the Old Street studio with a ruler and pen keeping just alive creatively. Here now the same drawings were flung into action and the present, treated roughly and without reverence. Energise them and myself out of them and into a body as pen in physical warehouse space. Light, sound, fire and a mouthful of lit cigarettes were the additional elements. Wake yourself up Richard.

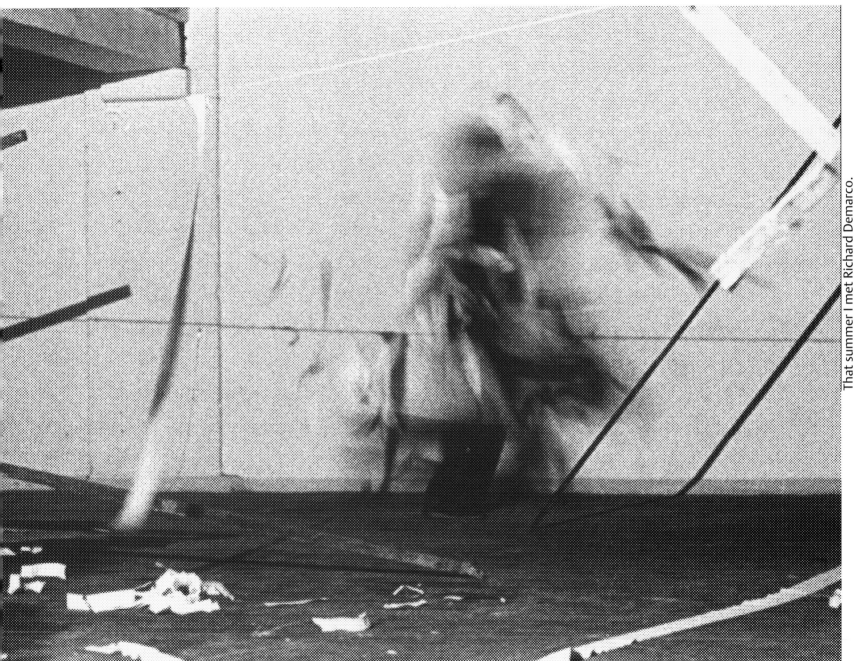

That summer I met Richard Demarco. He always had his camera out.

The enigmatic Richard Demarco is a single-handed Scottish phenomenon. He built international connections between Edinburgh and mainland Europe in the 1960s which put London to shame. As a student I'd experienced the new German art through his exhibition *Strategy Get-Arts* in 1970. This was the first time Joseph Beuys' work had been seen in Britain.

With a constantly precarious relationship to funding his ventures, in the 1970s he set up Edinburgh Arts, a kind of artistic/spiritual journey across Britain lasting several weeks. It became an annual event. Artists would join, leave, be visited, open their studios. Burial mounds, stone circles, churches, galleries and museums were taken in *en route*, always led by Richard in his red Ford Fiesta. The rest of us would follow in a minibus, a mixture of curators, artists, students and admirers. I joined Edinburgh Arts for a week in the summer of 1978 for the Welsh section – Blaenau Ffestiniog (the sculptor David Nash), Pembrokeshire (St Govan's Chapel) etc. I found myself with bronchitis sharing a bedroom with Richard and the head of the Welsh Arts Council.

Backwards Forwards

1979, an installation and performance at the Richard Demarco Gallery Edinburgh

A few days after returning I was unexpectedly phoned from Edinburgh and offered an exhibition in his gallery for the following January. Richard was still on his Edinburgh Arts journey. No money but an opportunity.

The man who brought Beuys to Britain. Of course I'll do it. Especially as I'm now a humble gallery administrator and invigilator responsible for the mailing list and varnishing the floor every so often. Servicing artists dulls the sense of being one myself. I spend four months preparing for it, then off up to Scotland. The single train fare is £8. I start filling the walls the evening I arrive and have three more days to install. Make it simpler than *Breaking Down*, deliberately less opaque. But a similar theme, rigid and loose. Although the second (basement) space is so much smaller that the 'rigid' section becomes the bulk of it: as directional arguments of rubber matting and ply; materials that slot into a rough edged gallery with a tacky carpet that needs covering. Shape it up a bit. Flashing lights in the corners, backwards/forwards, tape loop of electronic sounds.

I perform at the Private View for the first time but not the last, no problem. I'm able to disseminate the work to them, just like I wanted to at the Acme Gallery; engage directly with that audience, speak backwards, move in lines, animate the installation. There's a liberating sense of being in improvised space sound and time, uninhibited. I reflected afterwards about how this performance left the installation, following the action. The figure claims all. Next stage leave out the visuals. Not yet. Call yourself an artist, where's the art gone? Skill free zone. Hurry up.

Backwards Forwards
1979
Below and right
Installation
**Painted plywood, rubber matting, flashing lights.
tape loop**
Below left
Private view performance

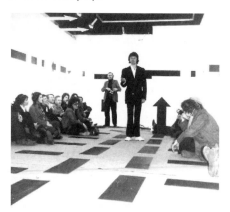

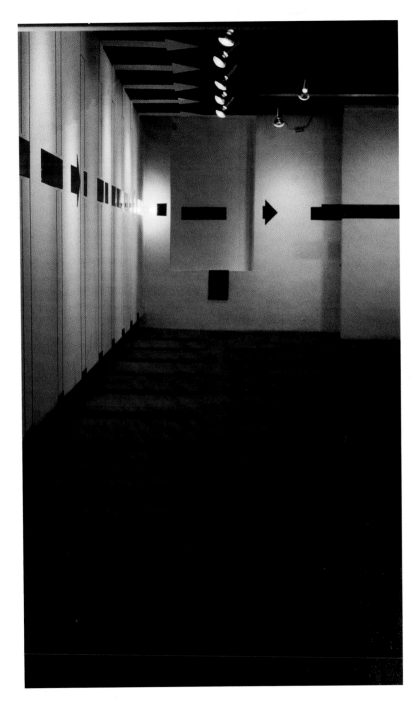

Invigilating at Acme allows time for looking into opportunities. The gallery has all the art magazines and receives mail shots of announcements and ads.

Steps

1979, residency, installation and performances (gallery and street) Spectro Arts Workshop Newcastle upon Tyne

A two month residency in Newcastle. Open submission, advertised in Artists Newsletter. Acme agree to giving me time off but I think I'm pushing my luck a bit. Spectro is half for working half for showing – workshops, gallery, performance space, sound studios. They want me to make something which brings their separate working disciplines together – screen-printing, photography and sound.

Steps as a title and theme is a big shift from *Breaking Down*. Have I gone too far? I stay in the director's family home along the coast in Whitley Bay and feel like a lodger out in the sticks. It's the photography and performance that take off for me. I spend a lot of time around Eldon Square, the main shopping centre, taking time lapse photos and slides of people's legs. Occasionally the result is one frozen leg in space on tiled flooring. Spend too long in the screen-print studio producing the publicity.

The installation at the end of the residency has an amplified floor; step, ladder and stair forms; slide and photographic sequences. Foot poetics.

I reluctantly agree to do outdoor performances to publicise the exhibition. One or the other would have made more sense – either perform or publicise. But it gets me out there, back in Eldon Square, mixing it up with Geordies and it's OK. It may be a long way from aesthetic subtlety but something else is going on and people join in. I get eight teenagers to walk in a line, up and down two steps. Up and down they go. Wearing a dark woollen hat and white clothes I follow my own screen-printed footsteps carried in a bag, looking like a political activist/leaflet-ist with nowhere to go. Back in the gallery I do performances in the installation. By now I have so much to say about steps that it flows well.

Steps
1979, photography and performances, Newcastle
Opposite
leg in Eldon Square
This page
From the outdoor performances

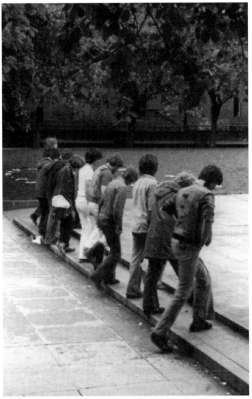

Normality Performance

1979, 40 minutes, Wolverhampton Polytechnic

A student events week at Wolverhampton Polytechnic. The Fine Art Department at Wolverhampton included a time-based area of film, video and performance, like a number of others *ie* Coventry, Sheffield, Brighton and Newcastle. It was aimed at students from this and other colleges. These kind of 'events weeks' were flourishing, student-organised, enthusiastic and chaotic. As an artist they were attractive in part because a responsive audience was virtually guaranteed and there was also the sense of directly influencing up and coming artists. It was an opportunity. Can't remember why I agreed to perform outside. Probably because I knew the bleak urban location and it struck a chord with the artists' community in East London where I was living.

Normal in Wolverhampton, behavioural veneer stripping.

Outside on the grass beside a piece of corporate concrete sculpture overlooking the Wanderers football ground next to the multi-storey polytechnic building. Nicely placed, references all around.

Table, chair, sensible plastic hold-all, tape recorder, making it homely, respectable. But I'm on the outside, literally.

I behave decently then take a sip of 'tea' which stains the mouth blue (food colouring), like a horror clip allowing for the change to happen. I spit out the blue tea and groan. Relief. Close to student perception maybe. They loved the transformation. Behavioural and physical layers are gradually removed and upset until I start to act like you're not supposed to, ripping off pieces of shirt and persona, stuffing grass down my neck, climbing onto the concrete sculpture, animal-esque. At home in an alien urban landscape.

It had such a simple structure. Maybe that's why it lingers, along with the urgency of the few photos taken by I can't remember who. The delight of a low-profile event where a hype-free honesty is possible. An opportunity to step into the voluminous permission of performance art, enacting social commentary and unconscious inner need. A place where art can smack you in the face. Do this out of context you're in real trouble.

Quietly setting the scene was a straightforward device and also consistent with a slow build-up towards catharsis and release. Part of the fond memories of this performance come from its location, the fact that few people saw it, that it hit home with students, that it didn't compromise and still makes me smile.

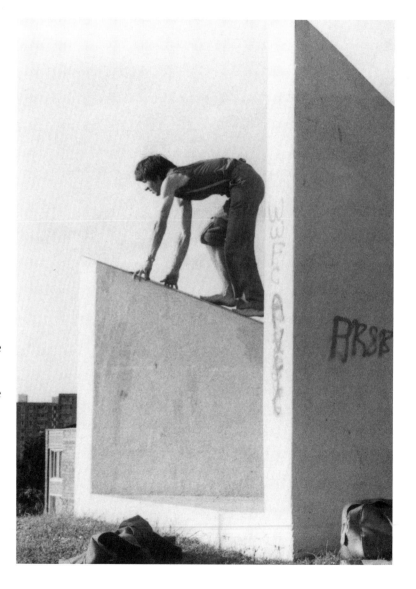

Resources and curating

Normality
**1979, performance
With modernist
architectural sculpture,
arm-less shirt, cassette-
player, bag, radio,
microphone**

The Acme Gallery is a bigger resource and support than I realise at the time. I become itchy to curate something. I notice short slots available here and there in the programme. Jonathan Harvey agrees to my proposal for a strategy which makes more of less: *8 in 4 Days*; performances and installations, '… each artist is allotted one floor for one complete day, with the previous day for setting up'. Marty St James as a radish. Keith Frake with mice. Tony Sinden with projectors. Stephen Cripps with explosives. Myself with wooden planking and an *Audience Performance*. Later I programme myself ahead into another short vacant gallery slot with *Conversations* in 1981.

The gallery acquires a reasonable video camera. I use it late in the evenings to make a rough crash-edited videotape relating to *Steps*. I submit this for a two-year Gulbenkian Foundation Video Fellowship.

Two months earlier Owen was born. Two years later I'm living alone with a visiting toddler who talks about 'Daddy's house'.

Floor

1980, videotape, black & white, 15 minutes

'Hello, this is Roy from Aidanvision in Carlisle. I was on the interview panel yesterday. You won't have heard officially yet but I'm sorry to say that you won't be offered the two year Gulbenkian Video Fellowship. It went to Peter Donnabuer (slight pause). Anyway, I'm phoning to see if you'd like to do something with our STUDIO FLOOR. We're having a new one laid in a couple of weeks and when I saw your interest in feet yesterday I thought you might like to come up to Aidanvision and do something with it, on video.'

I really wanted that fellowship. What's this I'm being offered in Carlisle? A week of mucking around with a floor, no money. They can muck around with their own fucking floor. Who is this Roy anyway? All I can remember about him is the odd stupid question he asked me in the interview and his cornish pastie shoes. And what the hell's Aidanvision? What kind of consolation prize is this?

A good one as it turns out. *Floor* is shown nationally and internationally and at the London Film Festival. It crosses that boundary between sculpture, performance and video and carries its own identity. As a first serious video it maybe has a freshness that I can never reclaim. It leads to a one year Arts Council video bursary at Brighton Polytechnic.

Overleaf
**Stills from *Floor*
1980, videotape
Wooden parquet flooring, legs, hands, tongue**

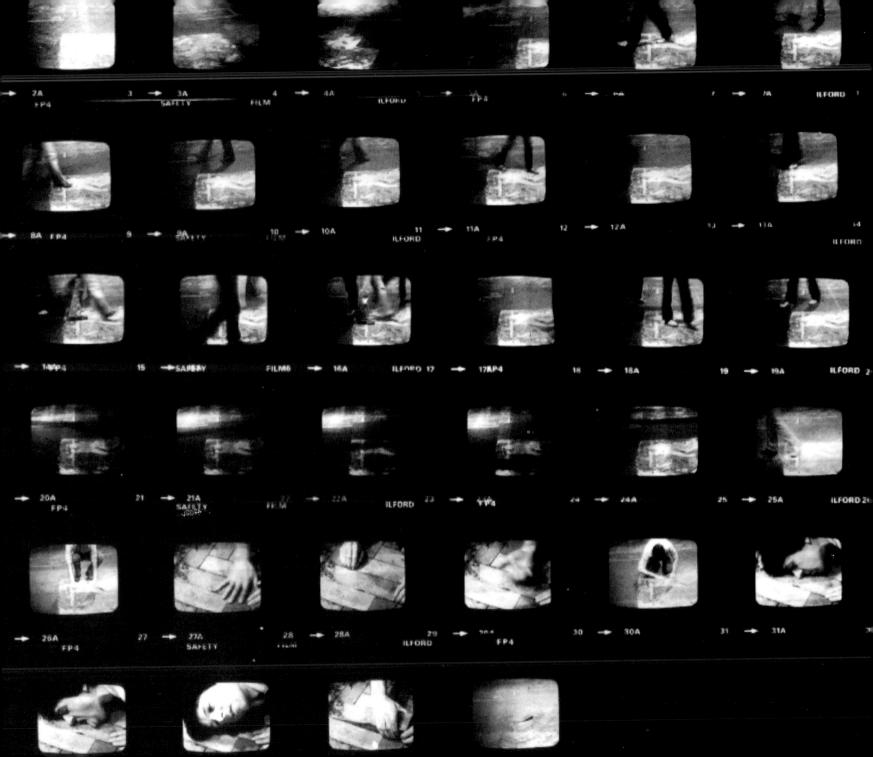

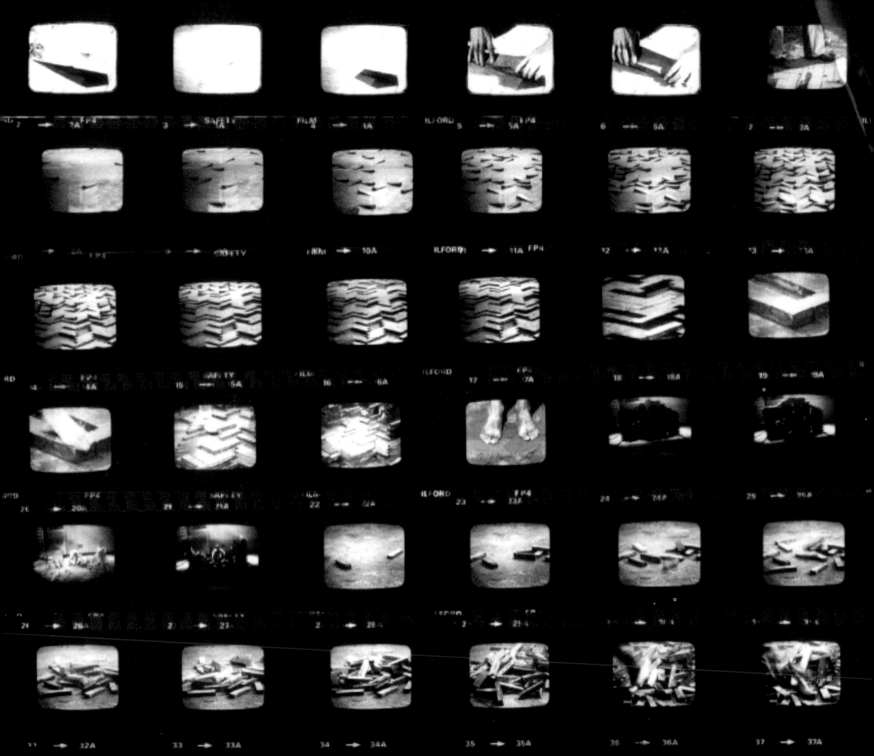

Twitch

1980–81, performance, 30 minutes
Commissioned by the Basement Group,
probably for about £30 plus travel

The Basement Group operated in Newcastle in a basement room at Spectro Arts Workshop. It was an artist-run space loosely based on the Canadian model and was one of the very few venues dedicated to performance art in the late 1970s and early 1980s. It later became Projects UK and is now Locus Plus.

The audience was almost exclusively an informed one, with a close link to Newcastle Polytechnic. *Twitch* acknowledged this but purposely stepped across and referred obliquely to other artforms – theatre, comedy and popular entertainment.

The name deliberately short, simple, unflattering and behavioural. I do twitch sometimes and don't mind admitting it. Twitching, the involuntary movement, lies somewhere between control and losing it, gesture and spasm, the body revealing vulnerability, a minuscule breakdown.

It had a simple rational structure. Time divided up in equal parts. Comfortingly familiar, a geometric rationalism going back to my interest in Constructivism and grid-structures. Half an hour at five minutes a-piece comes to six. Six behaviours. This kind of thing:

```
GESTURE, MIME
LYING DOWN MAKING NON-LANGUAGE SOUNDS [WEARING A RED
NOSE]
USING PROPS (CHAIRS, TABLES ETC.)
IMPROVISING
STANDING ON CHAIR
MOVING FAST
SITTING ON A SEAT WEARING LOTS OF CLOTHES
BEING COMPLETELY STILL AND MYSELF
DESCRIBING THE ROOM AND TIME WE'RE IN
```

It was the switch-over points which made it interesting, how one sequence changed abruptly into another. The structure allowed for any kind of behaviour within the five minute time span; any combination of being (not acting) within the comfortable framework of a clock ticking away, a ring after each five minutes and an alarm to go off live after thirty minutes. Having someone at the side ringing a bell after each section didn't seem appropriate. I needed to be self-contained; the individual struggling with self and levels of behaviour within the self. The figure locked into an external system which controls him.

It was behavioural, disturbing and funny and it set a broad agenda for many subsequent performances:

```
Sudden changes of behaviour, switch-over points
Behaviour itself as a central concern
A shifting relationship to audience
Relationship to other performance forms – movement,
mime
Combinations of humour and provocation
Manipulation
```

It was the relationship to props here that took a strong stand. They were minimised. The body was enough. The being was enough. Being in the present was enough, real-time.

And it was performed several times: Basement Group, Battersea Arts Centre, Brighton Polytechnic, NATFHE (Teachers in further education) Conference at Adelphi Hotel, London (see review below) and the Open University's Art & Environment Summer School at the University of East Anglia.

The last two were not usual venues for performance art and where it caused most controversy: people's intelligence insulted, emotions stirred, ambitions raised (Mike Cocker, an Open University TV producer, saw this as a chance to make a programme about me for Arena, his big break that didn't quite materialise).

A freshly shaven and appropriately dressed (teacher-smart) Richard Layzell gave a thirty-minute performance on one evening during the conference, using a ticking alarm clock and a tape – pre-recorded with an alarm bell breaking the silence at five minute intervals.

This rigid structure – an unusual departure for him – provided a framework for various categories of behaviour; 'an intelligence playing with possibilities'; reacting to stimuli; although each category was not pre-planned as such.

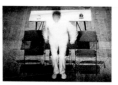

For the first five minutes he just sat and indicated how he felt – through silence; shifting; nervous statements; (which also reflected or instigated the audience's response). With brilliant timing he moved onto his second sequence when he assumed a much easier attitude, commenting in familiar terms on the architecture of the room and the situation we were all in.

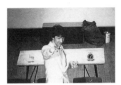

The third sequence was one of mime when he tried, unsuccessfully, to engage a few recalcitrant members of the audience staging some sort of personal protest at the back. During this sequence he also tested to the limits the properties of certain furniture – for example, daringly tipping up the table by balancing it on its edge; stamping on the bit in the middle where it creaked alarmingly. This tendency to flirt spontaneously with moments of potential hazard seems to be a characteristic of Layzell's work ...

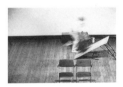

The fifth sequence was a 'demented' one; half animal, half idiot – the part of us all that is capable of insanity – he moved among us, giving rise to embarrassment, distaste, alarm and such emotions that reflect so much upon us ...

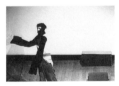

Layzell exploits the oscillation of our view of him as a 'performer', and our perception of him as a 'real' person. He is exposing facets of himself rather than using learned ways to communicate. His aim is to make us more consciously aware, by throwing into doubt all the conventions we have established for negotiating relationships with others and with the environment. Anne Painter, *Aspects*

Video in Brighton 1980–81

At Brighton Polytechnic I had access to a broadcast quality television studio and was given a small office on the top floor opposite the canteen. From my desk I could hear the space invaders machine. It was trying to tell me something. I hadn't been regularly back in an institution since my schoolteaching job in Hackney. It was slightly numbing. I mixed with staff and students. That was the advantage of being an artist in residence. There were warring factions in the staff room. I wasn't sure where I fitted in to this conflict and preferred the company of students. The ones I had most to do with were in a mini-department disturbingly called Alternative Practice. I involved them in my videotapes as much as possible and in the first couple of weeks performed *Twitch* in the Sallis Benney Theatre.

Some of the students I worked with subsequently became celebrities – Roy Hutchins joined the cabaret circuit, Steve Hawley now teaches in Sheffield and makes video, Tessa Elliot is head of the Digital Arts course at Middlesex and is active as an artist. At this time the ambitions of video artists were to have their work distributed in local video shops, to have it broadcast (pre-Channel 4). It was all a long way off. Many video artists moved on to the media industry and made rock promos etc. It felt like a mini movement of its time. Video art was hip and happening.

Titles of videos completed in 1980–81: *What Do You Mean by That?* (p.30), *Guide, Eye to Hand* (p.32), *For Space, Power* (p.34), *So This is How You Spend Your Time, Mustn't Tremble, Synch.*

The bursary at Brighton was practically full-time. I reluctantly resigned from the Acme Gallery. Video then seemed the obvious

What Do You Mean By That?

1980, videotape, colour, 30 minutes

The first work made in the Brighton Polytechnic TV studio at Moulescoomb (on the way to Lewes).
There were ten subjects:

```
ladder
apple
movement
water
communication
clock
mirror
dice
hello
bread
```

I'd recently seen American poet/performer Jackson Mac Low at the Acme Gallery. He was a constructivist in performance. He used mathematical structures and as a contemporary of John Cage said his work represented another methodology. His influence was here and in *Twitch*. In media-speak *What Do You Mean By That?* was a series of shorts. It was also a basis for using the video in other contexts.

It became a performance (with the video) at the AIR Gallery at 6–8 Rosebery Avenue in Clerkenwell, further down from Sadlers Wells Theatre. The Space Studios offices were upstairs and at the time AIR was the main London rival to the Acme Gallery. *That's What I Mean* was an installation in the Brighton Polytechnic Gallery, again using the ten subjects and the video. The subjects now took on physical form. Bread became baguettes. Ladders were on hire. Apples were grafted together and referred directly to *Black Room 1* from 1969. The glass-fronted gallery overlooks Grand Parade, the main road leading down to the seafront and past the Pavilion, just before the buses turn round at Old Steine.

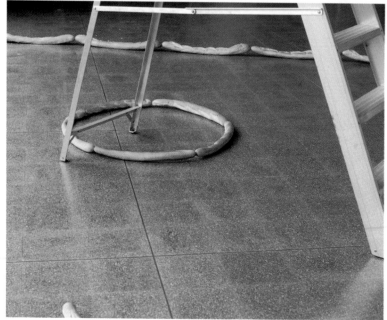

Above
What Do You Mean By That?
Video still
Bread
Below
That's What I Mean
installation at Brighton Polytechnic Gallery
Twisted baguettes, ladders

Hello was a performance for the AIR Gallery and had Brighton influences – video and space invaders. *Conversations* at the Acme Gallery happened shortly after. Going back to Acme as an artist was liberating. No conflict of interest now.

Conversations

1981, at the Acme Gallery

We sent out publicity material saying:

```
'CONVERSATIONS'
Richard Layzell
An Exploration of the Upper Gallery and its Events
Performance 8pm each evening
Thursday 30 April to
Saturday 2 May 1981
FROM NOON DAILY
```

Deliberately understated. There was no exhibition, nothing. The audience came in through the glass doors on Shelton Street, passed through an empty Lower Gallery and went upstairs. I was simply present with a video camera on a large tripod and encountered them as they came upstairs. By then they were half committed to the experience. It was awkward for them to turn around and walk out with me there engaging them in conversation. They would agree to be filmed in some way. We would collaborate on this. An Iranian who kept saying he wasn't embarrassed. A nun who would only have her shoes filmed. They, and others, were invited back for the evening performance which was an improvised re-run of the day's events, accompanied by the day's played-back video. It was an excuse for mayhem.

The audience came in in the dark with the TV switched on – air and musak playing. Using a torch he directed them to their seats cinema style, the chairs arranged in rows in the centre of the room. An audio tape played with the sound of space invaders, the now familiar concrete buzzes becoming one single hum. Pure colour came on the video screen fading from red to yellow to blue. Hovering around the edges of the audience Layzell started to put in to motion a crude, unseen programme of sensations. Starting with an audio joke using a slide projector – clicking slides monotonously lecture-wise he started to syncopate with wooden blocks clacking together. He then moved around the audience with the blocks in the dark and the joke started to become threat, the aggressive clacking putting people on edge. Then water sprayed from a hydrator, literally cooled people off and renewed the sense of a joke as people slowly got wet. Then threat once more. Marbles thrown across the audience landing on the floor deafeningly. This time there was no relief when they were followed by ping pong balls. Again, it was something in a 'quirk' of Layzell's innocent-psychotic nature that put a whiff of fear into the air, as effective an implied physical threat as when Keith James once walked around a pitch black room with a Black & Decker drill (Action Space 1976). Layzell switched on the light, a retina-scorching experience after 20 minutes of darkness, and calmly started to bring himself into the experience where previously he had been an operator. He started making small sounds relating to things in the room and then to the room itself. He then painted his face red and blue and drew a circle of string around the audience. gaining coherence, he then read slowly from a Ladybird Book called SHAPES. He then talked on random subjects for five minutes, and finished the performance. (The talk was intended to have no meaning – but feeling a sense of relief, people tended to find the speech amusing). The main thing he felt was that people came out feeling good. In this case he had deliberately contrived it to be so, in an almost theatrical sense, but clearly for his satisfaction, or for this stage in this series of works. The audience themselves had been put through a purifying process.

Conversations the final work I saw, was for him the most important work to date, and was certainly the work where most was left up to chance. Again, it involved Layzell handing out his personality on a plate, as it were, in public. I suppose that what distinguishes him in his ability to actually do this without being pretentious, obscure, dull or just plain loony is his ability to draw a firm line while stripping away all safeguards down to the bone in a way that clearly embarrasses the average angst-ridden, secretive artist. In *Conversations* he spent the

day in the Acme Gallery just talking to people with a video camera – in the evening performance, the results were roughly presented with an added commentary, on top of the soundtrack, by Layzell. His disturbing frankness added several dimensions to what were, on the face of it, reams of grey indistinct video garbage. His intuitive actions during the day gave results that looked like a mixture of sloppiness and a silly version of the avant-garde home movie pictures of feet, noses, elbows etc. But it later transpired that what Layzell had been doing was this: Someone would say – 'I don't want to be filmed' and Layzell would then say 'Alright, can I just film your shoes, gloves, etc.' Amazingly, they'd agree, and expressive aspects of the shy visitor would emerge, along with Layzell's description of minutiae, that would never be revealed with a straight recording.

Both *What Do You Mean By That?* and *Hooray* were relatively carefully structured, but *Conversations* literally was constructed out of totally informal moments. This informality could threaten the nature of the work; it could also threaten Layzell's seriousness of intent, and he came perilously close to demystification out of existence, where the audience began to overtake Layzell in the informality stakes. He would be talking, and people would be laughing and throwing comments back, when he would suddenly stand on one leg on a chair while carrying on as normal, or stand on the monitor. We got the flash of strangeness, the threat of madness, but somehow the rarefied atmosphere of previous performances was not there.

It was simply taken for granted that he would do things like that, that this was within the rules. But then, there was also a group feeling of a shared experiment, of a scientific collaboration. This can be an important feeling. All too often it can become obvious that a performance artist is engaged on some private experiment on his or her perceptions, consciousness etc., and is somehow incidentally doing it in public. It is all very well not to expect the artist to entertain or explain, but it can be hard going if the audience is totally excluded from the work, that its being there is a mere adjunct, a condition of the work being performed in the gallery, or getting a grant, or whatever. With Layzell's experiments, you are somehow in there with him, often against your will, but on the night I saw *Conversations* there was a full feeling of consent among the audience. That being said, the following night, he went on to impose a different regime by taking away all the chairs and the audience automatically lined the walls as if, once more, expecting a psychological attack from Layzell.

Performance Magazine

Eye to Hand

1981, videotape, colour, 10 minutes

With *Eye to Hand* I entered fully into video technology and trickery. Visuals and audio were mixed, overlaid and inter-woven in three broad sections which were then gradually broken down:

```
1] Spheres in space, planet like
   audio: Das Lied von der Erde by Mahler

2] Balls in air, juggled
   audio: Tyler is Guilty by UB40

3] Balls with a slow-motion naked baby
   audio: Monkey Chant by the people of Bali
```

A video still that looks like a photo but it's all sound and movement. How to film your baby and edit the material to look unsentimental? Here's Owen at 18 months spending some time with his Dad in the TV studio at Moulescoomb, pissing on the floor now and then and upsetting the cameramen. 'Chroma key' allowed everything to float in dark space: the body, the spheres and the juggler's hands. With this calibre of editing equipment I could slow down Owen's movements to a shudder and with the guttural Balinese chanting as a soundtrack this baby began to look menacing in naked abandon. I was half living in Brighton, half separated, clinging on to fatherhood for dear life.

**Eye to Hand
1981, videotape
Naked baby (Owen), ball**

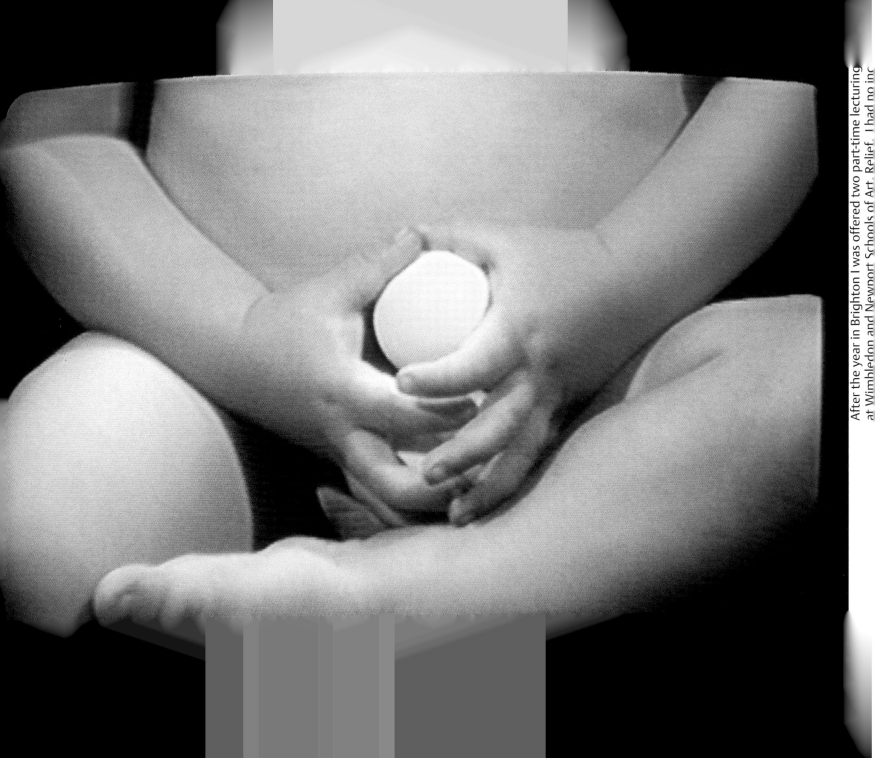

After the year in Brighton I was offered two part-time lecturing at Wimbledon and Newport Schools of Art. Relief. I had no inc

Power

1981, videotape, colour, 30 minutes

Working in the TV studio there were often three or four camera operators and technicians waiting to be told what to do. They looked on me as the Director. They waited for me to make up my mind. It wasn't a collaboration for them, more of an irritation. Frequently I didn't have a clear intention and needed the time to experiment. *Power* was a way of exploring the role they expected of me through performance. If they wanted me to direct then I'd go the whole way.

```
I am in control in the studio in Brighton, cameras 1,
2 and 3. Even controlling the vision mixing: cut to
camera 2, fade to camera 3. I am in the director's
chair controlling people as well as cameras. 'I want a
drink of water. Bring me a glass of water. Now
sprinkle it over my left shoulder. Not like that, like
that. Bring me an apple. Make it a Granny Smith. Stand
still both of you. Camera 3 zoom in on my face. Camera
2 zoom in on my hands. Now cut from camera 1. Bring
out the dots and the tape. Stick them on my face.
Carefully. You know how I like this done. Cut to
camera 2. Camera 1 show their faces while they do
this.' I have complete control. But I need to go to
the bathroom. 'Help me to the bathroom both of you.
Mind the camera cable.'
```

The camera operators became part of the scenario. They didn't know what I was gonna do or say next. I hardly knew myself. Just keep it rolling. A thirty minute progression from absolute control to helplessness. It later developed into a video/performance. Ideally shown with the videotape projected right behind me and also on two monitors on either side, all showing the same images. I sit in the middle, gesturing, occasionally repeating phrases from the video. Arrogance to humility. Crumpled tyrant has to take a leak.

This one went down well in America. It was uncompromising. A great grateful power trip no mucking around unashamed take it or leave it. (See review, p.35)

```
Clothing:
GREY GERMAN JACKET WITH PLEATS ROUND THE SHOULDERS AND
REAL LEATHER TRIMMINGS
YELLOW GLITTER SOCKS
FAWN TROUSERS. BROWN 'DECK' SHOES
WHITE BAGGY SYNTHETIC SHIRT
```

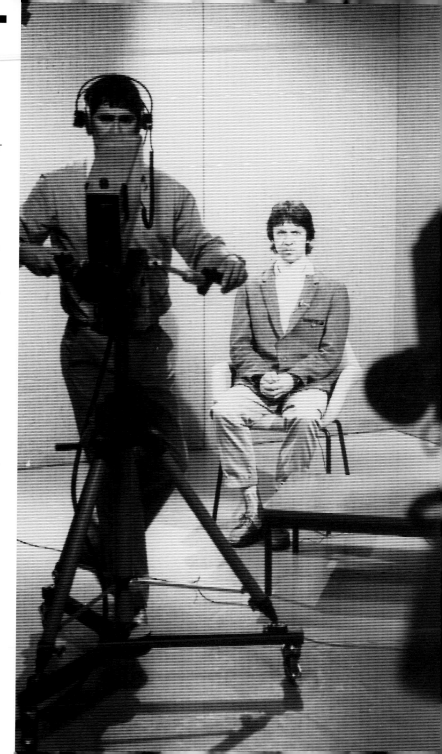

**Touring USA and Canada:
5 January to 13 February 1982**
New York, Toronto, Vancouver,
San Francisco

Going back to America ten years older and this time feeling like an artist. No ambivalence. But bloody cold. It froze the nostril breath. A networking and performing trip. In New York meetings at the Kitchen, Anthology Film Archive, the Performing Garage and West Beth Theatre Centre where they said yes straight away. Performed at Franklin Furnace. But it was self-publicised and not really part of their program. I did the live version of *Power*, with the video on a too-small monitor. It went OK. They were doing what they could at short notice. At West Beth I was given a ten minute slot which was part of a pretty mixed bag. Did three shortened sections from *Twitch*. It went OK. I was classified as a Stand Up.

Toronto was more welcoming. Spadina Avenue reminded me of the Holloway Road. On my first evening I saw the artist Michael Snow performing free-form improvised music at the Music Gallery. The true passion of this guru of avant-garde film was to thrash around in a music studio with a bunch of buddies. The audience was incidental. I was staying in Clendenan Avenue with Jonathan who was making a documentary film for TV about vegetarianism. Captain Kirk played the lead. Really. He's a vegetarian. Jonathan's girlfriend was a demure former stripper who reluctantly talked about her one-piece beaver costume. It was hard to imagine this shy woman unzipping in a crowded bar to shouts of

Power
1981, videotape
Three cameras, two other
performers (not shown)

'Beaver! Beaver!' But I suppose you could say the same about me. I gave a public screening of my Brighton videotapes at Trinity Square Video and foolishly gave a copy of them to a Vince Alexander from MTV who said he'd see what he could do. No doubt they were broadcast without the sniff of a royalty.

Club Foot in San Francisco was a worrying prospect but turned out to be the high point of this tour. Located in an industrial belt far out near railroad tracks it didn't look promising. But there was a network in place and the stark publicity looked good. It was the handiwork of the club manager J C Garrett, a gravel-voiced former punk with a sense of humour. I performed *Power* and a new improvisation:

Richard Layzell's performances are re-enactments of the post-tribal ego and id. He disconverts timespace by subverting relationships of mind and body, of personal and public presence. He cajoles and teases his audience into self-awareness through body gestures signifying a host of languages we are accustomed to, then subverts these impressions through theatrical tricks. He mimes emotional states and articulates quiet strength, surety and knowledge we all know is illusory. Richard worked that night at CLUB FOOT on a stage emptied of symbolic or literary reference. There was no narrative line to follow except during one of the sequences in which he was seated between two TV monitors. There was no theatrical lighting. His props are minimal and functional. During most of the performance we are told to, 'look at me, if I catch you looking at that,' pointing to the TV images, 'I'll ... well, you just do it and find out ...' On the monitors were displayed a performance situation inside a TV studio in which two people acted out

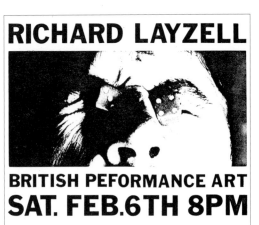

commands from Layzell. He controlled the videotaped scenario absolutely, even admonishing the camera crew to create the impossible. At certain points his performance intersected the video situation. (Two people stood up in the audience and began performing right there, at a moment they interpreted as a signal to them to mimic the actions of the two video people). This appeared farcical. It threw off our expectation as an audience and dissolved our conditioned behaviour, threatening the idea of participation mystique. Behavior, and its modification through intimidation was subject matter for Layzell.
Richard Irwin, *ART COM* San Francisco

Fourth International Symposium of Performance Art, Lyon

It was nice to be representing Britain, with Rose Finn-Kelcey. There was something prestigious about it being in France or in the way it was organised by a pre-horned Orlan and Hubert Besacier, a local man. Orlan announced that she'd decided to give up performance in favour of installation art. Was this a challenge to us, the internationals, the visiting performance artists? Then there was this fuss about the American's grand piano. The one he'd been given wasn't up to scratch. He wouldn't perform unless they found him a Bechstein.

I discovered I was scheduled into the Maison de la Danse, a very formal dance theatre. This was an unwelcome surprise. It didn't suit the work I'd brought. I had no say in this. Maybe I should have looked into it before leaving. Maybe they could have been a bit more consultative. This was a good piece of work I'd prepared; a new video-performance needing four monitors and a separate audio amplifier. The equipment was there but all they talked about was the fucking piano for the next evening. And then there were the logistics. The Italians were scheduled to go on first, then me, then the Swiss. It began to feel a bit like the World Cup. The Italians, Ascari and Frigerio, had technology fever. They would need to set up everything in advance. Then there'd be an interval for the technical change-over and I'd set up. Half-time. Third-time really. As the Italians came off the field the Swiss made a sudden and unexpected move from the touch line. They spoke in fluent French. Something was afoot. They really had to appear after the interval because they needed to be somewhere. This was the gist of it. A decent referee would have called a foul. But Hubert Besacier wasn't impartial. He

took me to one side and asked me to swap with them. He assured me they'd be very quick to set up. I found myself being gracious and hating it. It was already 10pm. An hour later they were just prepared. The audience were growing restless. Some people left. I wasn't feeling so good. Not good at all. Bad. Terrible. Flat. The Swiss performance was very long and not so good. It was midnight before I could finally get on to the pitch. This wasn't off-the-wall spontaneity but terrible organisation. There was a small crowd left. *Stand Up/Sit Down* was an intimate performance that echoed here in every sense; bouncing off the theatre's stately walls, and the audience. Man and technology thrashing it out on a ballet stage.

Jean de Breyne was sitting at the front. He saw the irony in it and was complimentary. He ran the small gallery where Rose Finn-Kelcey was performing. Two years later he invited me to make an installation (*Les Ailes*) for his gallery's tenth anniversary.

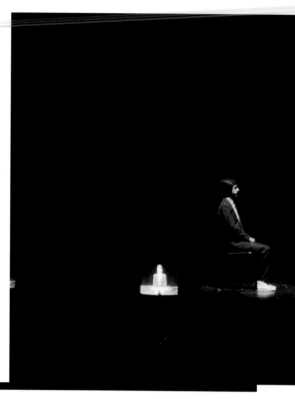

Stand Up/Sit Down

1982, video – performance, 25 minutes

An interaction between myself as performer on video and as live performer. The camera focuses on fragments of my clothing, face and hands, and wide-angle shots of certain actions; standing, sitting, lying down. There are captions and voice-overs giving instructions and commands. These can be obeyed – as they are on video – or ignored.

Stand Up/Sit Down overtly deals with power and the media, man and machine, performing and acting. Who's controlling who? The performer on video? The performer live? Or the audience?

Sample commands and captions:

```
STAND UP
SIT DOWN
LIE DOWN
I FEEL TERRIFIC
MOVE YOURSELF
```

DON'T LOOK AT ME
SHOW YOUR TEETH
FOLD YOUR ARMS
KNEEL

Clothing:
RED CHECK JACKET WITH SQUARE
SHOULDERS MADE BY JOHNSONS OF
KENSINGTON MARKET
GREY TROUSERS
WHITE LACED BOOTS
RED/BLACK MOCK SNAKESKIN NARROW
TIE FROM NEW YORK

Above
Stand Up / Sit Down
1982, video-performance
Four video monitors, chair, performer, particular
clothing

Emotional content

Later in 1982, inspired by performances I'd seen in New York the year before, I started developing *Song Song*, a large-scale multi-media event for ten performers. Wimbledon School of Art's well-equipped theatre became a starting point. There was the opportunity to suspend (fly) video monitors and sculptural objects, project slides and film, choreograph movement sequences, experiment with lighting and special effects and develop it gradually through workshops. In the middle of the rehearsal period my mother died unexpectedly. I was thrown as much by my father's devastation as the sudden shock. They'd not long moved back to Britain from Australia and were living in a South Coast suburb. My brother flew over from Sydney. It fell to me to take control of the situation and that was not so difficult. It's what you do. But it was harder to return to the performance, which was scheduled for six weeks ahead. Some of the original enthusiasm for this ambitious project was lost, and an inevitable thread of sadness entered. It became less exuberant and more emotionally charged. Jeremy Peyton-Jones commissioned a second version of *Song Song* for the Midland Group in Nottingham the following year. I also made a videotape (*Colourge*, 1984) about my mother's aspirations and her passion for suburbia.

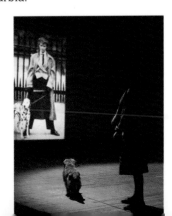

Left
Song Song
1983, performance
Wimbledon School of Art
Theatre

Second North American tour, 1983: the 'parallel galleries'

Canada excels in the concept of the artist-run gallery or workspace. Every major city has several, most larger towns have one or two. Sometimes they receive city or national funding but not always. The idea of offering your time to support other artists is commonplace. They're known as 'parallel galleries'. For some years they were supported and networked by a monthly publication *Parallelogramme* which listed the spaces and their programmes. Canada was also early to support the development and distribution of video art.

This tour was made possible by a grant from Canada Council (fee plus expenses) and the British Council (travel). I was based at Mercer Union in Toronto for the first month, then Western Front in Vancouver for a video residency (*Soap and Water*) and various other short trips, sometimes performing. I drove a hire-car north out of Toronto for a few days into the remoter reaches of Ontario. I was shooting for a video which had a title (*Swamp City*) but was never edited. I also collaborated on a short video (*Elephants*) with Noel Harding.

Not as planned, Not as planned, not as planned, not as planned,
NOT AS PLANNED. INPUT MORE THAN OUTPUT.

Who's Cool?

1983, an installation at Mercer Union, Toronto

Mercer Union was located in downtown Toronto, a low rent office space near some of the other parallel galleries in the area: YYZ, A Space, ARE and Art Metropole. The residency was a great opportunity. Long enough to feel at home. I felt liberated by being out of Britain. As the Canadian artists around me spoke of their national identity crisis I found my own identity was becoming stronger.

For Peace. It sounds so uncool. It was still a risk then to be a bit political in the art world, but easier being out of my own country of origin in a large expanse of fifth floor cheap rent artist-run gallery. It was part of a network of maybe ten similar spaces in Toronto alone. I had a Canada Council Visiting Foreign Artists Award. Bit of a mouthful. I lived in the apartment of sculptor Robert McNealy while he was in China. He was on the Board of Mercer Union. I looked out of the window a lot and played his records, especially the African lute player Alhaji Bai Konte. This expansive view across car park and office development became a tape/slide sequence so simple and probably the best thing I made there. I showed it with lute accompaniment and another version of *Who's Cool?* at Canada House in London the following year.

The title *Who's Cool?* came from club interventions in the UK:

The Academy in Bournemouth was larger than expected and looked like the Camden Palace, with videos, lasers and lighting grids. The club manager, Kelly, certainly had his ear to the ground. I was keen not to be the first act of the evening but Kelly was insistent: 'They'll be more receptive early on. They'll listen to you talking. You go on at 9.30, right?' Later, at our backstage briefing, I had to admire his hard-headed approach. At least you knew where you stood. His show was aimed at keeping the kids happy and interested. No room for boredom here. The performers and three DJs were each given a slip of paper with name and time of appearance, in case you forgot. There was something vaguely reassuring about this. You felt like part of a team – the greater aim was to make the evening a success. We were the individual parts – I almost felt like I was doing it for Kelly.

When my time actually came I was embarrassed by an incident with my trouser turn-ups but reassured by one of the audience 'They look fine. I should know, I'm a fashion student.' I waited in the wings for a nod from Kelly as he and one of the other DJs electronically descended in their console to below stage level. I looked down at him and waited while he forgot my name, '... a special guest, Richard Lay ... Lay ...' he looked at me, 'Zell!' I shouted, 'Richard Layborn' he said, adding 'The thing about this guy is he's very UN ... PRE ... DIC ... TA ... BLE.'

I cringed and moved on slowly, trying to deal with a backdrop which was mistakenly rising. Kelly and the DJ, who'd pressed the wrong button, didn't pick up on my cue for them to lower it again, although admittedly I was gesturing in slow motion. OK, head for the front of the stage and see how long I can hold their attention without doing much. I reached centre-stage, faced them squarely and tried to hold a balance of tension between us. As at Dingwalls (in Newcastle a week earlier), the reaction was unpredictable and I didn't have enough tension at my disposal. Subtleties of movement don't seem to work in an environment where the main medium is amplified sound. So I asked for volunteers, asked who was cool, told them they read the Sun, had fun, had voted Conservative and generally got a bit heavy with them, which seemed to get through much more.

By the end there was sufficient tension to be able to hold their attention with gesture and movement, then to make a slow exit. The smooth transition back to the music and dancing suited what I'd been trying to point at. It was also good to be able to join the dancers on the floor, have a good time with them, be cool and all the rest of it.

Performance Magazine

Who's Cool? 1983
Below
Installation at Mercer Union Toronto. Paper
Opposite
Performance at Canada House London
Paper, curtains, electric fans, grand piano (not shown)

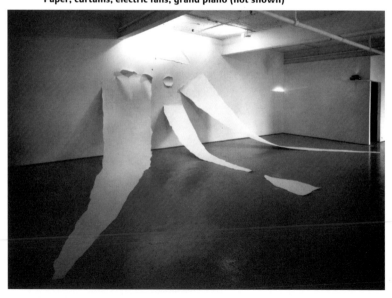

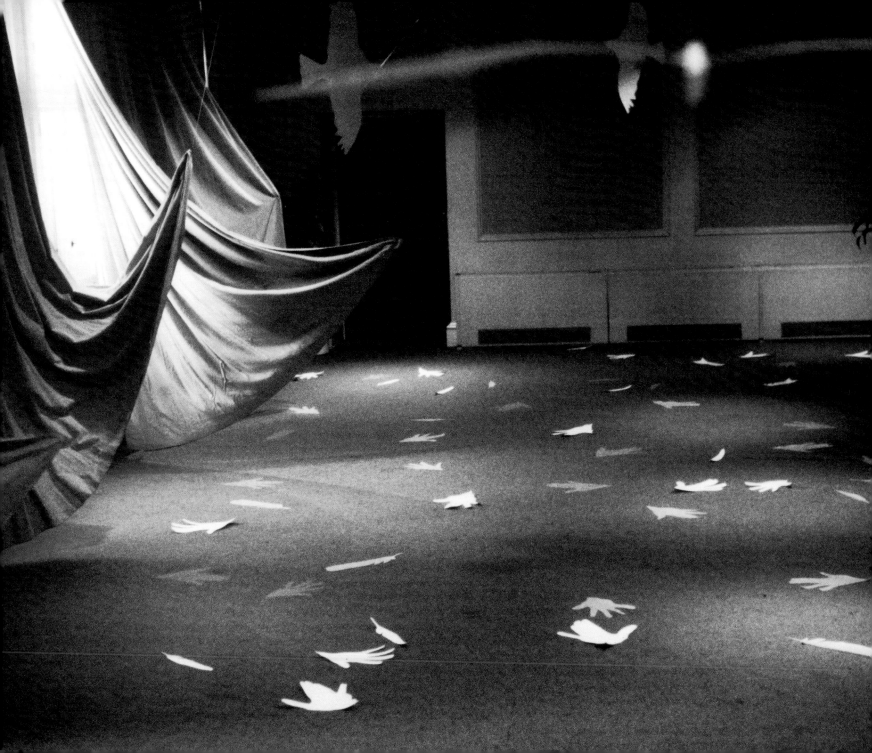

I wanted to question the cool that could miss the militarism build-up. It's easier to go clubbing, easier to make apolitical art, maybe it always is. It felt like any gesture was better than no gesture. I'd been living this in London, was living this in the London office of the Greenham Common Women's Peace Camp in Islington. As the only man in the shared house where the phone was always busy and reporters were at the breakfast table I'd answer the front door and women's faces would drop. This was a real political movement of its time. Addressing the peace/militarism dichotomy in artwork, however obliquely, became a natural extension of daily life.

Here in clean Toronto tearing white paper was such a minimal act, but enough – a white bird form that wasn't so literal. The following year I would be tearing paper in a Lyon gallery with my five year old son asleep in the corner at night. I'd be working with stolen time and an exhibition title *Les Ailes* (wings) which phonetically repeated the family surname. We would perform within the installation together at the Private View, such a buzz for me as the part-time parent, a public affirmation. And linking this to another performance (*Roles*) which specifically dealt with single parenthood and the father-role, actually saying a few things in public not for sympathy but for other men, 'Why are the monsters in kids' stories (apart from the witches) always called he?' Making work out of 'nothing;' imitating his movements and drawings from early video and saying what I think.

But now, here in Toronto, when the performance happened in the installation did it unavoidably read like a stage set afterwards?

The impermanence of the paper was just so.

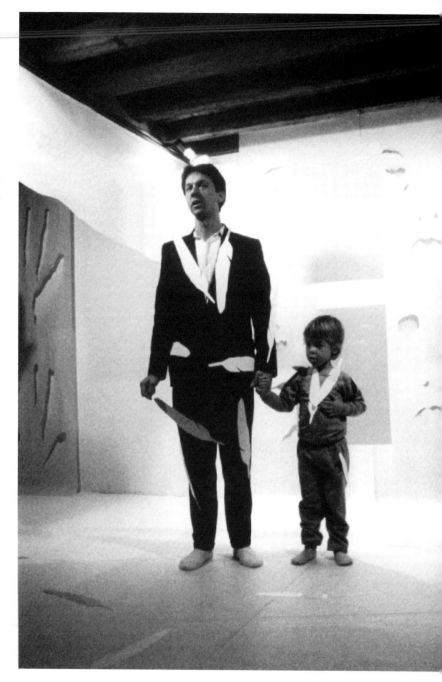

Les Ailes
1985, performance
With Owen at private view
Paper, suit, tracksuit, socks (to protect paper floor)

Bracknell Performance Festival 1982–84

This annual festival was held in the unlikely setting of South Hill Park, a former stately home in Berkshire, surrounded by a London overspill New Town. The extensive grounds, small gallery, theatre and meeting rooms offered considerable potential for performance excursions which often offended the regulars in the bar. It was organised by Jennifer Walwin and Alastair Snow and was always fresh and funky.
I participated for three consecutive years with *Power*, *Zangst* and an improvisation:

> Richard Layzell did one of his Improvisations in the elegant, panelled Recital Room. Armed with a few props, a couple of videos, and a lot of nerve, Layzell walked a tightrope of complicity. Highlights, for me, were being privileged to a personal demonstration (I happened to be sitting in just the right seat) of the op-art effect of moving his spotted tie behind the holes of a high-tech metal bookend, and an altercation with a member of the audience about Wee Willie Harris, whose photograph, which Layzell was holding, was taken in the same year, and conceivably at the same time, as the person (who had never heard of Wee Willie Harris) was born. I also enjoyed Layzell's *Dog* video.
>
> David Briers, *Performance Magazine*

Clarity

1985, a Television South West Production, colour, 12 minutes

Performance art for late night TV.
Filmed in the Television South West studios in Plymouth. This is the language they used:

```
Prog No: VFS/2172
Studio One
VT Date: Monday 8th July 1985
Txn Date: tba
```

Actions (in my language):

- Close-ups of mouth showing teeth grimace + blowing out smoke + spitting out marbles
- Figure moves across to banner and lines up behind it (squares on coat line up with squares cut out of banner
- Zoom in slowly on one square of the coat
- Figure, moving faster, removes black coat. Turns to show glass windows sewn onto white cardigan which is worn underneath. Leans forward.
- Toronto window slide sequence
- Close-up of palm holding miniature window
- Dissolve from eyebrows to bird-form over eyebrows

Started learning Tai Chi in a dismal school hall in Holloway. The teachers were Londoners born and bred. But they taught in (what

Collaboration

The train journeys to and from my teaching job in Newport were an integral part of the experience; space time. The fast trains stop at Reading, Swindon and Bristol Parkway. Then the long tunnel and you're in Wales, Newport first stop, an hour and a half from Paddington. Long enough to strike up more than a conversation with other part-time lecturers. Long enough to experience a 'polishing pen' (see *Definitions* p.44). Marian Schoettle, an American artist and designer, was teaching the same two days as me. Our collaboration began by including one of her coats in *Clarity*. The 'window' designs on the back of the coat became a thematic influence. Developing the collaboration further, I began working on a new performance based around another of her designs – a double shirt. It's a shirt without cuffs, one sleeve joined to the next, one shirt becoming another. It's worn double, shirt over shirt. Over a period of months this performance became *Definitions* and subsequently *Re-Definitions*.

Words

1985–87, performance, 20 minutes, Chisenhale Dance Space London, Franklin Furnace New York, The Hippodrome London

Words was performed in combination with *Definitions* as a kind of introduction or warm-up. The concept of a double-bill. It was also performed alone once at The Hippodrome nightclub in Leicester Square. Simple in concept and part didactic, it explored the use of words in and out of the media:

I open the Daily Mirror and read:

```
WHO TOLD THAT CHOPPER WHOPPER?
BATTY BIFFEN WAS SO WRONG
I'LL NEVER FORGET WHAT DIRTY DEN DID
BITTER SWEET SEX SHOCKER
TEARAWAY TINA'S TRIM TREATMENTS
DASH IN, CASH IN
AUTOWASHER PRICE CRASH
COKE ADDS LIFE TO
WITH THE EMPHASIS ON GO
DO YOU KNOW ME?
NEVER LEAVE HOME WITHOUT IT
```

Exploration of popular press language leads to vocal word-based improvisation which sounded international and multilingual:

```
EEWAHENAGH BROWSTEENG ACHSTRUBHNGHWAK
MOULTREWBSTRKEENG ORRK BEELGH HHUHHH LLERONN
UJESKLEEBROOD PATRESSTDROK AAHH
```

Then a more free-flowing use of language which suggested visual imagery. I always saw the words as being performed and not read as text. It was written with one phrase/image following another and no overall structure.

I open a black tome-like volume and read. Speak disjointedly as if struggling with a foreign language and with plenty of fragmented enunciation:

```
So on we went all quiet
waiting
yellow sky
grey bits
one morning
come to life
hidden pattern
we'd bin waiting
padded
```

Words
1985–87, performance
Blackboard, book, silver card
Right
At the Hippodrome, London
Far right
Franklin Furnace New York

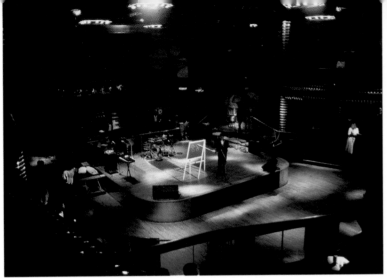

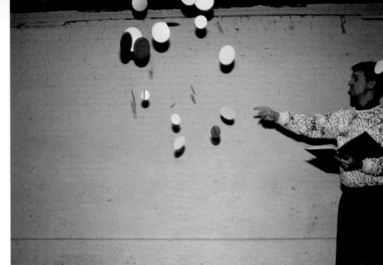

```
h-alert
ready
by the 'and
the big screen
da forest
spanning up
seein' down
switchbacking
h-understanding
youngah
softah
sofar safer
silent (pause)
QUIET (shouts)
public
trunk of a tree (speeding up)
no trace
missed
gone
a small moon
there, there, THERE . . . T H E R E . . .
T H A I R R R R R R R . . .
```

I scatter silver moons surreptitiously taken from inside the black volume – circles of card which spin and take time to land. A visual device and an illustration of the spoken words. I point to one of them lying on the ground for the final 'there'. Keep pointing. The 'moons' are left on the ground and become incorporated in *Definitions*.

```
Clothing
GRAFFITI-STYLE SWEATSHIRT
```

This page and opposite
Definitions
1985–87
**Performance at Franklin
Furnace New York
Suit, double shirt, scarf,
polishing pen (not shown)**

Definitions and **Re-Definitions**

1985–87, performance, 40–50 minutes

When *Definitions* followed on directly from *Words* and there was just a short pause, the two performances became interconnected. By now I was consciously including humour as an element in the work. Although *Definitions* took Marian Schoettle's double shirt as a starting point, once the theme of labelling had evolved it moved quickly into text. Eventually the 'shirt sequence' appeared as a section towards the end. I had a lot to say about stereotyping as an artist in no small measure. To call yourself a performance artist in 1985 was an issue in itself. It still is. I could expose this in the performance as well as issues of male identity. It could demonstrate the desire to break out, risk-take and confound people's expectations. By the time of its completion *Definitions* was dealing with one of my motivations to make art.

Music by Tuxedo Moon and Charlie Mingus

```
Give it a name and you're OK
Give it a name and you're OK
```

The opening section is more like an abstract dance/ritual with ambient electronic music. It's deliberately ambiguous and ends on a freeze. Then I speak directly to the audience something like this:

```
Is this what I do for a living?
Is this the kind of thing you expected?
When people ask me I never know what to say. I mean
what I usually say is: 'Well, you know, it's a bit
like acting and a bit like art, you know, nothing to
worry about. But what I really feel like saying is
c . . . c . . . c . . . come and see for yourself.'
It's as if they want it to be categorised to make them
feel better and sometimes, know the feeling, when
someone comes up to you at a party and says:
'Hello, I'm John. What do you do?'
John would prefer to hear something he'll feel
comfortable with, so he can pigeon-hole me (a boxed
hand gesture).
Give it a name – Architect, Teacher, in Marketing, in
the Financial Sector – Give it a name, you're OK . . .
I was sitting on a train, an InterCity 125 train a few
weeks ago when I noticed the woman opposite me was
painting her nails with a felt-tip pen. She was
respectably dressed, a business-type. This activity
didn't fit her image at all. It was more like punk-type
behaviour. When I looked harder, discreetly, I noticed
```

that she was actually using one of these (take it out
of pocket and hold it up. Start painting my own nails)
a Polishing Pen, the latest in nail cosmetics. I'd
never seen one before. A few seconds later the man
across the aisle lit up his cigarette with a gold
ball-point pen. I started to feel a little unreal. But
now I've seen them once I'm OK, can give 'em a name.
Give it a name and you're OK . . .

It's always a relief when new things become familiar
because you don't have to think about them any more.
And who needs those kind of thoughts? I mean we know
what's here, it's clear, familiar; wall, floor,
ceiling, light switch; perfectly, PERFECTLY clear, but
what's THAT? What's that thing there on the floor
(point to silver moon from *Words*), look at it, what is
it? WHAT . . IS . . IT?

WHAT IS IT? . . .

Maybe that's exactly what you're thinking about me
now.

Perhaps you've been sitting there making all kinds of
assumptions about this performance. Thinking, for
example, how much longer is he going on like this (sit
in audience and face performance area, speak
objectively about the performance). You may have
preferred the opening sequence because my relationship
to you was more distant. You may have already
categorised this as a certain kind of performance. You
may be trying to predict what will come next . . .

But if I was to come clean and tell you that actually
I don't know what's coming next, maybe that's a bit
threatening, coming under the heading of 'Performance
Art'. Or maybe you can then think 'Oh well, he doesn't
know what he's doing. The man's unprepared,
unprofessional. I don't have to take this so
seriously. That's a relief.' But if I REALLY don't
know and I intend not to know and that's exactly what
I want to express to you, NOT KNOWING, not knowing
what to do next . . .

But of course I do, no I don't, yes I do, no, look I
couldn't possibly, NO, I'd have to give up my job, no,
no, look I told you, it's impossible, I'm not like
that, it's too risky for me, no, what would my parents
think, what would my husband think, no, no, NO, no-one
would like me anymore, no I couldn't possibly . . .

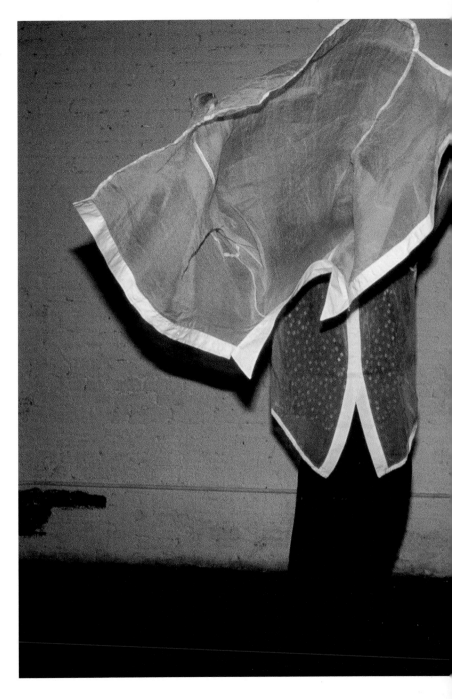

Sometimes I try to fit in, to behave like a 'normal' person, to think about 'normal' things like investments and cars and smart restaurants and being able to talk about BUSINESS and having BIG muscles and really BEING this image that's everywhere, this IMAGE, this vision of being a MAN. But it's there all the time; on TV, in commercials, in magazines, in newspapers, in the streets. There he is, STEVE (loud) How you doin' mate?

But don't get me wrong, I mean I don't want to upset anybody, I mean I'm not like that really, (voice and body language become timid, whining) I don't want to ask questions, I know everything's alright really. We know that don't we, I mean we know everything's gonna be alright because, well it's gotta be hasn't it, I mean they know what's best for us don't they, they're the experts. Cor, where would we be without the experts, eh?

I mean, those missiles, what do they call them, cruise missiles, they wouldn't bring 'em in if it wasn't for the best, would they? Tell the truth I think we're much better off not thinking about it, much better off, leavin' it to the experts. I mean what's the point in thinkin' about nasty things eh? I'd rather have a nice cuppa tea and put me feet up. I mean I don't wanna rock the boat . . . I don't wanna rock the boat (sit down and rock chair), do I? . . . Do I? (look at audience).'

Although this text was improvised there was a deliberate and sudden crashing of one section into another. And a deliberate turning the audience on and off. I wanted to do a little unpacking of prejudice there and then. The 'don't rock the boat' persona was based on my father.

Later sections included direct audience participation and a physical un-layering using Marian's shirt which I wore under the suit. Through a movement sequence the shirt is removed but hangs on through the sleeves like a shed skin that won't detach, until the second shirt is removed along with it. A blue shirt – a frayed old favourite – was worn underneath.

Clothing:
DOUBLE SHIRT LIMITED EDITION BY MARIAN SCHOETTLE
SECONDHAND SHORT SLEEVED DARK BLUE AMERICAN SHIRT FROM NEW YORK
FRENCH DARK GREY DOUBLE-BREASTED DESIGNER SUIT WITH PADDED SHOULDERS (for biceps) BOUGHT IN WIMBLEDON

Definitions was reworked as a commission for the *Conceptual Clothing* exhibition as *Re-definitions*. *Conceptual Clothing* began its tour at the Ikon Gallery in Birmingham. Mandy Rogers, an art therapist, saw it there and asked me to bring it to Springfield Hospital (for the mentally ill) where she worked.

A MAN of MANY PARTS Richard Layzell IS THAT MAN

**Definitions
1985–87
Drawing by one of the
patients from
Springfield Hospital,
Birmingham**

Third North American tour
January to March 1986
Back to the Avant-Garde

Franklin Furnace in New York has held on to its avant-garde independence through thick, thin and funding cuts. It's one of the very few New York venues to actively encourage applications from abroad and I was selected for their Visiting Performance Program in 1986. This became the key opportunity around which to build a tour.

Anthology Film Archive, also in New York, agreed to my presenting and compiling a screening of recent British video art. Sculpture Space in Utica were interested in a mini-residency. Friends in Toronto organised *Definitions* at the Rivoli, a club room. Art Metropole in Toronto hosted a video screening. The Nova Scotia College of Art and Design in Halifax offered a three day visiting artist slot.

The tour began at Franklin Furnace and I was to return to New York at the end. I visited Performance Space 122 in the East Village a few times. It had an ambience which is hard to find in Britain. They presented performance art effortlessly alongside music, comedy and fringe theatre. The audience accepted it as part of a mixed bag. One evening Eric Bogosian gave us an extract from his off Broadway show. He'd been a regular performer at PS122 before he hit the bigger time. The microphone was playing up. He gave a look of resignation. 'Back to the Avant-Garde, eh?' The audience cheered and applauded. It stuck in my throat. Back to the Avant-Garde? This must be where art and theatre divide.

Siteworks

Bookworks, publisher and maker of artists' books, was then based under railway arches close to London Bridge. The area between Borough Market, the River and Southwark Cathedral was one of the first former warehouse districts to be developed/yuppified. The pub serving them was one of the first to self-consciously adopt the old look, of fake antiquity and imported Victoriana.

In 1986 Bookworks held an open submission for a project which they called *Siteworks*, encouraging artists to make work out and about in this locality. Other commissioned artists were Langlands & Bell and Cornelia Parker.

The experience of the residency was so intense, there was so much to say about it, that I later developed a performance based on it called *The Blue Fingers*. It was illustrated with film and slides taken during the project and music by the Penguin Café Orchestra. It toured successfully for about two years.

The Blue Fingers

1986–88, residency and performance

So you know the place, you know where it's gonna be and you know when and you've put in a proposal so you've got a sort of a theme about ecology in the city and that historical link going back to what's underneath these buildings, this ground, this river that's been here right through and is why this city was built here in the first place, this Southwark. And you'll operate as a performer/artist out there on the pavements, public property; corporate culture with a cathedral.

I go to the local reference library and start reading and looking for images of what it was like before, this bridge, this London Bridge. I find pictures of this gate, Traitor's Gate I guess, where they used to stick people's heads on stakes. Londoners walked underneath them every day as they crossed the bridge and it was just over there, a few yards away. Haven't thought about Traitor's Gate since Primary School. Now it hits home. If you stand on the river bank here, it was just there. I get a bit fixated on this engraving, this image of the bridge that was. This becomes the first idea: I'll just stand there holding up this engraving of the old bridge in line with the actual bridge. I'll stand there holding it up and see if anyone notices. If I stand still with my arm

Above right and overleaf
The Blue Fingers
1986, residency
Chalks, suit, briefcase (not shown)

extended for long enough will someone connect the picture I'm holding with what's in front of them?

I find other things in the library, heraldic kind of imagery, Roman imagery, all of it relating to the natural world and how strong it would have been here once. Fish in the river, plants in the soil, stars in the sky, the river freezing up in winter. This place would have been on the edge of the city, or even a separate part of the City on the opposite river bank. Loose-living and different laws and wilderness or landscape just out there over the road, across the River, Southwark.

The end result is pretty straightforward. This is now a banking and office sector. People around here are workers in the office buildings. They mainly wear suits. Most of these buildings are new or newly converted. The people are new. The pub is new and where they go at lunch-time and in the evening. But it looks old. It's in a converted warehouse. The old sailing boat, the Kathleen and May, is moored here alongside the pub. It's been imported too. For effect. It never actually docked here when it was in full sail. The office people are immigrants, maybe Londoners, probably commuters, but living this kind of mid 80s life, where things are on the up and a business image is worth having, worth wearing, worth conforming to. The awkward jagged edges of art and nature are submerged. We work in offices, we walk to London Bridge Station, we catch the tube or train home. So I'll conform, I won't look like an artist. I'll wear a suit too as I make these large drawings on the ground. Coloured artworks that relate back to images of nature, the nature that's under the ground, in the river and the night sky. The nature that's not pretending to be anything other than what it is. It'll be about the doing of it more than how the drawings end up looking. It'll be a performance that will confront people as they pass by, to and from their place of work and their place of refreshment. Not drawing but *performing*. Out there in the street in all weathers.

This will be the plan.

So you work on this. You visit the site a fair bit. You choose your suits. You buy your exclusive pavement chalks. You decide on an initial strategy. You sort out the briefcase (your Dad's old black imitation leather one with the solid plastic handle). Then you start.

Despite my suit – it wasn't quite the right suit – the people who engaged with me, talked to me, asked what I was doing, were not the ones wearing suits. They were the cleaners, the caterers, the vagrants, the security guards. They were friendly, said I was brightening the place up, seemed to enjoy the contact. But I was after the suits and started to approach them deliberately.

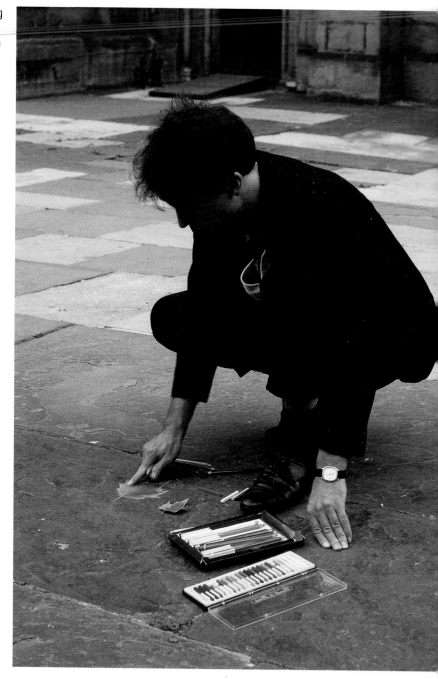

From field notes:

7th Oct afterwards
Approached today by security guard and African man
coming back from the post office. I approached American
tourists, elderly lady who talked about art classes,
very funny drunk - 'You got me bamboozled,
bamboozled…'

Young man with a dog, looked like a busker, threw me a
coin while I was drawing. I gave it back. This
confused him.

13th Oct 11.50am
'That's very good work there, very good indeed. How
long have ya been doin' it…? Listen - have you got 25
pence for a packet a chips?'

22nd Oct 3.30pm
Raining again. I've started trying to talk to the
businessmen. Only one young man has replied to my
clearly audible 'hello.' I asked him if he worked in
one of the office buildings. He replied 'I'm afraid
so.' His friends looked aghast that he was talking to
me, maybe it's the blue fingers (from the chalk). The
businessmen are continually stand-offish.

From the performance:

'I started deliberately saying hello to people. All
but one ignored me. I tried to think of a situation in
which I wouldn't reply to someone saying hello to me
and I couldn't think of one.'

It was when they heard there was money involved that the ripples really started. I was being paid to make pavement drawings. Their bank had even put some money into the project.

As the drawings grew bigger the risk of confrontation increased. I was asked to stop by a security guard. I explained what I was doing and he went away. A second security guard came out from the same building and repeated the request. Again I explained and told him that his company had helped fund the project. A third security guard appeared. It was is if we were gradually moving up the social scale, maybe this was as high as you could go in security. He was to tell me the full story. A boss had complained, said I was making a mess. Not just any boss but the big boss. He could see me from his window at the top, so I had to stop.

From the performance:

I thought about the big boss sitting up there looking
down at me. Maybe I'd wanted this to happen on some
level. I thought about this 'mess' I was making and
the mess his company had made of this area. I imagined
sitting him in a chair beside one of my drawings
(wheel on swivel office chair) and giving him a good
look at what I was doing, telling him straight :
'Well, big boss, they say that bankers have got money
in front of their eyes, that's all they can see. Why
don't you have a close look (tilt the chair forward to
face the drawing on the floor). Look, it's a sun, a
heraldic symbol relating to the past. People like it.
And it's not permanent, it's already fading, reflecting
the passage of time. It will gradually disappear. But
your buildings are permanent. And they're disgusting.
So let's get this straight - Big Boss - I'm not making
the mess around here, YOU ARE!

Over the years I've developed a strong natural resistance to most forms of 'experimental performance' and all the solemnity that so often goes with it. All those intense searchings and strivings as if cracking a joke or telling a joke was a deadly sin. With his one-man show 'The Blue Fingers' though, Richard Layzell has overcome some of my powerful prejudices against the genre. It's the story (I think) of a banker who turns renegade, or what it's like to be a pavement artist in Southwark. Looking remarkably dapper and smart, Layzell presents us with his observations on the area, the workers who inhabit it during office hours and the visitors who stray through it, his chalk-drawn attempts to inhabit the environment and the responses of the public (plus a couple of security guards who object that he's messing up the place). All this is shown through the medium of an illustrated lecture combining slides and film. Sounds formal? Far from it. Layzell's commentary on what we're shown is oblique, subtle, thought-provoking and very funny.
Time Out

Clothing:
SUIT 1: GREY CHECK 1950'S ENGLISH, DELIBERATELY BAD
FIT, BOUGHT FOR *GRAVITY*, JACKET TOO SHORT, TREWS TOO
BAGGY, LEGS TOO SHORT
SUIT 2: BLACK CONTEMPORARY, SQUARE CUT JACKET, FAINT
GRID PATTERN, VERY LOOSE TROUSERS, BOUGHT IN A SALE
FROM TOP MAN IN NEWPORT, GWENT

The recurring suit

In the 1980s men's attitudes to suits began to perceptibly change. Young men wore conventional business suits with pride. They went beyond status and into vogue. They became the uniform to flaunt and celebrate monetarism, to identify success, to happily conform, to wear down the boozer at lunchtime. Men in suits. Suits men. Me suit. Mate. Nice stripe in the fabric. Not to wear a suit became a statement in itself.

The suit in performance had a different function. It showed you'd made an effort. It was dressing up properly. It declared artistic ownership – claiming and subverting the suit for other purposes; to fuck about in, to look cool in. If you were self-employed your purchase could be set against tax. You could buy a suit and, via the Expenses column on your accounts, reinforce your professional standing artistically.

When I consciously started commenting on the business uniform this relationship changed. The suits had to conform if I was to blend in. It took a while to get this right. In *The Blue Fingers* (1986) I never made it. From *Business Tree* (1988) onwards I hit a closer note. Man in suit looks like us. (Briefcase not quite right though. Never mind.) Trust the bastard. Buy the bastard a drink. What the fuck's he doing with his briefcase?

In *Infiltration* (1997) the suit was another kind of challenge, on a university campus. Students who would be wearing one soon enough as 'graduate recruits' saw my suit as a dress code invasion, especially on the dance floor. Although intentionally confrontational, it also fulfilled a clear aesthetic decision. The suit to suit many locations and situations.

Gravity

1986–88, performance, 15–40 minutes (different versions)

Around this time I agreed to play the lead in three low budget films. One of them, *Vernissage*, was a National Film School production. It came at a time when I was working flat-out on a performance for a three week run at the Gate Theatre in London (*Nature of Reality*). Oskar Jonasson, the director, had been to see *Words* (1985) at the Gate and concluded I was his man. He liked the 'funny talking' as he described it in broken English. Bloody cheek. But he was Icelandic, what could I say? I agreed to do it on condition that he and the producer helped me build the props for the theatre piece.

This Icelandic film-maker believes he knows about art. Maybe art and film are taught together in Reykjavik. He asks me to be the central character in *Vernissage*, an artist's demise set in London. Is this acting when you go for a take? 'Stand by we're going for a take. Scene 12 Take 3. Run Sound. Run Camera. Action!' Or when it's someone else's story? Being what Oskar thinks an artist of roughly my age would be like at his Private View, his 'vernissage.' This is the story. The gallery owner has lost confidence in his work. His work is crap, pastiche on plinths. He's upstaged by a performance artist, makes a scene and runs. This is the story. And I'm supposed to empathise with the protagonist, Victor. I can do it but his 'sculptures' are terrible and meant to be seen as such. Oskar is satirising the art business but our sympathies are meant to lie with Victor, the artist, and his work is clearly no good. It doesn't add up. It's a case of anyone thinking they can make art, like those paintings you see in TV ads.

The business of making the film is serious though, this is a National Film School production. These are ambitious experienced people and we're all doing our best for Oskar. I begin to enjoy going for a take, reapplying the paint on my face in the same place, practising Victor's perplexed look even though I'm losing empathy for him. Arriflex cameras, mature actresses picked for their extraordinary looks from the pages of *Spotlight*. 'I'll do the part darling so long as you pick me up and return me to Wimbledon. I must be picked up and returned darling.' It's interesting working with actresses who do a lot of radio plays for the BBC.

Maybe I want some kind of revenge, being implicated in so much pastiche. Maybe the overlaps with autobiography are so many and varied that I want to expose them and reveal the hollow replicas. So it develops into a performance where I embellish and act out the story of the film, confusing Oskar with Lena and Victor and then actually show it on video. It becomes my story more than Oscar's. Eventually there's no need to show the film. The performance is enough. It was best of all at Chisenhale Dance Space in East London, where there was a real sense of space and a great wooden floor.

It became funnier, stressing the improbability of this story about a story of the making of a film and then actually showing the film at the end. Frequently audiences thought the film had been made for the performance. I started working with Colin Watkeys at the Finborough Arms in Earls Court. He had a 'Saturday night is comedy night' regular slot. We programmed in *Gravity* one Saturday night. Colin was getting sick of gag comedy. I made a start and then had some serious heckling from a man in a striped shirt. Along the lines of this wasn't very funny. Like as soon as you open your mouth you're a target. And I'd hardly started. It wasn't meant to be funny yet. I stopped completely and addressed him directly. 'Who said this was meant to be funny?' We were all looking at him. He apologised. I continued. Then it got funny.

Clothing:
BADLY FITTING GREY CHECK SUIT FROM CHARITY SHOP IN
NOTTING HILL GATE ALREADY MENTIONED

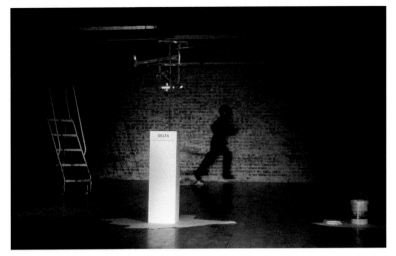

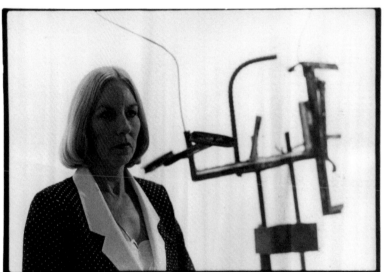

Gravity
1986–88, performance
Figure, white paint on face, 'sculpture' on plinth, paint can, stepladder
Top
At Chisenhale Dance Space
Above
'Devlin' during filming

November 1986, Provence
In a bar with the usual bad rock music in the background. Artificial gold roses. Don't like the barman's moustache.

Bruno's Leg

1987–88, performance, 60 minutes

The London Tate Gallery's new auditorium had opened as part of the Clore Gallery. Despite its carefully manicured styling it offered possibilities as a new space for performance art. The Patrons of New Art decided to commission new work for the auditorium from Tina Keane and myself. The room was equipped with video and film projection but no lighting flexibility. The architects had not visualised its use beyond lectures and screenings.

There was no escaping the sense of establishment and prestige associated with the Tate. Bring this free form artform into these hallowed walls, in by the back door. Publicity would be by large red poster and designed in-house. Three afternoons of *Bruno's Leg*.

There was a certain irony in the way circumstances forced this prestigious public performance to become painfully personal.

Bruno's Leg was a physical, perceptual and emotional journey. It linked ideas from my first year at art school with recent misfortunes and anecdotes. A very broad spectrum which employed recorded sound, projected film, video and slides, closed circuit video and a number of props. Clothing was important and symbolic: the Bermuda shorts from Burtons in Stoke on Trent; the collarless shirt and check trousers from Benetton in Milan, the specially made 'twinkling' coat. I was 38 and recovering from an exquisitely brief marriage. Maybe that's why I had my hair streaked blonde. In the Italian sun it rapidly bleached white and I became prematurely grey. I danced uncontrollably in a gay club in Milan – outlandish body movements that were destined for the Tate's new auditorium. I met Owen in Rome. He was now eight and more interested in the local comics than the local Coliseum. Absolutely. Mickey Mouse defies the language barrier. We were headed for Tuscany. 'Movement on the surface' and 'movement in the detail' were captions from my first use of video in 1974. I showed an extract in the performance, satirising my then serious intentions. You had to laugh. Ha. Non-verbal sounds gradually became another interlocking theme.

My notes:

I really like the thematic overlaps and the overlaps of information. To have it accurately cued and structured would take something away. Its richness and strength are that it's like living life as we do, in bits and pieces.

When you're on the move you see things differently. Looking, waiting, remembering, making everyday events into meaningful signposts.

Themes in the performance:
• The baseball player who started to bark (make involuntary sounds), 'Roof!' (a rare disease which ended his professional career).
• A brief disastrous marriage.
• Travelling across France and Italy to get over it.
• A broken leg on Bruno's birthday in Bordeaux.
• The bald male mannequin in Milan.
• Tuscan crisp packets with free gifts.
• Animal sounds in French, 'Coin, coin!'
• Pirates at dinner, 'Har!'
• A great wedding. We laughed, 'Ha!' See here in the wedding photo.
• A nightmare. 'Aaah!'
ROOF! ROOF!
COIN! COIN!
HAR! HARR!
HA! HAA!
AAAAAH!
The pain is too much.
Personal risks in the Tate auditorium.

For over an hour Layzell stood alone, narrating to the illustration of slides and video; an accomplished performance. He grasped his audience's attention with the assurance of a magician, yet here there was no sleight of hand, just an understanding of how long a performer can hold interest before the need to change tempo or mood. Only once did I detect the shifting of bums on seats. And never did I hear the contented laughter of relaxation: Layzell doesn't want his audience to sink into complacency; the smile on his face is never relaxed.

It is a way for the performer to test the water, to see whether his audience are laughing at him or with him, how playful he can be without letting slip the serious intent of his work.

At one point he acted out a solitary manic dance, explaining how he had shocked the locals in an Italian disco. In other hands it would have been hysterical, but here we could never escape the loneliness which prompted Layzell's deliberately alienating act.

Performance Magazine

The moment when the oversize deck-chair turned into a bed by removing the chair back, flipping over the sheet top and attaching the sheet to the shirt with velcro. I was standing in bed, recalling the dream, waking up with a start in a farmhouse in Tuscany. Everything was particular, the short-sleeved shirt, the references, the memories. Here was a visual link with the striped deck-chair images on projected slide of pure colour bands which hinted at hard-edge painting and reinforced an ongoing theme in the performance of searching for colour and being a perceptual vessel, grieving and vulnerable. The other deck-chair remained unchanged. This transformation, from chair back to bed, was perhaps my chosen moment from the sixty minute performance. Physical transformation amongst psychic transformation and crossing the line from art to theatre and back again, stripe me. It was also innocent, child-like; I'm in bed, no you're not. Recalling beds as a child, being tucked in, forever sick and hospitalised, left to dream. Now here relating to my own child, in his colour world of crisp packets, T-shirts and baseball caps. I got up at dawn most mornings not just to photograph the sunrise and the early morning light on the deck-chair stripes but to catch time before he woke, stolen moments in the elements. A grown man standing here in the Tate Gallery Auditorium taking the piss out of himself, his anguish and his quest for colour.

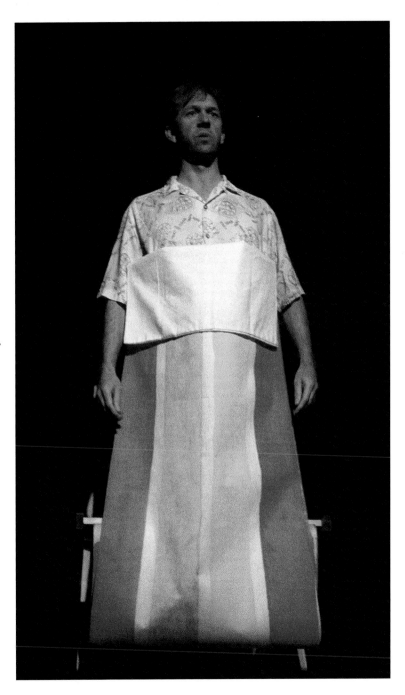

Bruno's Leg
1987, performance
Right
enlarged deck chair, painted fabric, velcro

Left and overleaf
images projected in *Bruno's Leg*: deck-chair in early morning light in Tuscany; road signs at Monte Antico; sunflowers in France

After a performance of *Bruno's Leg* at the Leadmill in Sheffield, Graham from Dogs in Honey asked me if I'd read any Kurt Vonnegut. I hadn't, but then I did. I could see what he meant.

```
Clothing:
HAIR STREAKED BLONDE
RED BASEBALL CAP FROM OXFORD STREET
TURQUOISE BERMUDA SHORTS FROM BURTONS IN STOKE
ITALIAN CHECK SUMMER TROUSERS FROM ITALIAN BENETTON
COLLARLESS STRIPED SHIRT FROM ITALIAN BENETTON
CREAM SHORT-SLEEVED PAISLEY SHIRT FROM NEXT IN EXETER
WITH ADDED VELCRO
WHITE TRAINERS

audio:
ITALIAN HOUSE MUSIC RECORDED IN A CLUB IN MILAN
PIRATES IN A THUNDERSTORM
TALKING ITALIAN ON THE PHONE
TWINKLING SOUNDS
LANGUAGE LESSON
BRUNO'S YELP

film:
COWS AND SUNFLOWERS IN FRANCE

slides:
STRIPED DECK CHAIRS
SUNRISES IN TUSCANY
FRENCH AND TUSCAN LANDSCAPE
MANNEQUIN IN MILAN
CLOSE UP PORTRAITS
MOVEMENT ON THE SURFACE
MOVEMENT IN THE DETAIL
THE WEDDING RECEPTION
PHOTOGRAPHIC COMMISSION FOR A FRENCH LANGUAGE BOOK
```

Move the Rabbit

1987–89, performance, 35 minutes

The Finborough Arms is a theatre/pub in Earls Court. In 1986/7 theatre director Colin Watkeys opened up the venue to include live art. He was becoming bored with conventional cabaret and fringe theatre. Following several performances of *The Blue Fingers* and *Gravity* he offered me a two week run, as part of a double bill with Wendy Houstoun (from DV8). *Move the Rabbit* opened the week before *Bruno's Leg*. On the days of the three Tate Gallery afternoon performances I went on to perform at the Finborough in the evening.

Why say no? But there's only two weeks to prepare and there's this other performance at the Tate and that's prestige – been working on it for six months. Why say yes? Because why not, push self into corner squeezed up and stuff comes out. Have to keep it simple. Stark images, roots, tree roots. Make it immediate. Be intuitive.

Get out there and photograph the fallen trees, following the Great Storm. The roots exposed on Hampstead Heath. Black and white and colour slide. Follow your nose. The title – *Move the Rabbit* – is found by sticking a pin in a short story by Italo Calvino. It took a few goes to find it.

The performance: I stand twitching in a corner, white face, hair all over the bloody place. Now and again I make a vocal sound like gasping or breathing out hard, 'Hah!' and twitch some more in whole body spasms, emphasis on jerky hand and shoulder movements. I look slowly towards the audience but can't hold eye contact through the twitching and start to speak:

```
I think it was a building society, or maybe it was a
bank. Yes it was a bank. An advert for it. 'Our roots
are our branches' (forced laughter then back to vocal
sounds) heh, heh, hah . . . hh . . . Aa . . . HAH . .
haaa
```

I take a root vegetable (large sweet potato or turnip) out of my jacket pocket and sit down on a rough wooden seat/table. I spend some time caressing the vegetable, putting it against my face, fingering it. Audio tape starts, the sound of waves lapping (recorded on a Greek island) then my voice. Dream imagery:

```
I got out of the lift on the top floor and there were
some stairs leading up to the roof of the building,
which I climbed. When I got there I looked down and
there was landscape all around me. This was the only
building in sight. I went to the edge of the building
and jumped. I landed very softly on some fine bright
```

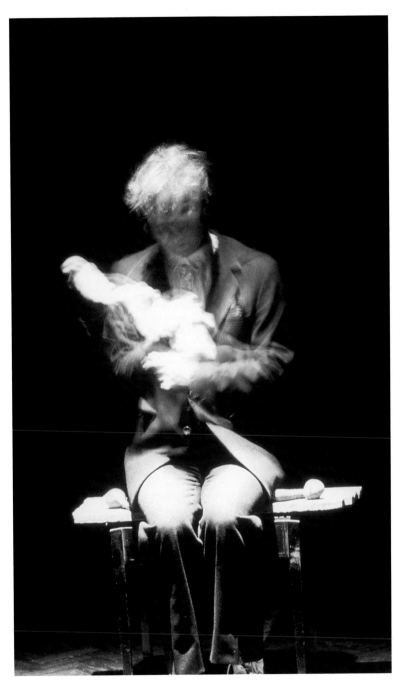

green grass which I then ate while kneeling down. Then
I fell asleep on the grass. When I woke up I couldn't
move my body only my head, my head ('head' is repeated
live in synch with the tape) but I didn't mind. I
looked around and went back to sleep on the grass.
This time I was woken by the sound of the wind. And
the trees cracking. This was no ordinary wind.
(sound of gale-force wind on tape). Followed by several changes
of mood and persona. One of them:

Spoken expansively, with strong physical hand/arm gestures:

CUT
CUT CHOP
CUT CHOP
CUT CHOP SELL
CUT CHOP SELL
CUT CHOP SELL
CUT CHOP
CUT CHOP
CUT CHOP
CUT
CUT
CUT CHOP SELL SELL SELL
CUT CHOP
CUT CHOP
CUT CHOP
CUT CHOP SELL INVEST
CUT CHOP EM ALL DOWN
GET RID OF EM
GO ON
WHO NEEDS EM?
MAKE A BIT OF MONEY ON EM
FOR PROFIT
GO ON
WHO NEEDS EM?
(TREES)
WHO NEEDS EM?
WHO NEEDS EM?

Move the Rabbit
**1987, performance
Wooden bench, root
vegetables**

The final sequence is silent apart from pre-recorded ambient music by Yello. I enact the latter part of the earlier audio story. The closing image is my head lifting and moving slightly while the rest of my body is lying and still.

Bare information:
```
MOVE THE RABBIT
A performance

It links the uprooted trees from the recent storms
with the wider devastation imposed by man on the
natural world.
First performed at the Finborough Arms Nov/Dec 1987.
The central character transforms from ruffled half-
human vagrant to animal to child to woman to man and
back to animal.
There is a slide sequence of storm-damaged trees and
their roots and a soundtrack including music by New
York musician David Garland.
Duration:
35-40 minutes
Equipment:
1 carousel projector
theatre spotlights
cassette recorder and amplification
Space:
Must have black-out
Suit design by Annabelle Lee
```

Move the Rabbit is a witty reflection on the recent storm that claimed so many trees. Layzell opens with a succession of anxious gestures, performed with a discipline that makes every twitch speak.

The Guardian

```
Clothing:
A MODIFIED TASTELESS SECONDHAND GREY SUIT
LARGE CURVED ADDITIONAL JACKET COLLAR is turned up
late in the performance
SLEEVES EXTENDED VIA VELCRO TO COME DOWN AS FAR AS
FINGER TIPS are pulled down late in the performance
SECONDHAND ITALIAN WHITE SHIRT top button done up
```

The theatre business

Move the Rabbit went on to a second two week run at Oval House a couple of months later. Following two separate runs (*Definitions* and *Nature of Reality*) at the Gate Theatre this became the fourth 'theatre' run in a year and a half. I was working in theatre. My terminology was changing. I talked of shows, runs, first nights, press nights, photocalls, technical run-throughs and door takings. I'd got my Equity card. I was being reviewed in the Theatre pages of *Time Out*, not Visual Art. It was an adventure. And the work didn't suffer. The night-after-night repetition refined and honed most of the performances. I enjoyed the collaboration with Colin Watkeys at the Finborough. He increasingly directed me and operated the lights and sound. There was even an immediacy about Colin splitting the door money after each show, crumpled fivers handed over after pub closing time. I didn't enjoy the theatre critics so much, they couldn't quite put a handle on me.

Is there a subtle difference between a 'show' and a 'work' or 'performance?' Or – essentially there's no great difference, artists, dancers and theatre practitioners working on the fringe are involved in the same process. It's a question of shade or degree. It comes down to where you see yourself. And I saw myself as a visual artist working in theatre who wanted to get his hands back on the raw 'making' process without reliance on raked seating and lighting rigs. *Long Done Crazy* (1988) was the last 'run' I done.

Business Tree

1988, installation/performance

A small opportunity. Part of a North London weekend festival organised by the Mario Flecha Gallery in the Liverpool Road, all over the area, low profile, nice. Times, spaces and places were available and a materials budget but no fees. I believe in supporting local events. I'm a North Londoner after all. I call in to the gallery to see what's available. There's a Sunday slot on the grass outside the Business Design Centre on Upper Street, just where Islington is beginning to look its trendiest, opposite The Dome. I know the spot but maybe not the grass patch. Good old grass. Gone now.

Actually the grass is new and covers a fair flat area. I think about the materials budget and decide to buy myself a business suit with it, making up for no fee – I'll make a public art statement wearing the suit on the grass with my briefcase. Everyone's wearing suits in the late eighties. There'll be more credibility by joining in, matching the code, dress management. The idea is very simple. I'm a subliminal eco-warrior, the suit with a statement. The businessman will make a full size tree from waste paper flat on the grass like a chalk drawing. A good view for people walking along busy fashionable Upper Street towards the Screen Cinema. An especially good view from the tops of buses (19, 38, 73, 171) passing through fashionable Upper Street and on to less fashionable Dalston Junction, Hackney Mare Street, Newington Green, the Essex Road and even Leyton Green. A reasonable view from buses going the other way, all heading for the West End. I'll interact with people as I'm making it, talk to passers-by, put it in context, be presentable or confrontative, see how the mood takes.

On the Sunday morning in question I pick up a few bundles of the previous day's unsold newspapers from a local newsagent. They weigh the equivalent of a small tree trunk. I put them in the back of the car, drive home and take out the suit. Two Canadian video artists, Paulette Phillips and Geoffrey Shea, are staying with me. I know them well but feel a slight pressure to be a host until I look out the window and see the trees thrashing about. It's become a very windy day. I'm due to be out on the grass in a few hours. Clearly the paper will blow around unless it's staked down. I need to move fairly quickly. Fortunately I find a couple of coils of bendable wire upstairs in a box. I spend the morning making wire stakes, hundreds of the bloody things, keeping a keen ear out for the weather forecast on the radio. They'll go in the briefcase. I make light of this frenzy of activity to my guests. 'Ha, care to join me in a little wire bending over lunch?'

I make a tentative start. Wind is still up. Stakes are essential. Hadn't thought about the newsprint blackening the hands. A nice foil to

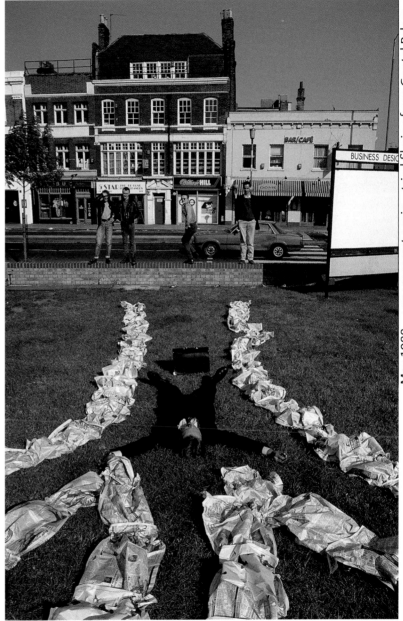

May 1988 very overcast again – tried filming from Crystal Palace but not clear enough.
n the drive this morning I saw in Camden Road two very old people.

Business Tree
1988, performance
Briefcase, waste paper, wire stakes, grass

the suit and a reminder of *The Blue Fingers*. Projected time to complete the drawing under still conditions was about an hour. With staking it takes three hours including some interaction with the public. Why should this be so tiring? It was. Having invested this time I want something more from it. Either it's an image from an earlier work returning or it's the obvious thing to do. I decide to lie down in the middle of the trunk, cruciform, briefcase at my feet, street-facing.

What began as a brief gesture extended into and became the central statement. I lie there for forty minutes. The longer the lie the more of a message.

Photographer Edward Woodman was commissioned to document the events. It also became a work for camera. Lying still.

Long Done Crazy (Madder Lain)

1988, performance, 60 minutes

A three week run at the Finborough Arms / Finborough Theatre Club, above the Finborough Arms pub in Earls Court in Finborough Road. Who was Finborough? A solo show.

Make a work about London. There's a notion. It's 1988. London's feeling a little downtrodden. Mrs Thatcher is still Prime Minister. Punks are still around. Live Art is becoming the new performance terminology. I happily embrace it as a broadened category. But later feel it's been a shade foisted. I'd just run a workshop in Wales for the staff of a free-thinking alternative home for young offenders called Bryn Melyn. A few years later they hit the national press for taking the boys on safari. I'm about to organise a three day out-of-gallery performance event in Derry in Northern Ireland, appropriately called *Live Art in Derry*. With Anne Seagrave, Claire Palmier, Tara Babel, Peter McRae, Bridget Wishart and myself. This is an opportunity to give *Long Done Crazy* a test run at the Little Theatre in Orchard Street. The local priest shows me how to switch on the lights in the vestry. He's the keyholder. It's strangely appropriate to be linking London with the Derry fast losing its London.

```
Long Done Crazy, Lon-Don-Crazy, London Crazies,
London.
```

It started from that bit of Celt-ish-ness in *The Blue Fingers* (1986). The Celts saw the Thames as sacred and threw their finest swords into it. The Romans were shocked by their blue woad-painted faces. Going beneath the City, the smart veneer, no-nonsense business centre to a raw romantic past akin to the American Indians.

I had an artist's grant from Greater London Arts , I'd use it for this performance. The grant encouraged me to take time, to research and experiment. The big break came in the Barbican Library when I came across the Celtic poet Taliesin; person and poem interchangeable. There was these words, words there was, them words like they was real alone with space around 'em like London speak, or not:

```
I have played in the night,
I have slept in the dawn . . .

I have been viper in the lake
I have been star with a curved beak . . .

I have been path, I have been eagle,
I have been fisherman's boat on the sea,
I have been food at the feasting,
I have been drop of the shower,
I have been a sword gripped in the hands,
I have been shield in the battle,
I have been string of a harp,
in this way for nine years.
In the water, in the foam,
I have been sponge in the fire . . .

I have been sow, I have been he-goat,
I have been a sage plant, I have been a boar,
I have been a horn, I have been a wild sow,
I have been a shout in battle,
I have been a stream on the slope,
I have been a wave on the stretch of shore,
I have been the damp gleam of a downpour,
I have been a tabby-headed cat on three trees,
I have been a ball, I have been a head,
I have been a she-goat on an elder-tree,
I have been a well-fed crane, a sight to see . . .
```

'The lyrical and the metaphysical are combined in an incantatory form that is close to magic.'
Celtic Poetry

This could feed a performance.

It would give free rein to a range of performed beings, art beings, 'bits of little bits of …' personification of a city; like fragments of London observed, experienced, invented and researched in different media and persona:

```
I have been a LECTURER (an expert on the Celts) as the
'opener' talking directly to the audience and quoting
the Taliesin poem as a lead-in.
```

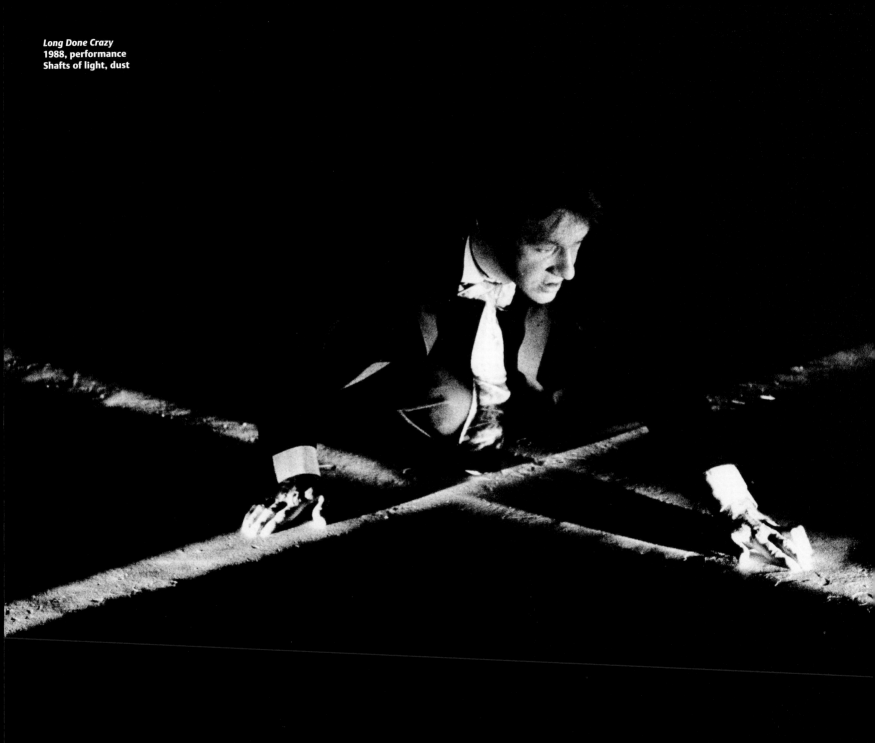

Long Done Crazy
1988, performance
Shafts of light, dust

I have been a MONEY BROKER (with a heart) a secret
environmentalist

I have been a SPECK OF DUST (lighting effect, low
lights crossing and revealing dust on floor)

I have been a DOG (slides: fashion models with dogs;
historical portraits of dogs looking up at their
masters/mistresses)

I have been a colour: GREEN (film)

I have been a bunch of art students on a CITY BUS TOUR
lying on the seats and seeing everything upside down
(slides of exactly this)

I have been a NIGHT-CLUB (embarrassed by this one)
(early house music (electro) and lighting effects)

I have been THE RIVER (film and one slide of a painting
showing the river frozen in 17th century)

I have been a BRIEFCASE (my father's)

I have been a DRESS

I have been A VIEW OF THE CITY (film)

I have been LITTLE BITS OF BITS OF (details past and
present) (slides)

I have been THE CITY ITSELF (necklace of flashing
lights, toy buses, trees and taxis)

So that by the end it builds to a fragmented portrait of the city.

From the Bits of Bits sequence:

I have been a trotter seller -
A WOMAN SELLING PIGS TROTTERS:
'Trotters, nice trotters, NICE TROTTERS, 'ave you
TASTED DAISY'S TASTY TROTTERS' She goes from pub to
pub.
And I've been one of her trotters eaten by a drunk in
Wapping. He choked on me.

From The City Itself sequence:

The woman downstairs screaming night after night,
banging her head against the wall, dragging furniture
in off the street, burning fires on top of the cooker
because the supply's been cut off....And this old
couple in the Camden Road both of them barely able to

walk and they link arms and shuffle along sideways
together, an ambling awkward dance they've done a
hundred times before to the pub or the shops... And
the man who'd always lived in the house on the Upper
Clapton Road washing the hall floor for the first time
in months stark naked singing and banging the bucket
on a Saturday morning... And in the same house the man
living in the next single room (sometimes visited by
his daughter) shouting in the night through the wall
(he's in there) again and again a woman's name
'Madeleine, MA-DER-LAY-NN, M-A-D-D-E-R-L-A-N-E, MADDER
LAIN'... And not just recognising buskers down
underground but knowing them, seeing them through art
school...

Presenting a theatrical portrait of London, as a one-man show, is like attempting the Ring Cycle on a piano. But such is the optimism of performance artists.

Richard Layzell's mixed media solo *Long Done Crazy*, creeps on this awesome subject through an extended 'What Am I?' riddle. Dressed in a business suit, Layzell begins in a soft spoken manner with a short talk about the ancient Celts. He then goes on to confess that he has been a stockbroker, a dog, the colour green, a nightclub, a river, until eventually the penny drops. He is not mad: he is London. Visual clues are supplied by slides and film, and the whole thing is skillfully lit by Colin Watkeys.

What Layzell seems to be striving for is to cut away the rational level of his dramatic monologue, in order to concentrate on the emotional charges that may lie underneath. Unexplained twitches and sudden abstract gestures are used to heighten the effect.

While this can be a bit like watching someone with a severe personality disorder, Layzell does possess an acute sense of timing that helps carry his audience along with his dislocated narrative. He also has enough physical discipline to make those insane gestures conjure up something disturbing and surrealistic.

But what exactly? In the end, we who crave for meanings are left floundering in a sea of ambiguity.

The Guardian

On the two occasions I've seen Richard Layzell's work his spare, incisive style and quirky ironic humour have succeeded in overcoming my ingrained fears of what's often termed performance art. His latest piece uses as its springboard an old Celtic poem and takes off into an odd, exciting, imaginatively presented account of the innumerable shapes and forms the trimly dressed figure in front of us has entered into: inanimate objects, a speck of dust, a dog, a nightclub, a river, a whole city. Using slides and film, as well as his fine vocal and physical technique, Layzell not only animates but positively inhabits these ideas. See him. He's an original. *Time Out*

Long Done Crazy
1988, performance
Projected slide: inverted
view of the city from bus
window

The apprentice

1989 was my year with an assistant, an Arts Council trainee, Trevor Cromie, recently graduated from the MA Fine Art course in Belfast. This was a new scheme, only tried the once. The theory was that Trevor would learn about surviving as a performance artist by working with one for 6 months. He was paid a little more than the dole. I was hoping he'd be good on press releases but they weren't his strong point. He was great for brainstorming. We came up with the name *Bailey Savage* together and Trevor later became PA to Mr Savage. (See photo, p.62).

The Revolution: You're In It!

1989, performance

Commissioned by Kettles Yard Gallery in Cambridge as an out of gallery event to accompany an exhibition called *After 1789: Ideas and Images of Revolution*. Performed in Cambridge, London (Watermans Art Centre and Kings Head Theatre) and Canada (Plug-In, Winnipeg; YYZ, Toronto; Open Space, Ottawa). Revolution was a hard theme to work with until I used it ironically. We were in a revolution, yuppie fever, no doubt about it, social values were being turned upside down. There was a good run-in time, six months to prepare. Research involved looking at public figures and religious converts. People who talk at you with a glazed expression. My invented persona, *Bailey Savage*, would be embodied for two weeks, day and night, without revealing my own identity. He would have a history, a biography loosely based on Alan Sugar, the founder of Amstrad, publicity material containing *his profile*, *his ideas* and *his schedule*. It would be like a political campaign without obvious politics. Bailey Savage is a businessman who's done so well under Mrs Thatcher that he wants to share his ideas with the people and show them how to be as successful as he is. This kind of approach would allow for all kinds of interaction, meetings, public speeches, special appearances. It gave an opportunity to target particular audiences: an old people's home, a children's home, people in pubs and on the river, the Business Park, the Cambridge Festival procession, local radio and TV, etc. The line between truth and fiction would be left unclear.

BBC Radio Cambridge Ian Peacock | CNFN Mike Souza | Christian Dior: Eau Sauvage | The Cambridge Blue landlord Tony Shelvington | The old people's lunch club | Keynote address at The Darkroom

A one dimensional work. This despicable man represented a value system that desperately needed satirising. Fervent supporter of Margaret Thatcher and product of late '80s culture, he was out there in the street with his chauffeuse talking about revolution. THATCHER'S REVOLUTION. My own name and identity were withheld. This was real life. He wasn't a politician but he couldn't help sharing his success with everyone he met. His accent was upper class with an occasional trace of Cockney. His promotional material was pithy and simplistic:

```
THE REVOLUTION - YOU'RE IN IT!
TO SUCCEED IN THE 1990s BE LIKE BAILEY, BE SAVAGE!
```

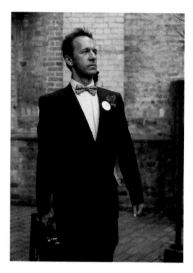

Everything about him was one dimensional. He was all image, all talk, all promotion.

Casting the media this kind of line was surprisingly acceptable to them. Dealing with promotion bred promotion. One dimensionality fed into the sound bite. Bailey had few statements but they were repeated endlessly and were eminently quotable. He was a walking talking press release. In his own words (very loudly with piercing eye contact but a slightly glazed expression):

```
WHATEVER I DO IT WORKS FOR ME. EVERYTHING I SAY OR DO
IS PART OF A PROMOTIONAL CAMPAIGN FOR ME, BAILEY
SAVAGE. I CAN DO NO WRONG, NONE WHATSOEVER!
```

I was surprised and somewhat disappointed by how well this process worked. What did it reveal about the media, about British culture? Embodying this man day and night for two weeks was a kind of shamanistic experience and he's still stuck inside me somewhere. There were certain things I began to take for granted, like sitting in the back of a large car, being chauffeured around, having doors opened for me, being treated like a celebrity. It became familiar all too quickly. I began to expect it and enjoy it. This was a shock. The fiction became reality. I had engineered this Frankenstein and now I was stuck with him. This one could run and run. But I'd had enough of him.

BAILEY SAVAGE - A PROFILE

```
BAILEY SAVAGE has brought his own brand of success and
energy to the world of property and high finance.
SAVAGE INTERNATIONAL PLC has grown from small
beginnings.
Just 12 years ago its life began in a two-storey
building in West London as 'SAVCO Trading'.
Now in 1989 SAVAGE INTERNATIONAL has become a major
international company with several thousand employees.
BAILEY has been described as 'one of Europe's most
successful and probing businessmen'.
Far from resting on his laurels and enjoying his well-
earned prosperity BAILEY SAVAGE has, in the summer of
1989, begun a nationwide campaign to share his ideas
and help others on the road to success.
It is unbelievable that a man of his stature should
literally TAKE TO THE STREETS of our cities to
celebrate and share his success.
Don't miss the opportunity of meeting this
extraordinary man of our time.
And remember BAILEY SAYS - BE SUCCESSFUL, BE SAVAGE!
```

How he talked, the kind of stuff he came out with:

```
IT IS EXTRAORDINARY OR PERHAPS NOT SO EXTRAORDINARY
THAT A MAN OF MY STATURE HAS DECIDED NOT ONLY TO COME
HERE BUT ALSO TO ENCOURAGE YOU TO CELEBRATE OUR
TREMENDOUS BRITISH REVOLUTION WHICH MARGARET MA HAS
HELPED US TO ACHIEVE . . .IF YOU INVEST YOUR MONEY
WISELY, IN A COMPANY LIKE SAVAGE INTERNATIONAL PLC,
YOUR MONEY WILL BE MAKING MONEY, JUST LIKE MINE IS,
DAY IN, DAY OUT . . . PRIVATE ENTERPRISE IS AT THE
HEART OF OUR REVOLUTION, THERE'S MONEY TO BE MADE OUT
THERE, PRIVATISATION IS THE GREAT ETHOS OF OUR AGE,
YOU WOULDN'T WANT TO BE IN RUSSIA WOULD YOU! HA HA!
LADIES AND GENTLEMEN I CAN SEE A FUTURE WHERE SCHOOLS,
PARKS, THE NATIONAL HEALTH SERVICE, INDEED EVERY SO
CALLED SOCIAL SERVICE IS PRIVATISED . . .
```

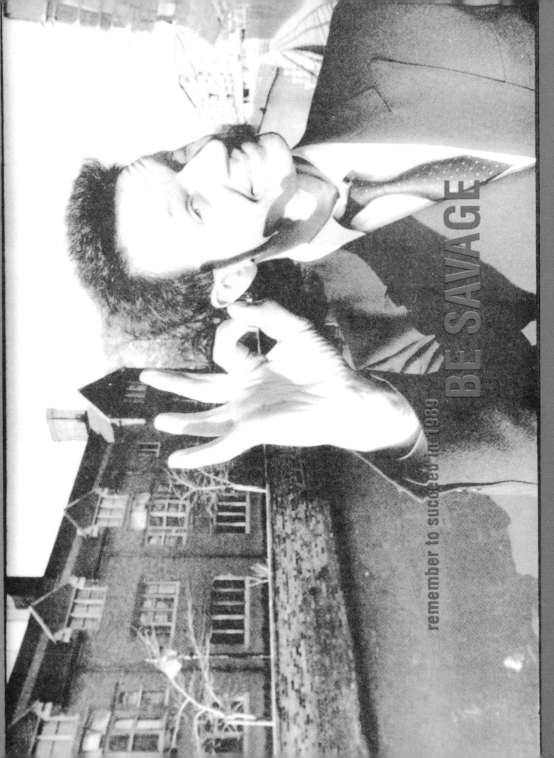

BAILEY SAVAGE says
THE REVOLUTION
— you're in it

BE SAVAGE

remember to succeed in 1989

MEET BAILEY SAVAGE ALL OVER CAMBRIDGE IN JULY

KETTLE'S

Towards the end, Mr Savage's occasional nervous twitch degenerated into a ranting chorea as he expounded the benefits of the trickle-down effect outside the public library.

Wherever he went Mr Savage was the epicentre of discreet curiosity and barely suppressed apprehension. While visiting a large suburban supermarket his party became aware of men in grey suits watching from a distance. While ordinary onlookers dealt with their bewilderment individually by simply ignoring Mr Savage, staring or laughing furtively, the supermarket were having to cope institutionally. After all, they had their customers and their businesses to protect. For all they knew, this man might run amok at any moment. Layzell, knowing exactly how to modulate his performance, skillfully saw to it that bewilderment should not turn to indignation. He approached no-one unknown to him, yet when he was recognised by people who had seen him earlier in the week, he returned their greeting, elaborated his credo and gave his card. I was the target of the manager's enquiry as Mr Savage completed the conspicuously accomplished purchase of strawberry tartlets at the patisserie counter. 'Who is he? Is this a survey? Do we know about this?' he asked. A performance such as this is not relinquished lightly and even a critic is drawn into its web. I explained Mr Savage's great importance in the world of international commerce. I suggested that my interlocutor might perhaps have seen Mr Savage's photograph in the local press or heard him on the wireless. (He hadn't.) Finally, I stressed that this was a private visit simply to enable Mr Savage to do a little shopping, which he finds relaxing, pointing to the pink socks, black rubber gloves, Irish whiskey and cat litter in Mr Savage's trolley. 'So long as he making purchases then,' the man in the grey suit responded. The security ring slackened, though the party was discreetly observed until it left. *Performance Magazine*

Materials:
```
1988 ROVER COUPÉ WITH SUNROOF
CHAUFFEUR AND PERSONAL ASSISTANT
DOCUMENT CASE
DARK SUIT (FROM BUSINESS TREE)
BOW TIE
BUSINESS CARDS
HAIR GEL
LAPEL BADGE
VIDEO PHOTOGRAPHER
THE PRESS
```

*The Revolution –
You're In It!*
1989, performance
Preceding page, opposite
**Bailey Savage on arrival
and assisted by Trevor**
Preceding page, right
Flyer (actual size)
Opposite
**Launching *The Bailey
Savage*, Watermans Art
Centre, London**

The launching of *The Bailey Savage*

As Bailey Savage in London, several weeks after the Cambridge campaign, he is in another place, over the edge, no longer any pretence of normality. He walks around the private view of *3D '89* at Watermans Arts Centre inside his boat, still talking of revolution and ma (Margaret T.), announcing the imminent launch of the boat he wears, named in his honour, *The Bailey Savage*. Trapped inside this wooden construction there was no pretence or assumption of real power as there had been in Cambridge where truth and fiction were at times uncomfortably indivisible. Here I was visually a victim of my own folly, a man in a boat that won't float. Or will she. 'I know what you're all wondering ladies and gentlemen, will she float?' **I walk down from the Arts Centre terrace onto the muddy banks of this Thames tributary, still muttering my slogans, his slogans, green rubber fishing waders knocking together,** 'Wee aaar in ay revoloooshun heeyaarr in Britt'n and izn't it maarvellous, will she float?' **I start to feel alone, remote from the crowd watching, wondering if I have the nerve to do this. The painful side is the implicit ridicule of manhood contained within this political pillorying. I feel like a complete jerk. But I'm doing it for art and for the collective release of the desperation withheld in this current political climate where there's so little questioning, keep your head down and sell, sell, sell. The straps holding the boat are pulling on my shoulders, I wish they'd been the same colour as the suit but the construction itself is a practical success, I can walk. This water is so shallow I'll have to go further out. In reality I'm looking for a large puddle deep enough to sit in. Will I be able to manipulate my legs inside this thing and actually sit down? Here goes.** 'Yes, she floats!'

The look of triumph in the photograph belies how I was feeling. This image succeeds so well for me because it demonstrates what I wanted the performance to achieve and didn't feel – being within it – that it had. The surrounding landscape puts him in perspective, overtakes him, dilutes the monster down, 'Shut up Bailey Savage.'

The cool

Performing as art is part vanity and display, with a maintained distance. The blurred boundary with the audience which encourages and rejects. Look at me. Stop looking at me. Keep cool in the onslaught. The space between performer and audience is cool and hot.

The language of performance cool is through gesture, voice, eye contact and fucking weirdness.

Bailey Savage was the antithesis of cool. But was it cool to embody him?

Maintaining a cool when the pressure is on when you're up there performing.

Is there a cool in simply having the nerve to do it?

Why is performing sexy?

Dancing on the Mountain

1989–90, performance, 60 minutes

After *The Revolution: You're In It!* I wanted to return to something more personal, less confrontational and located quietly within the art/gallery circuit. I needed to be reassured that *Bailey Savage* hadn't robbed me of obliquity. I used some chance techniques to find source material and chose an audio cassette in Our Price with my eyes closed. It was by Bruce Willis (yes, the now Hollywood star) and was dreadful but usable for its sad hard rock machismo. I had a strong feeling for what I was after: moody, intense, colourful and emotional, slightly gut-wrenching and plenty of improvisation. But how to achieve it? I still have a picture of these intentions and they don't closely match the resulting performance. That's process for you; order gradually imposes itself. It's working title was *States* and it evolved into sequences of ages/stages from old age to babyhood. Each one framed within different approaches to performing, props and states. The transitional sequences linking these 'states' came closest to my original intentions. I saw these as coming from a cathartic middle ground of frenzied movement and fragmented speech; a soupy unconscious condition from which the more fixed personas evolved. This approach was loosely based on *The City Itself* sequence from *Long Done Crazy*.

Preparatory notes/writings:

FUNNY SOMETIMES, BUTTONS MOVE, A TREE CREAKS, A HORSE BREATHES – THERE'S A WORD, LIKE THE MOVEMENT OF AIR, LIKE AN ALMOST SILENCE, LIKE A TEAR IN THE BOWL, A CIRCLE OF PAPER FINELY CUT OUT, A SOFT LOOK, A SHY SMILE . . . I'M HAVING TROUBLE BREATHING AND I FEEL SO HAPPY BECAUSE I DON'T CARE, REALLY I DON'T.
I'VE GOT THE ENERGY BUT I CAN'T BE BOTHERED, PLEASE EXCUSE THE MESS, I'M FURIOUS, BUT I DO KNOW HOW TO ENJOY MYSELF, WOULD YOU LIKE A SHERRY, DUTY FREE. BELIEVE ME, IT WAS A COMPLETE ACCIDENT, I HAD NO IDEA, THE WAY THEY USE LANGUAGE, PLAY WITH IT BECAUSE IT'S NOT SACRED, HELP YOURSELF, BE MY GUEST, WELL IF YOU'VE GOT A WIFE AND KIDS TO SUPPORT YOU HAVE TO GO WHERE THE MONEY IS…A FACE THAT MUST HAVE ONCE BEEN SO FULL OF EMOTION, OR MAYBE IT CHANGED WHEN HER FATHER DIED, WHEN HIS MOTHER DIED . . . AND THIS ONE'S GOIN' OUT FOR, WAIT A MINUTE, JUST A MINUTE, EXCUSE ME, JUST HOLD ON, IS THIS YOUR WAY OF SAYING GOODBYE, CONFRONTING ME LIKE THIS???? AND THANK YOU FOR THE FLOWERS THEY'RE LOVELY AND I MUST TAKE YOUR ADDRESS BEFORE YOU GO, JUST IN CASE, YOU KNOW, LIKE A PINK FEATHER THAT FLIES IN A SNEEZE, THANK YOU, CHEERS, LOVELY, I FEEL SO HAPPY AND I DO REALLY SOMETIMES, DON'T TALK TO ME, THANKS, YOU'RE WELCOME, HA, HEH, LOVELY, THANKS AGAIN, BYE . . .
LOOKING ACROSS A LANDSCAPE HIDDEN BY WINGS. YOU'RE SICK, YOU NEED TO REST SO YOU DO. A WELCOME BREAK FROM YOUR ANXIETIES. YOU LOOK AT THE ANXIETIES AND THEY TURN INTO JUMPING BEANS DRIPPING WITH OLIVE OIL. THEY LOOK SO PLEASED WITH THEMSELVES YOU HAVE TO SMILE AND THEY SMILE BACK, WICKEDLY. THEY KNOW WHAT YOU'RE THINKING, THEY THOUGHT IT FIRST.
WOULD YOU BELIEVE IT, HE'S DONE IT AGAIN, IT'S INCREDIBLE! WHY IS IT THAT YOU'RE NEVER SATISFIED, CAN YOU TELL ME THAT? IS IT SO HARD? I FEEL COMPLETELY MANIPULATED. WONDERFUL. JUST PASS IT ALONG THE LINE, THAT'S IT, TAKE YOUR TIME, KEEP IT HIGH, GENTLY, GREAT, LOVELY, THAT'S IT, ALRIGHT PAUL? FUCK OFF! ORANGES PULVERISED TO PULP.
AN EXTREMELY TENSE MOMENT.
THREE CROWS, THEIR BEAKS TOUCHING, TIP TIP.
A JET TRAIL IN THE SKY, BEHIND THE DARK FOREST.
WHITE FROSTING ON A CAKE BUT IT'S SNOW.

EXTRAVAGANCE. TIGHTNESS
YOU GIVE ME A CHANCE AND I'LL TAKE THE MONEY
BY THE WAY DID YOU SEE THAT FILM ON TV
I EXPECT YOU'RE WAITING FOR ME, FOR ME, TO TELL YOU
WHAT TO DO, WHAT TO, KNOW NO, YES, I'M JUST HERE, ONLY
JUST, SATISFIED, EXTRA SPECIAL, LIMITLESS, KIND PEOPLE
ARE NICE,
AMAZING AMOUNT OF BOTTLES HERE, GREEN, DELIGHTFUL.

Idea/image for the central persona:

It was Sunday evening, 18 December 1988. (The French
composer) Messaien's eightieth birthday concert season
at the South Bank. I've followed his music since I was
attracted to his record covers in the local music
library as a teenager. Sitting a few rows ahead of me
was an elderly man who kept fidgeting and turning over
the pages of a large book. This was distracting until
I realised it was Messiaen himself following the score
of his own music. At the end of the concert he shuffled
onto the platform with the help of his two debonair
suited sons to rapturous applause.

The image of this eighty year old visionary receiving public acclaim and flanked by his bemused conventional sons became a starting point for *Dancing on the Mountain*. I could develop and embody the persona of a kindly colourful elderly wacko who doesn't give a toss. He would appear at the beginning as the first 'state' and reappear at the end after babyhood. He could have an overview of the whole performance and comment on it.

At the end of his first appearance he/I throw(s) coins down after laughing about money. The sound is repeated and amplified on audio tape. This is a signal for the first 'breakdown' or linking sequence.

Second state

I'm not doing it, you can't make me, I'm not doing it,
not again, I feel stupid, don't make me do it, not the
stool, it's not safe, look at it, I'll fall off, this
is ridiculous, it's the last time I'm telling you, the
last time you'll get me up here... it's a lovely apple
though, a beautiful apple, look at the colour of it...
it's delicious, you can tell by looking at it...
The seventy year old trapped in his daily ritual.

'I'm shy, and in order to overcome that shyness I talk quite a lot and I put my views forward in a positive manner because if I didn't it would seem as if I was totally ineffective, and that's regarded by most people as being offensive particularly on TV, and as being rather arrogant.'

Let me just show you how you looked to us. You came. You took things that were not yours, and you did not even, for appearances' sake, ask first. You could have said, "May I have this, please?" and even though it would have been clear to everybody that a yes or no from us would have been of no consequence you might have looked so much better. Believe me, it would have gone a long way. I would have had to admit that at least you were polite. You murdered people. You imprisoned people. You robbed people. You opened your own banks and you put our money in them. The accounts were in your name. The banks were in your name.

At that time I once went in Milan to see a medium called Morosini who, after going into a trance, would read a person's present, past and future. He had barely gone into his trance when he said these very words: 'My son, you are one of the most envied men in the world!' The words of the medium Morosini often come into my mind.

He was all the more merry because it was his custom once a week to indulge in a violent debauch, after which he would vomit. When the Cardinal saw how cheerful the Pope was and how he was in a mood to grant favours, with great insistence he asked for me on behalf of the King, emphasizing how anxious the King was to have his request granted. Then with a great laugh the Pope, who felt that his time for vomiting was drawing near and had drunk so much wine that it was beginning to have its effect, cried:
'This very instant, I want you to take him home with you.'

Dancing on the Mountain
1989–90
**Four cuttings combined,
not strictly randomly,
during the preparation
process**

Linking sequence (frenzied catatonic movements and gestures, recognisable speech occasionally appearing):

Yes... even... I can... and... over my head... no
chance... and... absolutely... I... I'll take my
chances... keep your distance... take your time...
snowflake... and... and... and if I want to walk on all
fours in my own home then I <u>bloody well will</u>

Fourth state (white face cream applied to my face. It stays there in broad streaks):

```
I'm a wild woman . . .
```
Accompanied by African marimba music

Linking sequence (In the present here and now):

```
Watching Dick Whittington at the Theatre Royal in the
East End with my child and my ex-wife and her
boyfriend and their child and his ex-wife and their
child and her new child and of course it was a bit
difficult but I've got to try haven't I. The best thing
in the pantomime was this black actor who played the
cat and at one stage him saying he didn't eat birds
and then he sneezed and a coloured feather blew from
his handkerchief (gaudy red feather blows from my
handkerchief as I say this). And I thought I could use
that somehow . . .
```

Sixth state (I'm 27. I stand on the chair sideways on, slowly pulling out red ties from pockets. Bleeding, crumpled, I can't stand the music) Bruce Willis sings:

```
Comin' right up
comin' right up
all alone
don't be nervous
(no-one's here baby)
ahm at your service
bendin' your cup
said ahm belly up
ask for anythin' and ahl say yup
comin' right up
ha ha ha ha
ahl be right with you baby

I knock
I take a look in
I hear
dinner cookin' . . .
Don' forget that li'l cherry on top
comin' right up

Hey baby let me fix that seam on the backa your
stockin's
heh heh heh
```

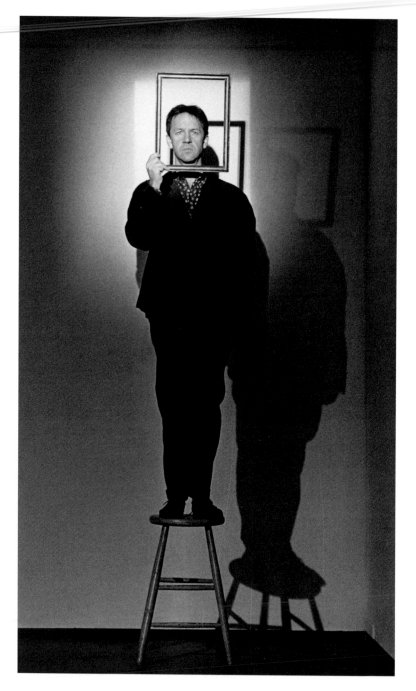

Materials to remember:

BREAD BOARD
FOOD COLOURING x 3
RUBBER GLOVES
APRON
ANGLEPOISE LAMP
ROLLING PIN ETC.
STANSTED BASEBALL CAP
FRAME
CHAIR
PAINT (SPARE)
PANEL PINS / HAMMER
SCREWS / SCREWDRIVER
FACE CREAM
MIRROR
CLOTH
COLOURED LANTERNS
COLOURED PAPER
PROJECTOR
FILM
AUDIO TAPES
BUBBLES
BOWLS
SHEET
CARPET
COINS
GOWN + HAT
PURPLE SHIRT
SHOES
SUIT
TIES
COAT
STICK

Dancing on the Mountain
1989–90, performance
Left
Second state
Stool, frame, spotlight,
apple (in pocket)
Right
Trevor Cromie's version of
the cuesheet for the
lights/audio

1) R. ENTERS FROM TOP OF STAIRS ———————— AUD. LIGHTS ————————

2) AS HE LEAVES ———————————————— " —— TAPE *1

3) HE ENTERS SLOWLY AS OLD MAN
 AS HE REACHES THE STAGE:......... ——— * CENTRE LIGHT —— TAPE OFF
 AUD. LIGHTS OFF

4) HE SITS AND TALKS "

5) HE THROWS COINS ———————————— " —— TAPE *2

6) AS TAPE ENDS ———————————— * GENERAL LIGHT —— TAPE ENDS

7) HE STANDS & ACTS WEIRD ———————————— "

8) SLOWLY STANDS ON CHAIR WITH
 FRAME ———————————— * FRAME LIGHT ————————

9) AS HE GETS DOWN ———————————— * GENERAL ————————

10) MOVES AROUND AGAIN ———————————— " ————————

11) GOES TO SQUARE TABLE ——————— * SPECIAL LIGHT ————————

12) AS HE STARTS TO OPEN BLUE JAR ——————— " —— TAPE *3

13) AFTER HE SAYS: "I FEEL LIKE A WILD WOMAN" — * GENERAL ———— TAPE *4

14) GOES BACK TO TABLE & STARTS TO REMOVE
 CREAM FROM FACE ———————————— * SPECIAL —— TAPE FADE OUT
 & REWIND

15) AS HE MOVES AWAY FROM SQUARE TABLE ——— * GENERAL ————————

16) AS HE SWITCHES ON ANGLEPOISE LAMP ——— * TABLE 2 SPECIAL ————————

17) AS HE TAKES OFF APRON & HAT ——— * GENERAL ————————

18) AS HE R SITS ON CENTRAL CHAIR ——— * CENTRE LIGHT ————————

19) XX HE STANDS & TALKS A BIT ——— * GENERAL ————————

20) AS HE PICKS UP CHAIR TO CARRY
 TOWARDS CENTRE ———————————— * CENTRE LIGHT —— TAPE *5

21) HE STANDS ON CHAIR & FEELS LIKE
 A LEMON "

22) TAPE ENDS, HE GETS DOWN ——————— * GENERAL ———— TAPE ENDS

23) HE MOVES AROUND & TALKS ——————— " ————————

24) HE GOES TO THE BACK & STARTS STAMPING —— * BLUE LIGHT ————————

25) AS HE MOVES FORWARD OUT OF LIGHT ——— * GENERAL ————————

26) WHEN HE LIES DOWN ON CARPET ——— * CARPET LIGHT ————————

27) AS HE GETS UP & PUTS ON GOWN ——— * GREEN LIGHT —— TAPE *4 again

28) AS HE EXITS ——————————— BLACK OUT —— END TAPE
 (1

29) APPLAUSE? (HE LIVES IN HOPE) ——— GENERAL ————————

July 1991 'OK, who's gonna wear the *hat*?'
spoken in my sleep last night

Fourth North American tour: November 1989 to January 1990
Toronto, Regional Ontario, Ottawa, Halifax, Winnipeg, Calgary and Vancouver.

Two months touring with four performances: *The Blue Fingers, Move the Rabbit, The Revolution: You're In It!* and *Dancing on the Mountain*; all packed away in my luggage. The tour was as enjoyable as ever but it made me take stock. It was all performance. I could go on like this or have a period of reflection when I got back. I went for the latter and halted the cycle of one performance work overlapping and following another.

Materials and strategies 1990–93

The period of reflection began by renting a studio in Bethnal Green where I started making, doing, fiddling, assembling, writing, drawing. I was consciously stepping back into the fine art arena and turned to other strategies. It was a period of withdrawal from the mainstream. Many of the projects were deliberately small.

The *House of Nations* (1990–91) challenged the perceived gap between artists working in 'education' and the art world. Collaborating with artist/photographer Jerome Ming and a primary school in Paddington where most of the children were semi-homeless, we devised an installation and performance/ritual under the umbrella of the Serpentine Gallery. I devoted a one person show slot at the Café Gallery in Southwark Park to the completed *House of Nations*. This included considerable input from the children. But it wasn't simply children's art. It was my one man show. And it achieved a sensibility which was only possible through this kind of collaboration. It was audience prejudice which had difficulty in reading or placing it.

Torremolinos (1991) was a one-off performance at the Camden Arts Centre which looked at cultural snobbery. It was accompanied by an in-depth slide sequence of the place itself.

No Way to Behave (1991) was also one-off, at the Galerie L'Ollave in Lyon; a free-flowing follow-up to the use of recycled materials in the *House of Nations*. Coming now from a more sculptural base I found my renewed interest in materials was increasingly driving the performance work.

Resting and Nesting (1992) were commissioned sculptural platforms for water birds on the River Wandle in South London to rest and nest on. Primarily designed for coots, moorhens and passers-by, they were exquisitely functional and stimulated a flurry of nests in the first year. They also bridged the gap between art and populist audience more successfully than anything I'd previously achieved. There was no confusion. Their reading was clear as day. Humans and birds were enthusiastic about them. Except for the National Trust, who ordered their removal. Environmental snobbery.

Tree Man (1992) was developed in collaboration with Common Ground for National Tree Week and Tree Dressing Day. Rather than 'dress' a tree I decided to dress as a tree. Familiar references to the green man etc. did not deter me from constructing a coat, hat, gloves and glasses which were branch and twig infested. This primeval gesture of so obviously communing with nature was an experience I wouldn't have missed. To walk inside this kinetic sculpture was ponderous and methodical. Approaching elderly ladies across common land and parks in South West London I was concerned not to give them too much of a shock, so I developed a lilting vocal hum to announce my presence. I was within a

Above
Torremolinos, 1991, image from slide sequence
Below
Resting and Nesting, 1992,
Timber, twigs
Right
Tree Man, 1992
Branches, velcro, thread, wire, glasses, hat, coat

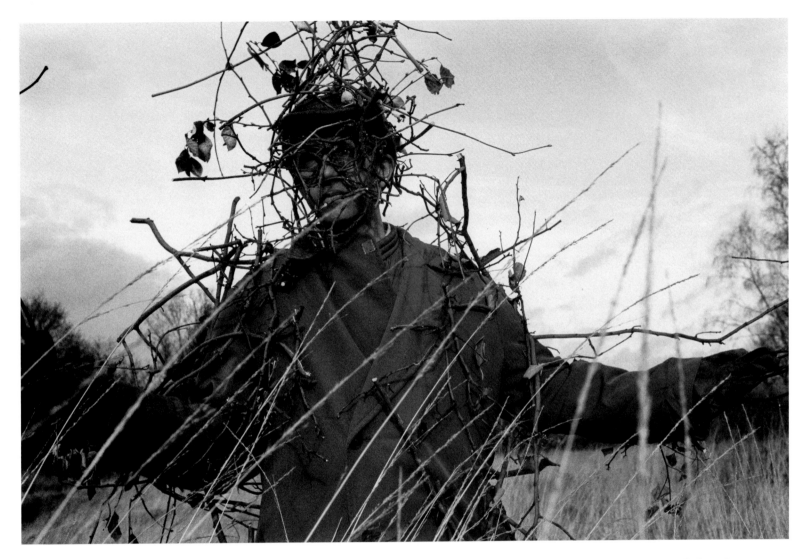

1993
Royal Festival Hall. First concert 3 May 1951. 'Bat and ball' carpet.

framework of elder, prunus, oak, alder and lime; each species with its own distinct qualities of construction (bending, cutting, snapping, gluing, tying, splicing). Velcro, thread and wire played a key role in the making of what could have been interpreted as a costume. When Jerome's photos were processed I was struck by how far I'd moved from a minimal and conceptual use of props in the early 1980s. But this was my return to materials. No call for conceptual snobbery.

Big Map (1992) for the Whitechapel Gallery involved 30 artists and 500 participants, from schools, special schools and community groups. A mosaic-like site plan was divided into sections, like city blocks. Each group, artist-led, took on one or more of these pieces, encompassing many approaches to the concept of mapping London's East End (where the groups were based). The culminating installation was 300 feet long and on public display for two weeks at Spitalfields Market alongside the Whitechapel Open Exhibition: bit of a

Perfection, 1991 revised 1993
Above
From sketchbook
Below
Stage 3 of revised performance at Royal Festival Hall

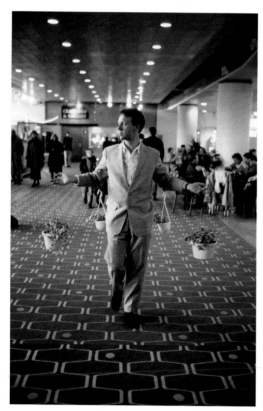

culture clash. I devised, designed and co-ordinated *Big Map* and saw it as a networking project, capitalising the energy of individual artists and workshops to bring them together into one piece of artwork with its own identity.

Perfection (1991 revised 1993) in its first version at the Café Gallery was a return to improvised performance. And I was very excited by it. It regained the freshness and spontaneity in performing that had been the missing element a year earlier. The quest for perfection through the mundane; the saxophone as a symbol of male potency; the celebration of the moment; the open book as roof form; the linguistic link between Gaston Bachelard and Gazza the footballer. Such were the issues which surfaced. *The Quick Festival* at the South Bank Centre in 1993 was the occasion for its revised version. But here there was a very particular location – the foyer area of the Royal Festival Hall – and I decided to include research of the building's history, whilst reacting to the pressure of a more high profile occasion. Perfection via the mundane remained a constant theme, with approaches to the building itself becoming the major framework. I developed three strategies to the building and the audience:

1 Intimate discussion of building details and concepts. This included the 'egg in a box' principle (of architectural acoustics) and took place in the Champagne Bar over a cup of coffee.

2 Leaving the audience where they were I moved down to the foyer music area. Using the microphone I created a more distanced and conventional relationship with them. A celebration of the mundane followed: plants in buildings (two planters were held up by assistants and repositioned); filling the foyer itself with muzak and pointing out a section of false flooring

covered in wood-effect vinyl, which was then fully energised with dry ice.

3 After attaching hanging plants to jacket elbows and fingers I slowly moved outwards into the hall as a whole, including a photographic exhibition by Robert Doisneau in the ballroom, moving arms and plants in a slow circular fashion based on Tai Chi. I was now aiming at the wider, casual audience while the invited audience looked on from the Champagne Bar.

In Transit (1993) developed further the role of performer as tour guide which had begun in *Perfection* at the Festival Hall.

I'm resting and half-posing for the camera outside Shadwell Tube Station. The first tour is coming to an end. I am a performance guide for this bus tour of installations located along either side of the Thames and in connecting tunnels. I'm wearing images of the other artists' work as sealed security badges, which are rotated as we proceed. The blue swimmer, for example, is taken from a video installation by Chris Meigh-Andrews. Other badges contain historical images of Marc Brunel's first tunnel now used by the Metropolitan Line, early tube trains, map details, wartime photo-graphs of the Docks and aerial views of Greenwich and Woolwich. I'm an information giver. I use the microphone on board the bus and build a relationship with our driver, Les. When I meet him beforehand and warn him of what's to come he smiles and says 'not a problem'. He says that a lot. It's his way. But experienced as he is, by the end he looks sincerely rattled. I am

overflowing with underground anecdotes and practical demonstrations en route. Including the story of how the first Paris Metro trains sprayed perfume at waiting passengers as they pulled in to the platforms, to soothe the effects of engine smoke. I demonstrate this with filtered water and essential oils. I'm wearing a vintage zoo keeper's jacket and equally vintage train driver's hat. I have my captive audience between venues. It becomes a marathon. Bethnal Green to Rotherhithe, Greenwich, Woolwich, Shadwell and back to the starting point. Then a second tour lasting three hours. At the entrance to the Greenwich Foot Tunnel a tourist singles me out to ask where the toilets are.

In Transit
1993, performance
security badges, zoo
keeper's jacket, compass,
hat

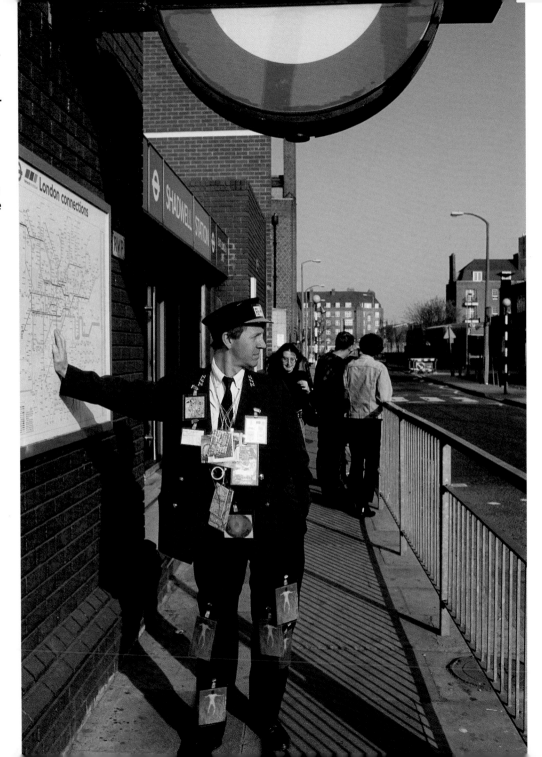

Here One Minute

1994–95, performance/lecture, 20–40 minutes

and **Mentations** (Mall walls really *are* plastic)

1994–95, performance, 50 minutes

These two performances were larger projects, one commissioned, the other planned for showing abroad. They were both performed several times. I was back in the touring groove and out of the studio. They became interlinked. One fed the other.

Here One Minute – a performance/lecture which claimed a history for live art/performance art – was audacious. Was I associating myself with these significant grey photographs and anecdotes going back to the beginning of the century? But this is a history that needs affirming. And who else was doing it from an artist's perspective? The Futurist Noise Machine and a rare recording of how it sounded. Black and white photographs of Robert Rauschenberg, Claus Oldenberg and Robert Morris making Happenings in the 1950s and doing a pretty good job. Many internationally-known artists have seriously worked in performance, but their dealers don't make much of it for obvious reasons and the history fades. There's an equally untapped British tradition: Gustav Metzger's auto-destructive 'paintings', the Event Structure Research Group, Gilbert & George's *Underneath the Arches* and Ian Breakwell's *Incident in a Library* in the 1960s. I would celebrate these projections as rare records of Live Actions, Events and Happenings through the quiet homage of the slide projector and my observations.

In one sequence I was dressed by assistants Dada-esque in an equivalent of Hugo Ball's costume of tubes of card for the Cabaret Voltaire. I found a barely-known sound poem by Kurt Schwitters in a large book on Dada & Surrealism. I was looking for a poem to demonstrate while animated in the ridiculous costume, ideally something obscure and unknown to the audience. When it came to the first couple of performances I felt awkward. Who was I to perform a sound poem by Kurt Schwitters, one of my heroes? Then the other questions came – How should it be performed? Had it ever been performed in Britain? Had it been performed anywhere? How would he feel about it? However, the audience responded each time as if it was a set piece within the performance/lecture and I felt moved by it. I grew passionate about this experience. It was a tribute not a rip-off. It became a psychological embodiment which gave an empathy real or imagined to how he felt because it was how I felt as an artist working in temporal media. And this PRIIMIITITTIII TISCHA TESCHO, PRIIMIITITTIII TESCHO TUSCHI had been hidden at the bottom of

a page, not on a gallery wall, not in a private collection or bank vault. It was a temporal slither.

I later included this Kurt Schwitters episode as a sequence in *Mentations*.

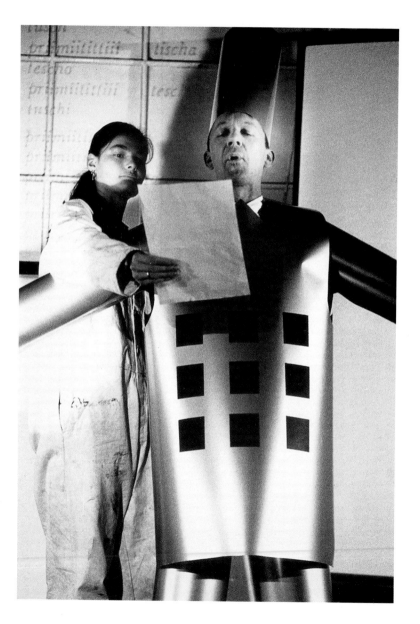

Here One Minute
1994–95, performance
Left
Dadaesque card costume, reciting Kurt Schwitters
poem, assisted by Emiko Duindam
Above
Script

Mentations came from wanting to approach ideas more like a musician or poet – choosing from a selection or repertoire of 'pieces', as if songs or poems. 'This one is from my last but one album.' 'This one's about urban discovery.' The working title was '*Shorts*'. This format would allow for many forms of presentation from pseudo-lecture to anecdote, physical action and visual narrative. And the freedom to target audiences through the chosen units; leave this one out for the gig in Eastbourne, include these two for the Hammersmith Palais. And a random element, like choosing playing cards from a pack. It was mainly developed to take on tour in Canada but was also shown in Poland, London and Birmingham.

I saw it as observations, reflections, an approach to figments of time. How could I find a way of combining international anecdotal experiences? It became an ongoing process and was continually added to. *Mentations* as a work could go on for years.

At the start of every performance there would be a random selection of cards, each one a different mentation. Pull a few out and that would be it. Once the video and slides were added there had to be a more fixed pre-planned structure. Ideally there would be a computer-driven menu and a real possibility of the random.

Like every new work, this was going to be *the one*. I spent months planning it, trying out sequences, lifting sections from here and there. They need not relate at all each to each. They would all be mentations:

- INTERNATIONAL CLOTHING
(what I'm wearing)
This shirt, French designer label,
bought in London, made in China.
This second-hand jacket,
bought in Nottingham, made in USA.
These shoes, bought in London, made in Italy.
These trousers, American label,
bought in London, made in Africa.
Four continents of regular clothing.

- THE LINE AS A RECURRENT VISUAL EXPERIENCE
The coffee stirrer as line in space
Reflected linear light through moving windows
The incidental kerb
If the unknown artist (of this linear sculpture in an English field) is here in this audience, step forward and claim your authorship! (slides).

• SPORTING ACHIEVEMENTS

(four slides) shouted into the far distance:

'Double J, Double Jerk

You're goin' down, you're goin' DOWN

GO BACK TO <u>MAMMA</u> WHERE YOU BELONG

You're goin' DOWN'

Waving that stars and stripes

Getting up off your seat

And it's a win for Double J'

• BLUE JEANS AS ICON

(slides and performance)

Look at these jeans worn world-wide. Would you know
the country we're in from the clothing? Jeans in
Krakow, jeans in Brooklyn, jeans in Manhattan, jeans
in London, jeans in Palma de Mallorca, jeans in
Athens, jeans in the Algarve (slides).

What is it about them? It's a conspiracy of trouser.
Former communist Europe is a key. This was what you
wore, still wear, the status clothing. Cotton
currency. This link with the fucking West. It's this
cheap blue fabric with a few studs, work inspired
clothing. Internationally they're interchangeable.
Knowing (I know this) that Levi's profits, <u>clear profits</u>
last year, just in Europe, <u>just in Europe</u>, were one
billion dollars. And we all collude in this crap

As if there was a JEAN god

As if they looked good on more than 10% of the wearers

As if there weren't better fabrics

As if there was no choice

(I get physical with a pair of them, humiliate them,
stamp on them, chuck 'em)

• PLANTS IN BUILDINGS (slides)

• UTICA MALL

(slides that gradually zoom in closer to the detail)
This is an ordinary bland shopping mall in the US.
We're looking at the outer perimeter wall. If this was
a castle the parking lot would be the moat. The
external approach is an opportunity to advertise the
retailers within the walls. It is shown here by the
sign KIDS 'R' US. The walls are white flat and smooth.
As we move in closer we notice a subtle change in the
surface. There is a functional detail or a slight
imperfection in the concrete or plaster surface.
Closer still and the camera reveals what we always
suspected. Look where the plaster surface has been
picked off. These walls are actually made of
polystyrene with a thin plaster skin. Mall walls
really are plastic.

Mentations
1994–95, performance
Utica Mall, images as
projected

Enterprise Rent-a-car (The Sucker)

1994

Sculpture Space Inc. is an artists' studio/workshop in Utica, a small city in upstate New York. It was founded in 1975 at the Utica Steam Engine & Boilerworks plant. They have an ongoing series of residencies, some with foreign artists. Between twenty and forty artists, mainly sculptors, are selected each year on a competitive basis. It's a practical facility set up for working in steel, timber, etc. They offer free use of facilities and sometimes funding towards living expenses and materials. Following a short productive spell with them in 1986 (*Definitions* and *Peta*) this was a more formal residency. I wasn't planning to use the facilities much and wanted to do more with the 'car as icon', in the land of the automobile. The first job was to find a suitable car and then some funding.

> Dear Richard
> Congratulations, you have been awarded an un-funded residency at Sculpture Space …

I take the white car. It's the biggest you can rent in Utica. This is a poor city but full of cars like every other place.

I get in, stretch my legs and hit the cassette play button:

```
ROCK MUSIC INTRO
MAN: Pontiac would like to thank you for choosing a
1993 Grand Prix and welcomes you to driving
excitement.
WOMAN: You've selected one of America's best road
cars. No other mid-sized car can match Grand Prix's
value-packed blend of styling, roadability,
performance and comfort. Sporty good looks and
performance will make your driving a pleasure.
MAN: Whether you have the Sports Sedan or Coupe LE SE
or GT your Grand Prix continues the Pontiac
performance heritage with trend-setting style. This
program will help you get acquainted with the controls
and features of your new Grand Prix. To benefit most we
recommend you park (the fucking thing) and follow
along. Remember this is just an overview. Your Owner's
Manual will provide a more in-depth look at your car's
features. Now, LET'S GET STARTED!
```

Mmmm.

I take the car to Sculpture Space and set about seeing it as raw material, raw canvas. Check in to the A1 Motel. It's cheaper than Howard Johnson's. I'm unfunded remember. I get free use of studio facilities but don't need much. Be nice to drive the car in there though. Just drive the big white sucker into the art factory.

Utica is full of dollar stores. Stores that sell everything for a dollar. Sometimes it's two for a dollar. The stuff in there. I spend a long time looking. Might find some materials for the CAR. Find these battery operated closet lights and some red flashing torches. Think they could be used in the trunk under black cloth, flashing and twinkling like incongruous stars. But there's too much daylight, not enough impact.

This is a hire car, current model, automatic. Drives like a dream.

Owen and I drive to Toronto for the weekend, stopping at Niagara Falls. Can you be an artist with your 14 year old son around and you only have seven days? Collaboration, that's the thing, get him involved. And work while he's at the motel plugged in to cable TV. Don't fight it. There are no rules about being an artist, I remind myself. Park the car outside my friends' house in Toronto. Give it a first shot as an artwork in their street, Virtue Street.

Trawl the dollar stores again. I find white plastic bowling pins. Black fabric from Sculpture Space. White 'self cling' plastic sheeting for the windows is hard to find but easy to peel off. Find some familiar white filling fabric in a studio store. I used it regularly when I worked in upholstery; the job that saw me through college. My mother was an upholsterer. It was a sensible London trade for young girls in the 1930s. Her boss, Bob, the ex-accountant with a nose for fabrics, employed me two days a week in his decaying suburban sweat shop. So I knew what this fabric could do when I saw it in Utica. We called it 'bumph'. I'll stuff it out the car windows like foam cloud. Everything has to be portable and quick to install. I'll have to drive the sucker.

I still need some funding for this. I make a connection with a local high school (Proctor) and become a 'visiting artist' for 3 mornings. Tough cookies but they like it when I'm noisy, very noisy, like they're not supposed to be. Tell them I'll be back with a CAR AS ART. Do they believe me?

Owen agrees to take part so long as no-one can see him. I can't keep leaving him in the A1 Motel. He gets sealed inside by the white and black-out. He's in the driver's seat with the engine running, emergencies flashing. He revs the engine, flashes the lights, honks the horn now and again. You can't see him. The small kids go wild. The big kids think it's computerised. Now they believe me.

This interaction with a specific audience. But when it fully becomes art for me is when it's out there: in the parking lots of the shopping malls and the train station, casually sitting there, CAR AS ART.

But ultimately you know this is *really* about getting hold of the flashy car as international icon and defusing it. Sending it into ridicule and impotence, publicly, in the land of the automobile.

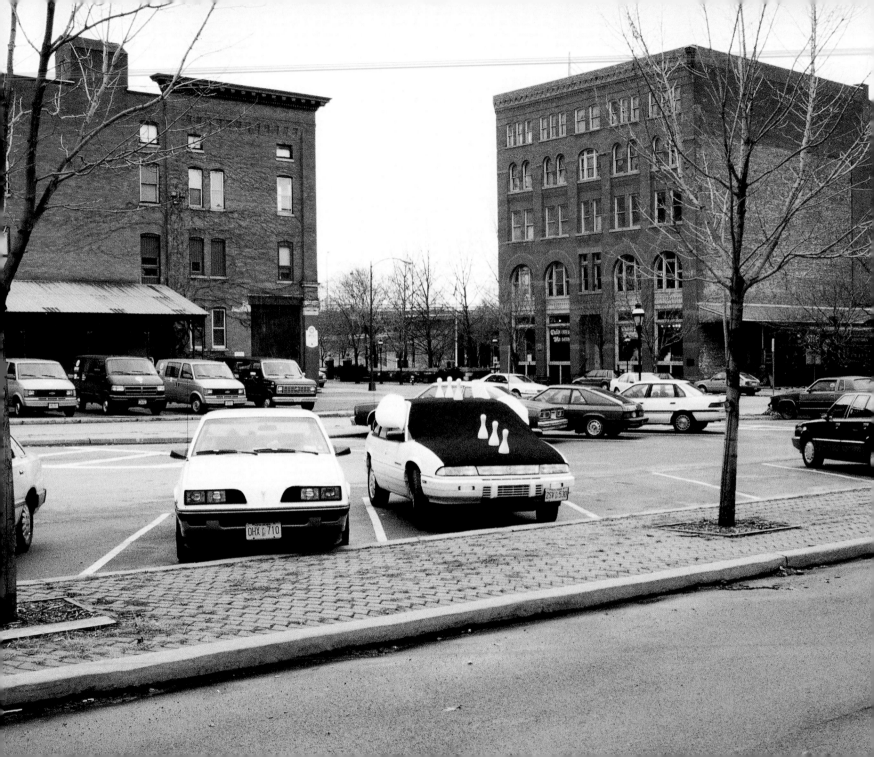

Strange car bowls them over

Second-grade students at New York Mills Elementary School crowd around a piece of performance art by Richard Layzell yesterday. Layzell transformed his Pontiac Grand Prix rental car, demonstrating that a sculpture can be made out of anything. The car, covered with cloth and bowling pins, makes strange sounds, honks and, occasionally lights emanate from it. The windows are covered so the children could not see inside. Layzell, a London sculptor, is a resident-artist at Sculpture Space. He is also doing a mini-residency at Proctor Senior High School, arranged through the Kirkland Art Center. He and his car will be at Proctor this morning.

Utica Observer-Dispatch

Enterprise Rent-a-car
1994
Car, bowling pins, black
fabric, 'self-cling' on
windows, 'bumph' out of
windows

```
To Mr Layzell and Owen - Thank you for coming to
New York Mills - from Victoria
....................................................

Your car is awesome - from Jenelle Barrett
....................................................

you can have the English flag. Or the American flag.-
to Mr Lazell and Owen - from Richard Hickel
....................................................

cool man! do you like me - thanks for showing the car
- by jon lookonbake
....................................................

I liked when the car went beep beep. - by Kenny
....................................................

I like The car - cool - Thanks Mr Lazell
....................................................

Dear Mrs Lazell and owen Thank you for visiting
our shoell The car was the coolest car in the world
I can't wait to see you again - By Mike Salamy
....................................................

The car was awesome I liked the bowling pin on the
hood - Love Nicole Austin
....................................................

Thank you! For bringing the car - car under water -
from Keith Manley
....................................................

From: Michelle Misiaszels - The Car is Awesome -
I want to visit
```

an unexpected phone call
could I go to Poland in a couple of weeks?

Samples of the Modern World

(You know why this work happened,
slow down and speak clearly)

1994, performance, Oronsko Poland

A two week symposium at the Polish Sculpture Centre in Oronsko, a hamlet off the main highway between Warsaw and Krakow. We were ten artists from Poland, Portugal, Italy, Norway and Britain. A symposium meant living and working together in the grounds and buildings of a former country house. I could only stay a week so the pressure to produce was on. I also felt an obligation to make a performance as it seemed that was my raison d'être in this group of sculptors. However, the Polish performance artist Janusz Baldyga (from Akademia Ruchu) chose to make sculpture. He didn't feel pressured and by example demonstrated the uncomplicated relationship between fine art and theatre in Poland. They flow effortlessly one into the other.

The Centre housed studios, workshops in wood, ceramics and metal, two galleries and a bar. There was a gate-keeper with a peaked cap who lifted the barrier for the occasional vehicle coming or going. It was hard to see why, but it probably harked back to days of full employment under Communism, like the cloakroom attendants in Warsaw. Or the women found in museums who slide silently across wooden floors in the early morning, polishing them through the soft cloths tied to the soles of their shoes. A grey-haired ballet.

I was keen to reflect and observe this culture in flux. Radom, the nearest large settlement, had shops and a department store. There was an introverted consumer frenzy around and some great coat hangers.

You know why this work happened, slow down and speak clearly.

I was learning the new formula for coca-cola through English language programmes; English for Poles; consumerism through knowledge, knowledge of consumerism, red coca-cola mini vans in the sluggish city of Radom, basketball sponsored by Adidas in Krakow, a single large cola bottle as the centrepiece in a traditional window display, cheap colourful plastic goods which were less expensive in America. I knew, I'd just been there. This was adding up to making a statement in Oronsko, the village near the Sculpture Centre. An idea I had to sleep on.

Keep going.

Well, it came from assembling these domestic plastic products, bright pink coat hangers, nylon string, pegs, pot scourers and then a drawing of myself inside them hanging off me hanging off hangers suspended spinning turning dragging as I walked a mass of consumerism I can't do it.

Yes you can.

That's right. It was that thought of vulnerability and stupidity and what would people think that made it happen. Fear feels significant sometimes. I'd wander out into the village speaking of the new cola formula and I saw myself standing like a framed kinetic invader down on the nearby main road which ran between Warsaw and Krakow. I didn't expect to meet a funeral procession on the way but it was all strangely reverential and mutually respectful you go your way I'll go mine. Sounds tasty, it *was* tasty, try it you'll like it. Internal test taste panels confirm it. Another kind of death.

I carry samples of the modern world. Plastic pieces of civilisation, brightly coloured and ready to go, either into the mouth, onto the shelf or into the garbage, go, go, go. Try it you'll like it. Sounds tasty, it *was* tasty.

Samples of the Modern World
1995, performance
Main road between Warsaw and Krakow
Wooden 'yoke', wood and pink plastic coat hangers,
'zip' bags containing various consumables: pot
scourers, plastic items, advertising clips

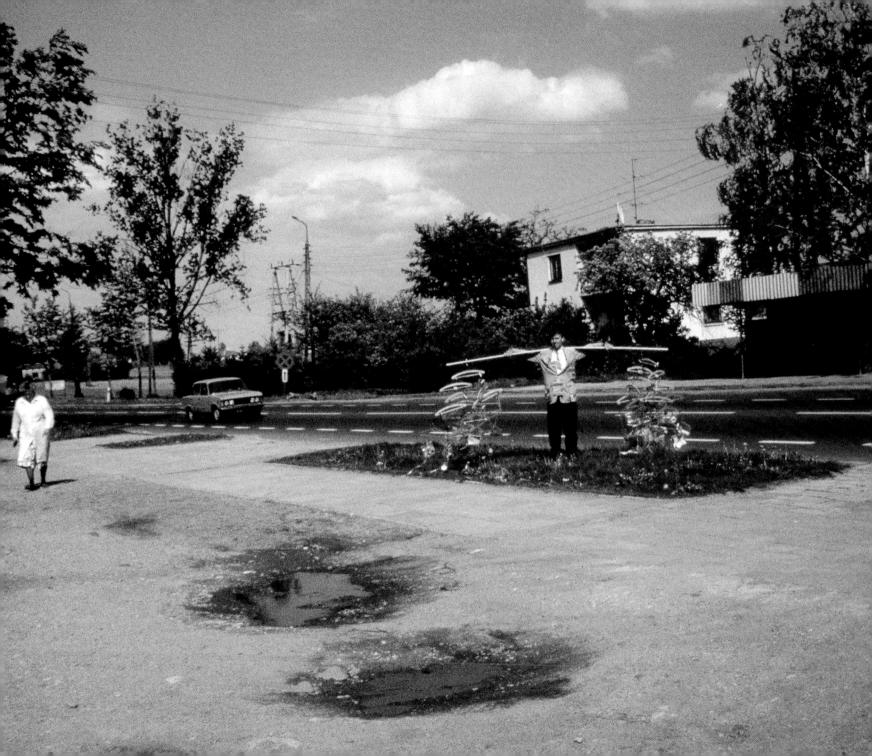

Photography of the moment

The relationship between the photographer and the ephemeral artwork is a tad under-acknowledged and under-explored. I love photography all round. The obsession I had with seeing those photos Derek Jarman had taken of my performance in 1969 has often been repeated since. At their best they speak more fully and poetically about a work than text or video. The relationship between photographer and artist is complex and varied. Who's paying them? What agenda do they have? Are they artists themselves? Who's exploiting who? Who's directing who?

I've encountered six categories of photographer for the ephemeral in art.

1 The artist him/herself and fellow artists. The sensibility is totally empathetic. Technical deficiencies are outweighed by enthusiasm and spontaneity. Represented here by Jo Stockham, p. 65; Egil Kurdol, p.81; and myself.

2 Artists who also work professionally as photographers. Again great empathy but also some directing of the construction or choreography of the image, *eg* they have their own creative agenda. Represented here by Gary Kirkham, pp.2, 92–94; Jerome Ming, pp.71–73; Jim Hamlyn, pp.85 inset, 87 top; and Amy Robins, pp.74, 85, 88, 91.

3 Photographers who specialise in documenting the ephemeral in art. Genuine enthusiasm for the material. Great technical expertise. Can produce astonishing and passionate results. Represented here by Edward Woodman (London), pp.4, 51. 57, 98–99; and Peter McCallum (Toronto), pp.38, 68.

4 Theatre photographers. They specialise in the 'photo shoot' or the 'press shoot' to produce an edited selection of photos available for the press to take away on the first night of a theatre run. Surprising use of lighting, results are often dramatic as a result. Represented here by Sheila Burnett p.59 and Simon Anand p.97.

5 Quality press photographers. Take photos for the 'picture feature' on one of the 'Home' pages of the broadsheets. Tremendous manipulation of the subject to produce a result which is often impressive but can be far removed from the content of the artwork. Represented here by Kippa Matthews, front cover.

6 Regular press photographers. Very hit and miss. Even more manipulative. Results can range from the appalling to capturing the audience response or the moment. Not known for subtlety of composition.

The intense short-lived activity in real-time gives rise to a frozen silent moment with an indefinite life. The photo/photograph/image itself, particularly in slide form, has the added dimension of potential incorporation in another performance.

Life goes on.

Jumbo Rumba
1996, performance
Below
Coral Winterbourne in period costume at the foot of Jumbo carrying broom
Overleaf
Firemen, smoke, paper

Jumbo Rumba (The biscuit barrel incident)

a Happening

and Blind in Japan

a performance, 1996, commissioned by Colchester Arts Centre

Colchester has two main arts venues, both interested in developing and promoting live art. The Arts Centre Director Anthony Roberts had seen my work a few times and suggested a small open-ended commission: 'I don't mind what you do so long as you don't spend the money on your book.' There is invigorating generosity and trust implicit in this statement, whether the fee was large or not. It wasn't. There wasn't a history of live art commissions in Colchester. This was an Arts Centre known mainly for music, fringe theatre and cabaret. If that's your attitude then I'll give you more than you bargained for. Did I take it as some kind of challenge? I just liked the approach. Do something for me and something for you. And the something for you, *Jumbo Rumba*, got bigger and bigger until, as

Tap Ruffle and Shave is commissioned by Glasgow Museums. I become co-curator (with Kathleen O'Neill) for *Art Machine 95* ('Scotland's biggest interactive event') at The McLellan Galleries in Glasgow.

I began to suspect, there wasn't enough room left for *Blind in Japan*. All he said was do what you like.

This spectacular huge water tower near the Arts Centre, on top of the hill, known locally as 'Jumbo'. A local landmark, disused, planning permission applied for. I noticed this in the local paper on the way back to the station, the longest platform in Europe, 'Big plans for Jumbo to be made into flats,' with drawings by architect. Fill the bastard in, fill in the sides, stick a lift up the middle, very desirable apartments. But this monument to industry, a million bricks, 200,000 gallons of water, up on high to run down low with gravity, these SPACES between these five

great feet. Fill it in, it's gone, done for, anaesthetised. Clean up the bricks, double glaze the windows, make it invisible.

Anyway. It's too big. Too big on my small budget to make this the subject for an outdoor Happening. I think about that description of the Alan Kaprow Happening in 1962 in the courtyard of the Mills Hotel in New York. Not to recreate but get some flavour of. This now defunct functioning place of water is what it is, a construction of bricks and air, a sculpture near as damn it, a site that local people like but take for granted. There could be a hidden agenda to do with the Planning Permission. By paying it attention and making art spout from it it's taken more seriously and re-enters the consciousness of civic pride. The people's water tower, Colchester's monument. Stupid idea, too ambitious. A challenge.

Check on access, check on permission, check on availability. It's possible. Possible means no turning back and now it's a case of who to work with locally. Who can cope with huge structures? The fire brigade. Waiting to meet them in their bland temporary offices on the edge of town to talk it over there was a minor crisis when the biscuit barrel disappeared. Had there been a theft? Robust men like biscuits with their tea. Is this a universal ritual/concern? But they were up for it, providing the ALP (aerial ladder platform) wasn't needed at the time for a real emergency. They would need the police to cordon off the approach road to Jumbo. Surprised to be involving two of the emergency services. The Arts Centre had strong links with the Sixth Form College. Head of Music Nigel Hildreth was on the Board. He'd taught Damon Albarn and he knew all about rumbas. They would work on something. This was a start.

What about *Blind in Japan*?

It was there in the background and would happen in the Arts Centre's theatre space, a converted church with lights and a scandalous Friday night disco. Anthony was clear that Saturday night would be best for me, the same night as *Jumbo Rumba* during the day. Maybe he was being considerate about my time. I was concerned it was too much in one day but had managed in the past. *Blind in Japan* would be about my strange short visit to Japan during the summer when it was all about humidity, smells, sounds and imitation food sliding off plates in restaurant windows; visiting a celebrated school for the blind in Chiba and staying in the Chiba Washington Hotel because it was air-conditioned and nice for Westerners. But I would have preferred to be soaked in sweat like everyone else carrying little squares of towelling strictly for the dab-dabbing of facial perspiration in such a way that you knew they'd always done it and they all did it.

The taboo about even mentioning blindness after talking to organisations for the visually impaired. But I was blind in Japan.

Blindness is in all of us even if those who lose their sight don't always want it back. I was there on a mission to collect tactile ceramics made through touch and bring them back as excess baggage to London then Glasgow. Simple enough but all the experience around it was breathing fire. I had some video taken in Essex, somewhere local, with a plumber's camera that goes down drains. This drain was a bit hush hush but you wouldn't know, piping is innards. And audio and slides from Japan. I saw it as an improvisation with reference points. High risk. It would come off or not.

Jumbo Rumba became a collaboration as much with the Arts Centre as local groups. They were a local group in themselves. They found portable ex-army searchlights on the back of a lorry, a bagpiper for the top, smoke pellets and a PA system. They acted as go-betweens with a rare enthusiasm. Technical assistant Finnimore designed bin bag parachutes carrying a sweet-a-piece for launching from the top and kid-grabbing. It would be abstract, a family event but really a Happening, starting with the fire brigade taking the piper to the top on the aerial ladder platform. We were getting ready the night before, and under this time pressure I had an idea that wouldn't shift. A broom is repeatedly thrown by a woman in period costume from an upstairs window with a scream, like release. Then she goes down to collect it and repeats the action. This was the closest to a 'meaning' in *Jumbo Rumba* and everyone asked what it meant, even the fire chief. When I explained to him afterwards the references to fairy tales and housework he suggested I lie down for a while. I didn't mention the biscuit barrel incident. The piper was late arriving and he was phoned for a second reminder. He knew exactly what he was doing. When he did arrive he looked at the ALP and Jumbo and doubled his fee. Not a good time to find a replacement. Up he went wearing a helmet but not allowed to play till he reached the top. Safety reasons. The wind blew in the right direction for paper tape to stream. The sixth formers began their rumba, Nigel sort of conducting them with an unexpected fury on a piece of rough staging. The searchlights began. Out went the broom with a yell. Down came the parachutes. Tallest kids got them first. A scuffle. Smoke from the top visible from all over town. Piper played on the way down, firemen resting easy now.

Inadvertently we, as performers and audience, had all been standing and moving around Jumbo for about an hour. This was probably a longer ritual than its official Opening Ceremony in 1884 You could say that this was my central intention – a quiet homage.

The flats didn't get planning permission.

Tap Ruffle and Shave

1995–98, an interactive installation

A big project. It began as funded research under the banner of the 'Arts Council of England's New Collaborations Fund'. With a working title of *Drum Touch*. I initially visualised it as a performance aimed at the hearing and visually impaired. They would become participants, performers and audience. It would stress the hands as universal symbols of expression and vulnerability. African drumming would be a key element. I was training with Ghanaian drummer Isaac Tagoe at the time. Sound through touch.

The research period went on for over a year and was confusing and invaluable. Through meeting many representatives of the deaf and visually impaired communities I gradually concluded that an installation would have more impact than a performance. And more people would experience it. Several collaborators became involved, including an engineer. In 1995 it was commissioned by Glasgow Museums for *Art Machine 95* at the McLellan Galleries, a large interactive and audience-based exhibition which I subsequently co-curated with Kathleen O'Neill. A year later *Tap Ruffle and Shave* was commissioned again by the South Bank Centre for the Ballroom at the Royal Festival Hall in London. This was an opportunity to completely revise it for a very public space. Although the installation was primarily designed for sensory impaired people it was gradually opened up to be very inclusive and increasingly playful.

Discovering how visually impaired people experience the world had a strong influence:

> My body can recollect the narrow little strip of ground over which I have passed, and it consists of tiny details ... here the footpath goes up slightly, there is a nick in the kerb, this telephone pole has a metal plate screwed to it but this other one is smooth.
>
> John Hull, *Touching the Rock*

This is close to an art-attuned experience. It draws out the sense of touch and of mapping without vision. Dominated as we are by the visual we tend to associate touch with smut. Allowing touch to be the driving force brings the visual flowing gently behind. And the audience, being driven by the sensory-impaired, explored the work freely – especially at the Festival Hall. There was no touch taboo. Many were far more uninhibited than the British are supposed to be. They crawled on the tactile carpet, wrapped themselves in silk drapes, resonated the wood and steel, made sounds. They became the performers, the interactors, the collaborators. It was their space, their zone. Wheelchair users, babies, concert goers, businessmen, came and tinkered, not

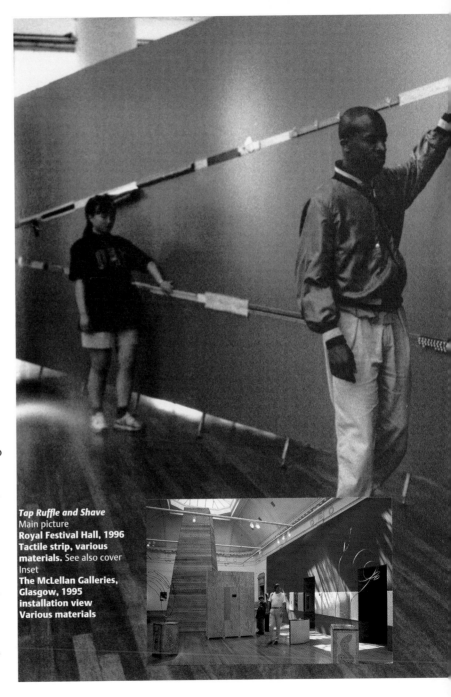

Tap Ruffle and Shave
Main picture
**Royal Festival Hall, 1996
Tactile strip, various materials.** See also cover
Inset
**The McLellan Galleries, Glasgow, 1995
installation view
Various materials**

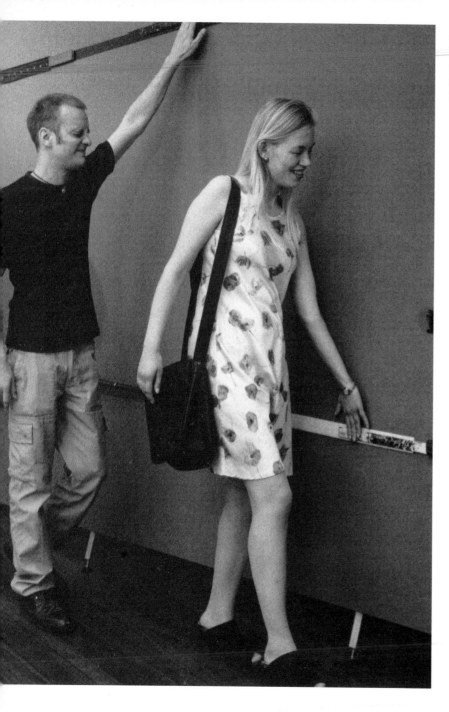

always knowing it was art they were in. What does this make it? Populist, popular, filling a gap, collaborative (twelve artists have contributed to it in its different manifestations). It makes it *Tap Ruffle and Shave*. The name itself begins to carry it and define it, like good PR. It is what it is. Weird stuff for people.

> I know of few greater pleasures than holding a lacquer soup bowl in my hands, feeling upon my palms the weight of the liquid and its warmth.
> Junchiro Tanizaki

As the title might suggest, this is an exhibition intended to take the visitor into sensual realities beyond the visual. Its main creator, Richard Layzell, has a distinguished track record in live art and performance, so when he thinks about making objects for an exhibition he likes to do something that demands more from the visitor than merely a passive response. *Tap Ruffle and Shave* is a collection of things which you walk upon, open, tap, turn your hands over or insert your hands into, and generally engage with in many physical ways. There are flashing lights, dripping water, giant trousers, prepared pianos and all manner of contraptions.

Much of the work was originally conceived with disabled people in mind, including visual art for the visually impaired and musical instruments for the deaf. But other people are welcome too. When it was installed at London's Royal Festival Hall, besuited executives would take a break from their business lunches to put on blindfolds and caress their way along the multi-textured wall.

The question whether it can all be classified as art is not one Richard Layzell seems overly concerned with. 'it's partly serious research and partly a bit of fun,' he says. And it certainly has a laboratory feel about it – its presence at the Museum of Science & Industry is totally in keeping. The difference between this and the Museum's educational displays is that the enquiry here is an aesthetic one. It's a testing ground for a way of making art which recognises that there are many more ways to touch the human spirit than through the optical nerve.
City Life Manchester

Advertised as an 'installation to meddle with' this is an exhibition not to be missed. Much intense practical work lies behind it. you can blend enjoyment and involvement without effort. I went around twice, once with the helpful guide who explained things I could not 'see' and once on my own. The items produced different responses from my senses each time and the large space in the Festival Hall Ballroom showed everything to its best advantage. There is access for wheelchair users.

Tap Ruffle and Shave
1995–98
Mechanism inside sensory
cabinet, fluorescent wool,
spindles, motors

Photographs, a video, print and braille labels are around to describe each piece.

Richard Layzell was available for discussion about the ideas behind the show. This was riveting, descriptive and showed that he knows the true value of shared sensory perception for everyone. Among the amazing delights, the three lovely sculptures made by blind Japanese students were an outstanding 'touch' for me. Close by stood three pianos. Each had their own 'voices' when played, including a mute one with vibrating canes on top.

Disability now

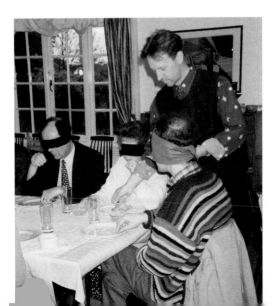

Tap Ruffle and Shave
sensory evening
Firstsite Colchester, 1996
People, blindfolds, food,
drink

Tap Ruffle and Shave sensory evening, Firstsite, Colchester

It's early summer 1996. A reduced version of *Tap Ruffle and Shave* is shown as part of *Love at Firstsite* in Colchester. Local people are invited for a sensory evening. Some arrive in suits straight from work. Others are younger and out for a good time.

After isolation of smell and touch we move on to taste, in the café. I'd envisaged collaborating with a vegetarian cook to make exquisite foodstuffs but the budget wouldn't quite stretch so we took a trip to the supermarket. Exotic fruits, Thai rice dishes, juices, cheeses, Indian snacks, nuts, raw vegetables, pastries. It was a pretty good spread. People sat with their friends if they came with them and were blindfolded. I prepared them for possible feelings of withdrawal and mild depression from losing sight for an extended period. About one in ten sometimes have this reaction, myself included. There were a few comments about them needing to trust me not to poison them and others about this being some kind of power trip. I could see their point. Once the feeding began they settled down pretty quickly and started chatting and giggling. Small portions of food arrived on their plates. I'd either tell them it was there or tap them on the shoulder. Fairly soon the food became less of a focus, conversation started to play an equal part. After an hour of serving them tasty morsels and titbits I began to feel that the power rested with them and their relentless appetites. I was thus enslaved for three hours and it started to become conceptually interesting. The blindfolds began to look sinister and exclude me. I wasn't one of the clan. The camera took the place of the observer, the viewer of this perverse ritual, feeding the cuckoos.

Tap, Ruffle and Shave, materials used and their sources:
FROM THE FABRIC STORE FINSBURY PARK: FAKE FUR, FAKE
LEATHER, BRIGHTLY COLOURED AND TEXTURED FABRICS
B AND Q: VARIOUS SCREWS AND NUTS, BLACK DOMED,
COUNTERSUNK, BLUE SELF-TAPPING, SILVER DOMED, BRASS
COUNTERSUNK, STANDARD NO 8s; ARTIFICIAL WOOD-EFFECT
FABLON; DRAUGHT EXCLUDERS; VARIOUS PLASTIC DUCTING.
IRONMONGERS OPORTO PORTUGAL: LARGE BRASS DOOR KNOCKERS
AND STAINLESS STEEL HANDLES
PENTONVILLE RUBBER KINGS CROSS: LATEX SHEETING, BLUE
RUBBER MATTING
BOW GARRISON: 3 SECONDHAND WARDROBES
PAMPERED PETS HOLLOWAY ROAD: VARIOUS CAT FLAPS AND
BUDGIE BELLS
ARGOS HOLLOWAY: 3 CHINESE-MADE WHITE COLUMN FANS
PONGS OLD STREET: WHITE SILK
OBJECT CARPET COMPANY, FULHAM ROAD: VARIOUS GERMAN-
MADE CARPET SAMPLES
ON HIRE FROM MARKSONS REGENTS PARK: 3 UNRESTORED
PIANOS
CAR BOOT SALES IN THE OXFORD AREA: VACUUM CLEANER,
WATER PUMP, FAN HEATER, SLIDE PROJECTOR, PERFUME,
FRIDGE UNIT
MANNINGTREE, ESSEX: TREE BARK

Industrial collaboration

(Ongoing residency 1995 to present)

AIT plc is a company of about 180 people based in Henley-on-Thames. They develop computer software mainly for the financial sector. An unlikely base for an artists residency. Henley was deliberately chosen when the company formed eleven years ago by five people as a pastoral environment to counterbalance high technology. Boats are moored nearby with names like *Sally Ann* and *Ketchup*. Swans breed furiously and leave mountains of slippery shit on the footpaths. AIT is now the second largest employer in the area.

In the two and a half years that I've now been at AIT I've instigated a number of interventions into the physical and working environment. I commissioned the photographer Amy Robins to produce a series of fictional narratives (double portraits) of staff. These were exhibited in a local gallery, then hung in the offices. Mini-installations appear on windowsills and pillars. Some are made by me. I've brought painters, poets, actors, photographers and eyesight experts into a finance and technology climate. Two former fine art art students from Wimbledon have been employed in the design department. Performance initiatives have included various bogus visitors – caterers, cleaners, surveyors, workmen and communications experts. The real and the fictitious happily rub shoulders. When the new building was officially opened by local MP Michael Heseltine he was met by another Tory MP, a cigar-smoking Winston Churchill lookalike. Several of these ideas arise in collaboration with the managing director Richard Hicks. It's become an unexpected partnership in which we are frequently creating anecdote and pushing the boundaries of work, art, anarchy and leisure.

**Ongoing residency
at AIT plc**
Right
'Installed' windowsill
Far right
Churchill meets Heseltine

Aggravation

1997, a video installation at the Bluecoat Gallery Liverpool

Video Positive is a biennial international new media festival held in Liverpool at several (mainly visual art) venues. A key part of the programming is 'collaborations' which gives opportunities for artists to work with selected local groupings – in education, with the deaf, in a high security prison etc. I was asked to work with retired people from the 'University of the Third Age'. I liked the idea, in part because I think ageism is increasingly implicit in our youth-and-beauty culture. I went to one of their monthly meetings. It was an illustrated talk on embroidery which was a genuine challenge to my taste-buds. I felt a touch out of place but met some of the key organisers and heard about U3A. They were clearly proud of it. Back in London I had a picture of them as a homogeneous group linked by age and that they had to be treated in a special way, my own prejudice was surfacing. As I got to know them better – 'Please don't ask us to reminisce, that's what everyone wants us to do.' – I became convinced that it would be more interesting and appropriate to treat their age as irrelevant and concentrate on making an innovative piece of video art with them.

Working and collaborating with retired people has a different ring from the University of the Third Age. Retirement is replaced by an upbeat notion of getting on with developing yourself when paid work stops. These people were ready to go.

I wanted to go beyond a single screen video projection, extend it towards installation, work intuitively, have a vision. They were open-minded. They talked about sites in Liverpool that they felt pride in – the roof of the Liver Building, the Cast Room at the Walker Art Gallery, the Catholic Cathedral ('Paddy's Wigwam'), the derelict Palm House in Sefton Park. We met for a morning weekly over six weeks and began filming at their chosen locations. They became performers. There was a deliberately ambiguous story line about this group of people being sensuous, restless, and continuously in search of an undisclosed person or thing. A sensibility was evolving. After they'd left for their next appointments I'd have time alone with the digital video camera, unashamedly exploring the visual. Pure colour re-surfaced as a personal obsession: blue (sky), red (cathedral windows), green (plants in Sefton Park). The embroiderers were not to be sniffed at after all. These three colours were later encased in small monitors inside wooden vanity boxes at the Bluecoat Gallery. They were fed by three separate video-tapes. The main videotape was to be projected large behind.

As a group Joan, Ralph, Doris, Harold, Barbara, Dorothy, Joan, Jack, Stella and Ethel became a delight to work with. They saw video art as an adventure. During this period I gave a presentation at the Chelsea Arts Club in London one Saturday lunch-time. I was confronted by artists of the same age-group as my Liverpool collaborators expressing immense hostility to the very notion of time-based art. It was a heated debate I could hardly believe I was having in 1997 and I thought about the open-minded group in Merseyside. Here in Chelsea this could have been a bunch of adolescents challenged by alien experience and calling it crap. Age had nothing to do with it. At the Private View in Liverpool the group were so protective of their work that for a while they resisted other people entering the room. I had some anxiety about how they'd react to the postscript I'd added, (speaking to camera in the city centre):

```
I don't know where they are. They're on the move.
They're all over the city. They've got their hands
into everything. And they're slightly out of control.
I just hope someone's seen them, that's all. (SIGHS)
```

They laughed.

Aggravation
1997, video installation, Bluecoat Gallery Liverpool
Three boxes containing coloured wool and video
monitors, video projection

Ventilation

1997, a Happening for the De La Warr Pavilion, 60 minutes

The De La Warr Pavilion in Bexhill-on-Sea is a marker in British architectural history. It's been abused, adored and restored. Twelve layers of blue gloss paint have been removed from the inimitable stainless steel chandelier. Bexhill locals are suspicious and intrigued. They're not so sure about it returning to the former architectural glory which has so very gradually been covered over with flock wallpaper and picture rails. When external ironwork was removed for the War Effort it opened the door for suburban domestication of the Modernist beast. The architects' vision was probably always a bit too much for Bexhill. But nationally, like the Royal Festival Hall, it borders on shrine status. A second floor roof area was designed for badminton until the fire regulations came in, now it's closed off. There's a permanent display of photographs of the building in the 1930s, its maybe heyday. You see the badminton players, the *Daily Herald* Ladies Exercise Team on the patio, the balconies lined with people, the clear lines and proportions of the building, the seaside simmering.

I'd been commissioned to devise a live art event that would celebrate the building and also develop the local taste buds for experimentation; a little like competing with the fish & chip shops. Following descriptions of her clear agendas for the project Caroline Collier, the director, would always say reassuringly: 'Of course you don't have to take any of this into consideration.' But my interest in the building was genuine and I took on the local issues as a part of the audience relationship. It was a clear follow-up to *Jumbo Rumba* but everything was different.

Ventilation as a title came from stirring a breeze up, incorporating the stiff wind that usually blew off the sea; opening up the glass doors. I kept thinking how good it would be to fill the building with people like in those early photographs, to redistribute the balance, tweak the energy levels and give it a good dose of acupuncture. But this felt like another one of those ludicrous ambitions.

I made contact with local groups and organisations, developing the project intermittently over a year. A primary school, sixth form college, art college, sailing club, kite flying club, model railway club, Voice Orchestra from St Leonard's and the local fire brigade were invited to take part. Most of them agreed. I spent an hour and a half with sixth form drama students at Bexhill College. The staff kindly left me to it. The signs were not good when, despite an upbeat presentation which included a video of *Jumbo Rumba*, they kept asking me what the point was. Hastings Art College was a healthier prospect and ten students became involved. *Ventilation, a Happening for the De La Warr Pavilion*,

was scheduled for a Saturday afternoon in April. It rained for the first time in three months.

John, the ruddy-faced Foreshore Manager (looks after the foreshore – beach, etc.), having hosted me in his buoy, flag and deckchair-filled hut underneath one of Bexhill's two famous cupolas, had agreed to lend me a very strange megaphone. He tipped me off that the best way to get the Sailing Club on board was to go along and chat to them on the actual morning of *Ventilation*. I didn't seem to make much of an impression on Eric, the club chairman. He said it was all down to the weather and looked at me with a subtle mixture of blankness and suspicion. There was a possibility of re-routing their mini-regatta to the patch of sea close to the Pavilion but it all depended on the wind. I wasn't hopeful. But he (or the wind) came up trumps. By 3 pm yachts were visible against the skyline, moving in a trajectory outwards from the Pavilion.

As people arrived they were greeted by 'hosts'. In the guise of tour guide I formally met them in the flock wallpapered theatre foyer, with its stunning ventilation duct, and then led them on an eclectic tour of the building. This role is a useful intermediary, the oddball information-giver in recognisable form. It was a means of accessibly pointing out light fittings, hidden stairwells, modifications from the original design and a renegade badminton player (Lehla Eldridge). The 'voice orchestra', dressed as cleaners and led by Jan Ponsford, echoed down the stairwell and circulated amongst what was now a large crowd. Michelle Griffiths created her own facial breeze with a fan-glove. Reluctantly positioned at the foot of the stairs, her fears were upheld when young locals started dropping things on her from the upper floors. There was a degree of chaos that was completely intentional. A few hours earlier, I had reluctantly agreed to draw up some sort of running order, partly for the fire brigade. It just happened to be the 50th anniversary of the Bexhill Fire Service and they were so keen to get back to their celebrations that they let off their 'wall of water' as soon as the badminton player, trapped in a time warp on the second floor roof, was rescued. But it was OK. Kites were being flown in the gallery but they'd arrived late and I didn't know they were there. OK too.

There were two stills and two video photographers. One was a local press photographer. Physically large, professional phallic protuberances strapped all over him, he had a knack of being RIGHT THERE IN THE ACTION wherever it was. I began to see him as another performer.

I'd had this strong feeling for large white helium-filled balloons as an outdoor marker for the event. And then discovered I was a balloon novice. Any slight breeze and they're all over the bloody place. It didn't work. So we had all these balloons with nowhere to go. Finnimore was

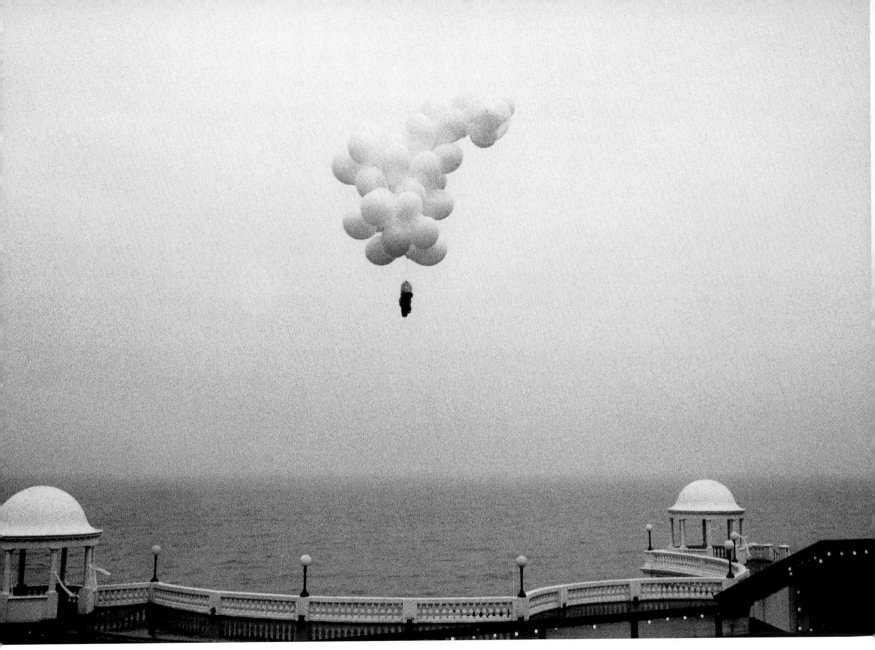

Ventilation
1997
Happening at the De La Warr Pavilion, Bexhill-on-Sea
Teddy bear, helium-filled balloons

testing out his Teddy Launcher (before it went to Warwick) with some success. Mid-performance I clicked into gear. WE'LL GO THE WHOLE WAY. A real teddy ascent. Get those balloons. Up he goes. Destination unknown. Two year olds in tears. Parents comforting in vain: 'It's only a teddy.' Older kids on bikes and roller skates, after him with a vengeance.

As people left there was less reverence and more reverence for the building. It struck me that the architects, Mendelson & Chermayeff, would probably have approved. But it was more than that – I felt I'd had a taste of their aesthetics and they of mine. It was similar to the Kurt Schwitters experience in *Here One Minute*. One of the Hastings art students, wet and bedraggled, approached me. She'd been on the beach the whole time making some kind of installation. I hadn't led the audience out there, too wet, had forgotten about her and felt a bit remiss. A fresh-faced reporter from the *Brighton Evening Argus* was keen for an interview: 'Talking to people here they have clearly really enjoyed themselves but they think you're barking mad. What do you think about this Richard?' 'Well I could talk about the line between irrationality and creativity, but I'm just so glad they've had a good time, lovely to talk to you … '

I recall the only unhappy-looking person I saw there, a middle-aged man who said to me 'It's just a total chaos.' And Richard responding to this by saying 'Well yes, that's exactly what it is!' But of course it wasn't. It was the work of someone who is by now immensely skilled in this novel kind of artwork to the point where he now seems to have lost all anxiety and, yes, to be continuing his insistence on incomplete planning so that things are bound to 'go wrong' by comparison with more orderly events. But that 'going wrong' is just what makes it 'go right.'

John Chris Jones

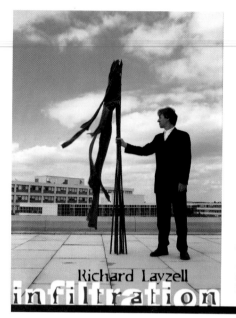

Infiltration
1997, residency
Mead Gallery, Warwick
Arts Centre
Left
Cover of post-residency publication
Opposite, left
Joan and Ethel of U3A, Liverpool, 'checking-in'
Opposite, right
Roving saxophonist on bus stop roof

Richard Layzell
infiltration

Infiltration

1997, residency, installations, performances, infiltrations, Mead Gallery, Warwick Arts Centre and the University

I want to take an angle on audience that is indivisible from a strategy. Who is this person in our midst awkwardly intense about his irrational activities? Simple strategies of confrontation. No animals allowed on campus, so let's bring one on; a large horse to stand on the grass outside the Admin building. This was a dead cert but we simply couldn't find one. But just about everything else happened: special events for the cleaners, radio station appearance, DJ in the open playing birdsong real loud, saxophonists on the roof in silhouette, dancers all over the architecture, kids as intimidating still silent presences, etc.

A university campus has its own culture, each one slightly different. Students are educated and serviced. Buildings fill and empty. Conferences come and go. Here at Warwick the peculiarities that first struck me were:

- the architecture
- the cleanliness
- the students
- the relationship of the Arts Centre to the campus
- the Students Union
- the farmed field dividing two sites

- the science emphasis
- the perimeter road and its walkway bridges
- the overall sense of a large community of people mainly of a certain age (early twenties)
- the complex hierarchy of the organisation supporting them

Infiltration could

- take many forms
- in several locations
- with different target audiences
- over a succession of days and evenings

This basic framework allowed for many potential events and manifestations.

Planning the residency beforehand and actually starting it were inevitably different states of being. I'd expected to need a working / office space. I was given Room 405(a) in Engineering, near the Concourse that was to play a central part in the project. I found sixteen 13amp sockets within arms reach, but no phone. And the phone proved to be the vital tool of the residency as I made contact with student groups, looked for the largest balloons produced internationally and communicated with the perfumed glider.

Second wave of impressions:

- Surprising amount of arts activities (often voluntary) on a mainly science and technology based campus — maybe for this precise reason
- Easy ways to contact them via pigeon holes — I arranged two lunch-time meetings and representatives of every organisation contacted showed up
- Definite thoroughfares where many people pass by at particular times of day
- Confirmation of the Students Union as a key meeting area
- Several Halls of Residence
- Animals are not allowed on campus
- Architecture of geometry and modernism — some dramatic rooftop locations

Where do education and art begin and end? Here I decided to incorporate 'educational' work wholly into the project. This allowed for the impact of young people of a certain age (under 11) infiltrating / performing on the campus, then broadening this out to include older people of a certain age (over 60) on another part of the campus also infiltrating / performing, thereby challenging age norms and

questioning the 'reality' of a community of people mainly in their early 20s. They were Joan and Ethel from the University of the Third Age in Liverpool. They arrived at the Airport Lounge (originally designed for Newcastle Airport), a student bar/restaurant area, with luggage and passports, looking for the check-in desk. People were so helpful. They carried it off like troopers.

Student Groups involved were from these societies: Latin & Ballroom Dance, Tap Dance, Contemporary Dance, Fresh Blood Theatre, Synergy, The Choir, The Brass Band, The Music Centre, W963 Radio and the Students Union.

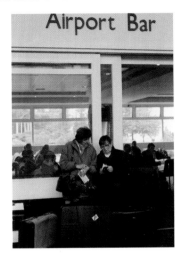 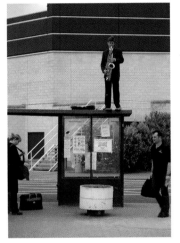

Teddy launching and ascents

The teddy is a surprisingly potent symbol of the link between child and adulthood, between home and leaving home. How many first year students bring their teddies to accompany them in their hall of residence? How many mature adults still keep him somewhere in the home? This event was humorous and ludicrous on the surface but more significant on a social and emotional level. It was also a way of actively involving people in *Infiltration*. Technical designer Finnimore's first 'launcher' rocket-fired the little devils only short distances. His second was an elaborate catapult which successfully launched teddies, on a gently curving trajectory, a distance of up to 100 metres. People brought along their furry loved ones for launching from all sides of the halls. Others watched from windows.

The Ascent was the ultimate sacrifice. Duncan the Teddy is attached to a cluster of helium-filled balloons and experiences the final launch. We see him ascend steadily and gradually, our feelings strangely with him, his destination unknown. Is this symbolic of

separation from the trappings of childhood? For the adult there is something liberating and touching about the experience. He represents our dreams, our thirst for discovery and adventure.

The Cooler

Pressure, a 'drum 'n' bass' night in The Cooler, an extravagantly well-equipped dance floor in the Students Union. In some ways this was the most risky and challenging event, with the potential for uncompromising infiltration and confrontation, getting under the skin of the self-consciously hip end of student life. People take their music very seriously and as I interrupted the DJ one more time, in this instance for the Latin Dance group to let loose, I was given a demonstration of what is and isn't art ('This bass riff is what I call art. Listen to it. That's art mate'), while over the other side of the room there were attempts to infiltrate the infiltration by a ghetto-blaster running on its own power supply. It seemed that only the perfumed glider was indivisible from surrounding sound and movement, weaving in and out in steaming beaming torch-light with offerings of garlic and after-shave.

Broadcast on W963 Radio

I gave a sixty minute improvised monologue on student radio interspersed with recordings – the Futurist Sound Machine, Eric Simms and his blackbirds, a Norwegian walking across shingle. etc:

```
A small dwelling in which people live and a gentle
introduction to this time we're going to spend
together ... a certain sense of history creeping in
here ... made in the nineteen teens ... it's nearly a
quarter to nine, is she normally this late? ... thank
you . . . interest ... ee ... be ... chance ...
deliberately so ... mmmmm ... and this tradition still
flaps about a bit it, knocks a bit ... the building
opposite having its floor restored ... a restored floor
for the Mead ... because you're sealed you don't hear
the sound of an English blackbird ... (with its pure
fluting notes and effortless delivery) ... not
particularly ... nice Eric ... thank you Eric to focus
and memorise ... little black thing flapping, a little
black flapper ... so common that p o t e n t i a l l y
we don't even notice ... and remarkably chance steps
in ... like sometimes you feel your time check ...
it's on the little dot of 5·30 ... there are memories
of infiltrations of small events that have already
happened ... I gaze across to Car Park 7 ... knowing
that at this very moment, as we share this time
together, an infiltration is taking place ...
```

Timetable

Tuesday 20 May

10·00–14·00 Young people as presences on campus plus double yellow line installations (with Wolston St Margarets Primary School)

18·30 Opening performance/lecture HUMANITIES LECTURE THEATRE

Wednesday 21 May

08·00–09·30 Temporary installations and performances, PERIMETER ROAD

14·00 Choir outside SENATE HOUSE

15·00 Cone event with Fresh Blood Theatre OUTSIDE ARTS CENTRE

16·00 Temporary installation SCIENCE CONCOURSE

17·00 Brass Band on TOP FlOOR OF CAR PARK 7

17·00–18·00 Broadcast on W963 RADIO

18·00–19·00 Teddy Launching RED SQUARE BEHIND ROOTES BUILDING

Thursday 22 May

08·00–10·00 Performances PERIMETER ROAD AND OUTSIDE LIBRARY

12·30 Special Event for Halls of Residence cleaners RED SQUARE

13·00 Sweet Descent BANK TELLER MACHINE COURTYARD

14·00 Confused airline passengers (with University of the Third Age in Liverpool) AIRPORT LOUNGE ROOTES BUILDING

15·00 Temporary installation SCIENCE CONCOURSE

16·00 Geometric Paper Descent MATHS BUILDING

17·00 Roving Saxophonists ARTS CENTRE ROOF

18·00 Teddy Launching OUTSIDE ARTHUR VICK HALL OF RESIDENCE

19·00 Teddy Ascent

22·30-23·30 Series of events at Pressure club night including Latin and Tap Dancers and the Perfumed Glider STUDENTS UNION

Friday 23 May

11·00 Special Event for Buildings Cleaners: Ballroom Dancing in SCIENCE CONCOURSE

13·00 Interlinked events: Amplified Sounds Outside-the DJ as naturalist: OUTSIDE STUDENTS UNION
Tap Dancing; ARTS CENTRE FIRE ESCAPE
Contemporary Dance: STUDENTS UNION STAIRCASE
Roving Saxophonist on BUS STOP ROOF

14·00 Teddy Ascent: OUTSIDE STUDENTS UNION

14·30–18·00 Solo actions in spatially expansive locations: ARTS CENTRE ROOF, GIBBET HILL FIELD, ROOF OF CAR PARK 7, BUTTERWORTH HALL, MEAD GALLERY

What happened over these four days didn't fit convenient categories. No single person, including myself, witnessed every event. It became almost a state of mind. A comment made in the preceding week by a member of Fresh Blood Theatre summed this up, 'Have you started *Infiltration* already? A friend of mine saw all these families having picnics on the campus at the weekend and thought you'd arranged it.' Art and life were flapping around together. But for me, the bringing together of cleaners and ballroom dancers in the Concourse on the final morning was the ultimate art event of the residency.

Infiltration
1997, Mead Gallery, Warwick Arts Centre
Right
The DJ as naturalist Birdsong amplified through PA system, dancers
Overleaf
**Ballroom dancing for the cleaners
Ballroom dancers, cleaners, cleaning supervisor, cassette recorder, Science Concourse**

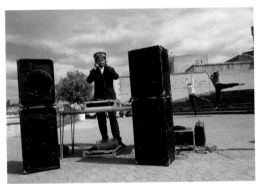

Ballroom dancing for the cleaners

The final day of *Infiltration* with the Mead Gallery and at Warwick University. Not a culmination but a high point. Mid-morning. Recovering from the previous long day and night infiltration of the Student Union drum 'n' bass night. I had this major ambition to target another group in the University and decided on the cleaners. Would the ballroom dancers show up? Would the cleaners show up? The beginning of real collaboration with the photographer Gary Kirkham. He lines up the cleaners on one side, their uniforms reflecting the colour of the dress. This is their treat. I welcome them. This event is just for you, no students invited. Thanks for coming. This corridor that you keep so clean is being animated, appreciated, it's a credit to you. The chemistry is a combination of place, performers and audience. It's not the quality of the dancing that matters, good though it is, nor the appreciation of it by the cleaners. It's that an art project has facilitated this combination of disparate elements, no other context would have brought them together. And everyone felt good about it. What's wrong with that? It was barely art and it was the essence of art, on the verge of life. A subversive tea break with cleaners made visible and students excluded, feeling in the way. Although they became the wider audience without realising it.

The tightest enclosure contained dancers and cleaners within corridor/concourse. The next perimeter enclosed photographer, video maker, artist and gallery staff. The final boundary enclosed students needing access to the corridor, en route to lectures or coffee machine. Three circles of influence, one within the other.

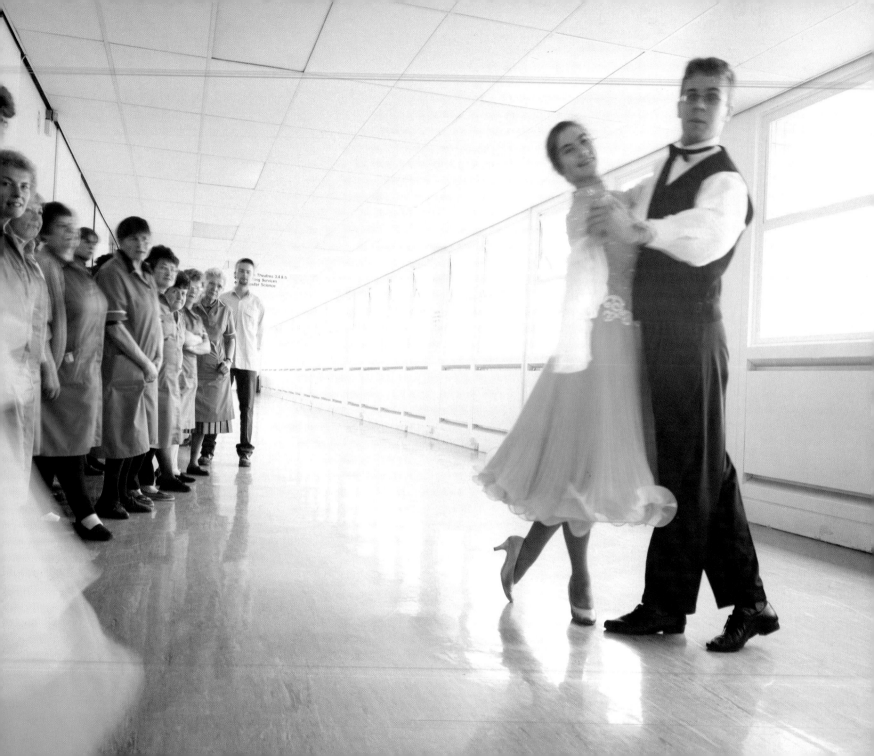

Present

I'm 49, a senior lecturer at Wimbledon School of Art and part of the senior management team at AIT plc. My son Owen is 18 and looking cool. I've had 3 wives. And 5 North American tours. I've made over 100 works – performances, installations and videotapes. Most of them have toured. I've shown at the Tate Gallery and a scruffy theatre above a pub in Earls Court on the same night. I've got 12 suits, 500 blindfolds and a studio in the East End of London. I've collaborated with 7 year olds and 70 year olds, and I regularly run the kind of performance workshops that Derek Jarman and Robert Medley kick-started me with in 1969. So how does it look from here?

I've deliberately been dealing with taboos and awkward areas, emotional and socio-political issues: consumerism, identity, stereotyping, death, ecology, the peace movement, monetarism, ageism, sensory awareness, fatherhood, the media. I've purposely crossed boundaries with audience in galleries and museums, with the public, in clubs, the street, schools, hospitals etc. From moving very close to theatre and comedy in the late 80s I've returned to feeling rooted in Fine Art. So much is possible under that tattered umbrella. It's still a big experiment.

Public funding is much maligned in Britain, it has absolutely supported the performance art/live art area. Non-profit organisations have been instrumental in altering the way art is seen and functions *eg* Art Angel, Public Art Development Trust, Common Ground, the Arts Councils, the Regional Arts Boards, Gallery Education (Engage), Projects UK, Acme Housing & Gallery, the ICA, Chisenhale Gallery & Dance Space, Bookworks, the art schools, regional galleries and museums and many more. Their effectiveness has been largely unacknowledged by artists and society, maybe because they are essentially services and because we – and the media – want personalities for fame. We as artists, and they as organisations, are very good at being proactive and radical on small budgets.

And the suits are still tax deductible, so long as they crop up somewhere else and are photographed in the right context. Artistically speaking that is.

Art Man Max
March 1998, performance
Publicity material

Material evidence

Particles remain
Clothes rail and studio
Sometimes it's hard to part with them
The chance of a re-run
Assessing their significance
Priceless and worthless
Making sense of the evidence
Like this book

**Documentation and
research books**
Above left
Black Room 1
Above
Album 1970

Clothing and materials
Below, from left to right
***Power, Move the Rabbit, In
Transit, Dancing on the
Mountain, The Revolution:
You're In It! Bruno's Leg***

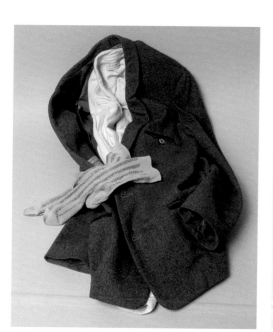

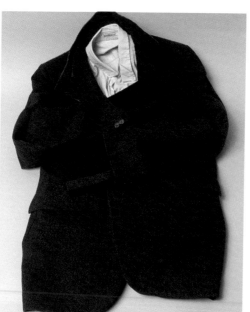

Materials
Right
The Blue Fingers
Far right
Samples of the Modern World

Right
Tree Man
Far right
Tap Ruffle and Shave

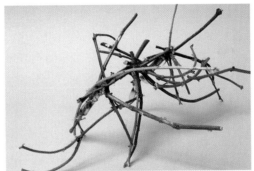

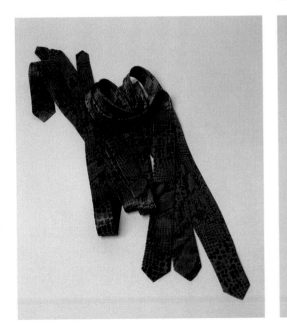

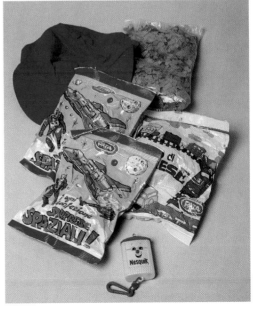

Anna Harding

Interaction and engagement

Charles Harrison, one-time member of the group Art & Language, writing about the late '60s said:

> In surveying the art of the recent past the confusion of memory and hindsight is liable to be further vexed on the one hand by sentimentality and on the other by desire for amnesia about whatever may be embarrassing or inconvenient to recall.[1]

In addition to this I would suggest that a wilful amnesia on the part of the art world has put much of the history of the last 30 years to one side and is in danger of being forgotten. There is a range of practices which elude the standard art histories of the last 30 years. A practice which defies constraints of media, moving between installation, video and performance, is particularly vulnerable to historical oversight. What is more, a practice which is live highlights more clearly than others, that meaning is located in the interaction with audience at a particular moment in time rather than in a finite object itself. A set of still photographs of an unpeopled installation, or a brochure stating the artist's intentions, tell a very partial story. Imagine a comedy show with the laughter left out. It is particularly difficult for live works to be recounted years later. Either you will have 'been there' and attempt to capture a sense of the unique experience you shared with a privileged few who now share ownership of that history, or you rely on interpretation of 'documentary' evidence, which only bears a tangential relationship to the actual event and can be misleading for what is omitted. Taking into account some of these problems, I will attempt to connect my understanding of Layzell's work with related artistic practices of its time, to examine the nature and significance of his art.

John Latham identified a change in attitude among artists in 1968:

> It is no longer necessary for the artist to make his work finite in terms of area or form; it need be neither tangible nor visible so long as his particular intention will carry into 'mental space' without an object to remember it by. The event is permanent.[2]

This attitude was identified most clearly with a generation of students from St. Martin's School of Art, where Latham had previously taught, who included Barry Flanagan, Gilbert & George, Hamish Fulton, Bruce McLean and John Hilliard. The history of this period has been dominated by the pre-eminence of the St Martin's artists, overlooking a richness and diversity of practices stemming from this attitude but less readily commodified and therefore overlooked. Although Latham's description of an 'event attitude' was highly influential at the time, the system within which artists work has not responded well to this major shift in approach to art making, and it generally remains artists who have produced some form of museum-friendly collectable objects who are remembered. The 1995 exhibition *Reconsidering the Object of Art: 1965-1975* at the Museum of Contemporary Art, Los Angeles[3] or the Yoko Ono show at the Museum of Modern Art Oxford in 1997/8 are evidence that there is a revived interest today in exhibiting the documentation of time-based work and we will hopefully see more of this in the near future.

Layzell attended the Slade School of Art in the late '60s – a challenging time to be an art student. Under the tutelage of Malcolm Hughes, Constructive Art seemed an attractive option and one which he adopted for a while. Developed out of the Russian Revolutionary tradition, Constructivists considered the potential role of abstract form and aimed to emphasise closer identification of art with the needs of society, upholding a utopian vision of social commitment. The British Constructivists, including the Systems Group (Malcolm Hughes, Jean Spencer, Jeffrey Steele and others), formed part of an international network with followings in Germany, Switzerland and Holland.

Stuart Brisley was instrumental in setting up a bookable dark space at the Slade and in developing a point of cross-fertilisation between 'events', experimental film and 'environments'. He became notorious for performances which involved endurance and bodily punishment, purveying a particular performance tradition associated with the Vienna Actionists. Layzell's approach to masculinity and vulnerability in his later performance work could be seen as a deliberate reaction against what could be described as an heroic, macho masochism. When Layzell made the performance *Yellow (Man)* in Regent's Park while still at the Slade, he realised some of the problems of performance when members of the public walked through the work without acknowledging it. Possibly as a reaction against this, he has often concentrated on reaction and interaction as central elements in his work.

1 Charles Harrison, 'The late sixties in London and elsewhere' from catalogue *1965 to 1972 – When Attitudes Became Form*, Kettle's Yard Gallery, Cambridge, 1984
2 John Latham in conversation with Charles Harrison, *Studio International* May 1968, quoted by Charles Harrison in 'Against precedents', catalogue essay for *When Attitudes Become Form*, ICA 1969
3 *Reconsidering the Object in Art: 1965–75*, Museum of Contemporary Art, Los Angeles, 1995

Two particular exhibitions during his student years had a strong attraction for Layzell. In 1969 *When Attitudes Become Form (works – concepts – processes – situations – information),* a major exhibition of contemporary work first shown in Berne, then at the ICA in London, included artists from Germany, America, Italy and Holland, such as Carl Andre, Hans Haacke, Michael Heizer, Eva Hesse, Sol LeWitt, Mario Merz, Dennis Oppenheim alongside young British artists including Victor Burgin, Barry Flanagan and Bruce McLean. Harald Szeeman's introduction to the London catalogue indicated some of the threads he saw in work at this time:

> the obvious opposition to form, the high degree of personal and emotional engagement; the pronouncement that certain objects are art, although they have not previously been identified as such; the shift of interest away from the result towards the artistic process[4]

This emphasis on process and concept (given many different names around the world: Arte Povera, Conceptual Art, Minimalism, Land Art etc.) has been extremely important to Layzell.

A second significant show, *Strategy: Get Arts*[5] at the Richard Demarco Gallery for the 1970 Edinburgh Festival, was the first major British showing of artists from Düsseldorf, including father figure Joseph Beuys. 'Beuys does not call himself an artist but an activator' stated George Jappe in the catalogue essay, which described his 'commitment to subjectivity, an energy … which also encompasses the spectator'. Further, his cultivation of a larger than life artistic persona as a focal point for his work would have a great relevance for personas devised by Layzell in later solo performances.

Also importantly to Layzell, both of these exhibitions demonstrated a general optimism as to the role that art could have in modern society as well as a desire to escape from commercial influence.

Performance and happenings became a significant part of the London art scene at that time, with the Arts Lab and Roundhouse in particular staging regular events. Some of the best known artists of the early '70s worked with performance. Gilbert & George declared themselves a 'living sculpture' with *Underneath the Arches* in 1969 and became internationally renowned. Wearing suits and with faces painted gold, they moved in a mechanical, puppet-like fashion on a small table for about six minutes. Their logo 'Art for all' expressed an intention shared with Layzell, to eliminate the separation between art and life, while focusing their art on their own ironic persons also bears a relation to Layzell.

In 1972 Bruce McLean formed The World's First Pose Band and in preparation for their work prepared 999 proposals for pose pieces. After a year of preparation and preview performances the Pose Band presented a lecture on 'Contemporary Pose' (1973) at the Royal College of Art Gallery, delivered by a stylishly dressed lecturer with obvious stammer and assistants, and various perfect poses were demonstrated. 1n 1974 at The Garage, Slade graduate Marc Chaimowicz appeared in what he called a rendering of female sensitivity[6] – 'delicacy, mystery, sensuousness, sensitivity, humility', within a reconstruction of his own room. The difference between these and Layzell's later works is that they were geared entirely towards an art audience.

From 1978 to 1981 Layzell worked at the Acme Gallery, helping present a programme which was distinct in allowing artists to take risks with the space and to allow the work to dictate the means of presentation. This policy attracted many proposals from artists interested in working with environments and performance. Ron Haselden installed a boat which he had dismantled and then re-suspended in the gallery space; Bill Culbert built a light shaft through the ceiling and floor using neon light tubes. Kerry Trengrove, Stephen Cripps, Tony Sinden, Darrel Vyner, Helen Chadwick, Bruce Lacey and Jill Bruce were among other artists to exhibit during this period. Along with fellow organisations B2 in Wapping, the London Musicians Collective and London Filmmakers Cooperative, a joint listings guide was published, encouraging crossover between media audiences, which in the '80s was largely lost. The more recent artform listings, broken into categories in magazines such as *Time Out,* has been detrimental to the promotion of cross-artform work. For instance, a Live Artist must make work at a recognised visual art venue to be listed under Art Events, with venues divided into Upmarket, Upcoming: East and Upcoming: the Rest – particularly derisory categories. Otherwise Live Art has to struggle for existence under the headings of Fringe Theatre or Comedy where there is little cross-over with visual art audiences.

In 1976 the Acme Gallery presented the Live Art section of the New Contemporaries exhibition at a time when

4 Organised by Harald Szeeman in Berne, the London showing organised by Charles Harrison took place at the ICA in September 1969
5 The exhibition included Bernard and Hille Becher, Sigmar Polke, Robert Filiou, Gerhard Richter, Dieter Rot and Daniel Spoerri, mostly exhibiting in Britain for the first time. The artists shared responsibility for selecting the show, 'out of mutual respect' rather than work with an external curator
6 Rose Lee Goldberg, *Performance: Live Art 1909 to the present*, Harry N Abrams, Inc, New York 1979

the organisers, based at St Martin's School of Art, were strongly opposed to such a development. This possibly highlighted a philosophical rift between the market-based conceptualism developed out of St Martin's and a less object-based approach coming from schools like the Slade and Reading. The Acme programme continued to promote occasional bursts of intensive live activity, when a whole series of works would be programmed over consecutive days. Two such events were programmed by Marilyn Halford. *5 Days in July* showed work in which film was used as a central component within live action and installations. The programme included Annabel Nicholson, Clare Dove, Alison Winckle, Dan Graham, Tina Keane, Coum Transmissions and Paul Burwell. *5 Days at Acme*, programmed by Marilyn Halford with Fergus Early, concentrated on dance as a core for performance, including Miranda Tuffnell, Ian Hinchcliffe, Hesitate and Demonstrate, Fergus Early amongst others. *8 in 4 Days*, organised by Richard Layzell in July/August 1978, included Tony Sinden, Marty St James, Mike Melluish, Keith Frake, Stephen Cripps, John Theobald, Bob Fearns, and also Layzell. These projects generally consisted of installations as starting points for performances when activated by the artists, perhaps twice each day. Marty St James described his work as 'a collection of ideas for investigation through performance, using the performable-painting-structure'. As part of the programme, Layzell's *Leap*[7] was described as 'an improvised installation' in which he aimed 'to set up a situation of risk where something fresh might happen'.

This area of work was also indebted to New York, the obvious point of reference until the emergence of the European conceptualists. Ellsworth Kelly's concern with installational aspects of painting and sculpture, beyond the object itself, and Robert Rauschenberg's idea of the combine, were important in attempting to move beyond the object towards installation and the performative. John Cage would seem particularly relevant to Layzell. Cage had demonstrated the possibility to pursue chance and freedom within a system underpinned by logic. In devising methods of notation for his scores, he insisted on notions of chance and indeterminacy. Such music would, according to Cage, make it clear to the listener that the hearing of the piece is his own action – that the music is his, rather than the composer's. Cage wrote 'My favourite piece ... is the one we hear all the time if we are quiet.'[8] His famous silent work *4' 33"*, a 'piece in three movements in which no sounds are intentionally produced', helped spectators towards the idea that everything they heard was music, reminding them of their own subjectivity and complicity in the work. Allan Kaprow's live events stemmed directly out of painting and a concern to go beyond painting, from Environments to Happenings. Kaprow's *18 Happenings in 6 Parts* at the Reuben Gallery, New York, 1959, was one of the first major public live art events. On the invitation Kaprow stated: 'you will become a part of the happenings; you will simultaneously experience them.'[9]

Layzell's 1981 project at Acme, called *Conversations*[10], was programmed as part of a series of three contrasting approaches to live work[11]. In this piece he was concerned with paring down his work to its basic essentials, and began to question the necessity of including objects altogether. Having worked at Acme for three years he had a particular insight into the context which informed this work. He embarked upon 'a highly speculative period of activity'[12], according to the press release, which involved talking to visitors coming into the empty space and exploring their responses to his frank questioning on video. The kind of questions he was asking in this work were 'Is this an art activity?' and 'Does it matter?' A performance then took place each evening drawing on the responses recorded during the day. He was focusing entirely on the interaction between artwork and audience. In this work he defined the role of artist as that of 'sensor', sensitising audiences to their environment and to the act of witnessing an artwork. This, in my view, is a key interest which has been significant for much of his later work.[13] While *Conversations* expressed his clear desire to focus on the act of communication, it would seem natural for him to move to single-screen video works and then to theatre and street, enabling him to work with a variety of publics and responses. Audiences, their preconceptions and perceptions, have come to form a large part of his subject matter.

From Layzell's initial use of video as a collecting and interviewing device, he spent a period of time focusing entirely on single-screen video works. An Arts Council/Brighton Polytechnic video bursary from 1980 to 1981 gave access to

7 The Acme archive includes detailed accounts of each event written by the various organisers, as well as artists' proposals and extensive photo documentation. It forms a substantial document of the art of this era, which deserves further investigation
8 See John Cage, *Silence*, MIT Press, 1961
9 See Allan Kaprow in Jeff Kelley (Ed.), *Essays on the Blurring of Art and Life*, University of California Press, 1996 edition
10 See Rob La Frenais, 'Richard Layzell' *Performance Magazine* 1981
11 Chris Welsby showed a film installation *Estuary*, Kieran Lyons showed *Dream ship sinks*, a performance on a corrugated slope relating notions of dreaming and drowning.
12 Acme archive op. cit.
13 See Richard Layzell, 'The art of invigilation' in *Engage 3*, 1997

high quality editing facilities, enabling him to develop several projects, some of which were shown in screenings at the ICA in 1981 along with fellow artists such as Stuart Marshall, Ian Bourn and Mike Stubbs and at other venues across Britain. These screenings were facilitated by the Arts Council's Video Artists on Tour initiative, which produced a catalogue of works available for hire and paid half the fee and travel expenses for artists to present their work. This enlightened support for video and film-makers (Film-Makers on Tour) was of considerable significance at the time. Artists' video libraries were also opening at venues like the Arnolfini in Bristol. Other potential new channels for distribution beyond the gallery, such as video rental shops, attracted some artists to video as a possibility for widening audiences. Distribution networks in Canada, the Netherlands and the United States provided further platforms. The launch of Channel 4 in 1982 initially appeared to offer another potential outlet, but apart from a few exceptional programmes, it did not emerge as the great opportunity that artists had imagined.

Travelling and exhibiting in the United States and Canada exposed Layzell to much video work, such as the awkward confessional talking heads of Tony Oursler. It also exposed him to more politicised practices. His work from the mid-'70s through to the mid-'80s reflected concerns with political – particularly environmental and gender – issues voiced by a number of artists. *The Video Show* at the Serpentine Gallery in 1975 brought together community activists and artists, including many women's groups, to challenge representations of women in the mainstream media. Layzell wrote an article called 'Artists know what's going down', published in 1984 in *Performance Magazine*[14], highlighting the writing of Lucy Lippard and

artists in New York working for peace outside the gallery system. The article also refers to the British group of women artists Sister Seven (including Shirley Cameron, Monica Ross and Evelyn Silver), who made work about the nuclear threat as part of the women's anti-nuclear campaign at Greenham Common. Richard at this time lived in the house which formed the London headquarters for the Greenham Women's campaign.

During the 1980s, the 'Third Area' became marginalised as market forces reinforced old formal hierarchies, with painting and sculpture at the top. Live Art largely slipped away from galleries, while a new form of 'installation art' surfaced. A number of performance festivals and dedicated Live Art programmes provided an alternative focus for activity – such as Bracknell festivals in 1979, 1981 and 1983 and the annual National Review of Live Art organised by Nikki Millican from the mid-80s, Hull's ROOT festival, EDGE in 1988, 1990 and 1992 and programmes in Nottingham, Sheffield, Newcastle and other regional centres. Critical debate around performance became more focussed through *Performance Magazine*, edited by Rob La Frenais, Steve Rogers and Chrissie Iles, and later *Hybrid and Live Art Listings*, edited by David Hughes. The Arts Council of Great Britain's[16] Live Art funding programmes under the Combined Arts Unit in the early '90s provided welcome support for certain areas of live practice. Higher education also provided a relatively supportive environment for a disproportionately large number of live artists whose work itself provided little means of earning a living. In addition, a number of performance-based degree courses were developed as well as specialised performance modules. All these tendencies allowed live art in Britain to develop at one remove from the gallery-

based art scene.

While Layzell made successful solo theatre performances at the Finborough Arms (1986–88) and the Gate Theatre (1986), it was somehow difficult for the same work to be contained within the Tate Gallery Auditorium (1987). Some critics found his embrace of a theatrical persona unintelligible in the realms of the art world. His stance in working with ironic personas and mental states in a live encounter is to confront audiences with their own direct response, which perhaps has a different value within a theatre or TV context. You feel sometimes he is on the verge of crossing the line between performed and true madness. Perhaps it is the art world's reluctance to reflect on its own absurdity which can make his work appear incongruous but which also makes it the more interesting.

Here One Minute, performed at numerous venues between 1993 and 1995, is a solo performance taking on a lecture format. Ostensibly presenting a personalised history of live art, Layzell succeeds in making the central theme of live-ness apparent by leading the audience into moments of ambiguity, uncertainty, improvisation and heightened sensitivity, alongside the more obviously rehearsed and performed aspects of the lecture. Notions of chance and the 'non-intentional' inspired by Dada radical performances by Kurt Schwitters, the Futurist Marinetti or Hugo Ball are all reference points, both for the content and also the spirit of this piece.

Layzell works above all as a sensitiser, by helping us overcome our own embarrassment and self-consciousness in front of art.

14 'Artists know what's going down' compiled by Richard Layzell, *Performance Magazine* No.29, April/May 1984 pp.35–36
15 Later known as the Arts Council of England

His generosity towards others in the way that he directly involves people as a part of his artwork means that many experience art through the direct interaction and engagement which he makes possible. In recent projects Layzell has taken the risk of allowing participant groups to become part of the artwork itself, to have a role in its making. *Ventilation* (1997), commissioned as a celebration of the famous modernist De La Warr pavilion at Bexhill-on-Sea on the South coast, took the form of a guided tour in which he regarded his audience as collaborators in a happening[16]. Moving through the building he highlighted the detailing of the 1930's modernist design and vision and the response of participants formed part of the work. In Layzell's view it is better that the audience are embraced and participate in the work than that they are embarrassed and ignore it, as is so often the case with contemporary art when visitors feel unsure of the correct response. His move to incorporate participants in his recent series of works creates a captive and involved audience who may be new to contemporary art. Engaging audiences in the making of his work is a brave and generous step for an artist challenged to make links between art and audience, always looking for more effective ways to pursue art as a communicative dialogue.

16 See Richard Layzell, 'The art of invigilation' in *Engage 3*, 1997

Biography

1969
Yellow (Man), *performance*
Bloomsbury Theatre, London
Black Room 1, *installation*
Slade School of Art, London

1970
NNYN, *performance*
Bloomsbury Theatre and Regent's Park,
London
The Human Presence, *installation*
Camden Arts Centre, London

1971
Black Room 2, *installation*
Slade School, London

1974
Support, *installation*
Slade School, London

1977
Breaking Down ... Finding New Paths,
installation
Acme Gallery, London

1978
Autumn Piece, *installation*
Camden Arts Centre, London
Line Flying, *performance*
2B Butlers Wharf, London
Leap, *installation & performance*
Acme Gallery, London
Audience Performance, *performance*
Acme Gallery, London

1979
Backwards Forwards, *installation &
performance*
Demarco Gallery, Edinburgh
Normality Performance, *performance*
Wolverhampton Polytechnic

Improvisation 1, performance
Basement Group, Newcastle-upon-tyne

1979–80
Steps, *installation & performance*
Spectro, Newcastle-upon-tyne; Camden Arts
Centre, London; Gardner Centre, Brighton

1980
... sense, *installation*
Battersea Arts Centre, London
Floor, *video*
black and white, 15 mins
Twitch, *performance*
Basement Group, Newcastle-upon-tyne;
Battersea Arts Centre, London

1981
What Do You Mean By That? *video &
performance*
Air Gallery, London
That's What I Mean, *installation*
Polytechnic Gallery, Brighton
Conversations, *performance & video*
Acme Gallery, London
Hooray, *performance*
Air Gallery, London
Eye to Hand, *video*
colour, 10 mins
Mustn't Tremble, *video*
colour, 20 mins
For Space, *video*
colour, 30 mins
Synch, *video*
colour, 8 mins
Guide, *video*
colour, 10 mins
Eye to Hand, *installation*
Arnolfini Gallery, Bristol

1981–82
Power, *video & performance*
Franklin Furnace, New York; Club Foot, San
Francisco; Bracknell Performance Festival;
Site Inc, San Francisco

1982
Stand Up/Sit Down, *video & performance*
Maison de la Danse, Lyon, France
So This is How You Spend Your Time,
video
colour, 25 mins
Improvisation 2, *performance*
Darinka, New York

1983
Soap and Water, *video*
colour, 15 mins
Zangst, *performance*
Bracknell Performance Festival; Dingwalls,
Newcastle-upon-tyne; The Academy,
Bournemouth
Roles, *performance*
ARC, Toronto; ICA, London: The Blackie,
Liverpool; SAW Gallery, Ottawa
Song Song, *performance*
The Midland Group, Nottingham;
Wimbledon School of Art Theatre
Hands and Feathers, *performance*
The Blackie, Liverpool
Elephants, *video* (with Noel Harding)
colour, 4 mins

1983–84
Who's Cool? *installation & performance*
Mercer Union, Toronto; Canada House,
London
Window, *tape/slide*
6 mins
Canada House, London

1984
Les Ailes, *installation & performance*
Maison des Expositions, Genas, France
Fingers and Fathers, *performance*
Newport and Derby Colleges of Art
Improvisation 3, *performance*
Bracknell Performance Festival
Boompah, *performance*
South Bank Centre, London
Colourge, *video*
colour, 15 mins
Dog, *video*
colour, 5 mins
Trix, *video*
colour, 8 mins

1985
Clarity, *video*
colour, 10 mins, broadcast on TSW
Cruising, *performance*
Diorama, London
It's Only Ice, *performance*
The Gallery, Manchester; National Review of
Live Art; Art Metropole, Toronto; Anthology
Film Archive, New York
The Artists Directory, *publication* (with
Heather Waddell)
A&C Black

1985–86
Definitions, *performance*
Chisenhale Dance Space, London; Franklin
Furnace, New York; The Rivoli, Toronto;
Sculpture Space, Utica, New York; Battersea
Arts Centre, London; Gate Theatre, London;
Zap Club, Brighton
Words, *performance*
The Hippodrome, London; Gate Theatre,
London; Franklin Furnace, New York; ARE,
Belfast; Finborough Arms, London; Glyn
Vivian Museum, Swansea
Faces, *performance*
Chisenhale Dance Space, London

1986
Peta, *installation*
Sculpture Space, Utica, New York
Peta, *performance*
PS122, New York
The Blue Fingers, *residency*
Bookworks, London
Scatter, *performance*
Serpentine Gallery, London
Nature of Reality, *performance*
Gate Theatre, London

1986–87
The Blue Fingers, *performance*
Finborough Arms, London; ARE, Belfast;
Spacex Gallery, Exeter; Seagate Gallery,
Dundee

1986–89
Gravity, *performance*
Zap Club, Brighton; Diorama, London; The
Pink Room, Loughborough; Gate Theatre,
London; Finborough Arms, London;
Collective Gallery, Edinburgh; Transmission
Gallery, Glasgow; SAW Gallery, Ottawa

1987
Re-Definitions, *performance*
Ikon Gallery, Birmingham; Harris Museum,
Preston; Peterborough Art Gallery; Highcroft
Hospital, Birmingham; Stoke Art Gallery;
Huddersfield Art Gallery; Fairmile Hospital,
Oxford; Cartwright Hall, Bradford
Bruno's Leg, *performance*
Tate Gallery, London; Sallis Benney Theatre,
Brighton; Usher Gallery, Lincoln; The
Leadmill, Sheffield
Move the Rabbit, *performance*
Kettles Yard, Cambridge; Finborough Arms,
London; Oval House, London; Pompidou
Centre, Paris; Progetto Sorgente, Milan;
SAW Gallery, Ottawa; Ed Video, Guelph,
Ontario

Right River, *performance*
The Trust, London; Finborough Arms,
London

1988
Biminghands, *outreach project
& performance*
Ikon Gallery, Birmingham; Wolverhampton
Art Gallery; Stoke Art Gallery
Business Tree, *installation/performance*
Business Design Centre, London
Long Done Crazy, *performance*
Finborough Arms, London; Orchard
Gallery/Little Theatre, Derry; CCA, Glasgow

1989
The Meeting, *outreach project*
Serpentine Gallery and St James & St
Michael's School, London
The Revolution: You're In It!,
performance
Kettles Yard, Cambridge; SAW Gallery,
Ottawa; YYZ, Toronto; Kings Head Theatre,
London; Plug In, Winnipeg
Video Dreams, *outreach project*
Newport Museum & Art Gallery; Library
Gallery, Cardiff
Video Dreams, *installation*
Chapter Gallery, Cardiff
Dark Angels, *residency & performance*
College Street Arts Centre and Queens Drive
Rec. Ground, Nottingham

1989–90
Dancing on the Mountain, *performance*
Chisenhale Dance Space, London; Chapter,
Cardiff; YYZ, Toronto; Contemporary
Archives, Nottingham; Third Eye Centre,
London; Plug In, Winnipeg; Western Front,
Vancouver; Harris Museum, Preston; Open
Hand, Reading

1990
House of Nations, *outreach project*
Serpentine Gallery and St James &
St Michael's School, London

1990–91
House of Nations, *installation*
Cafe Gallery, London; Castle Museum,
Nottingham

1991
Torremolinos, *performance*
Camden Arts Centre, London
No Way to Behave, *performance*
Galerie L'Ollave, Lyon

1992
William's Crumbling Drips, *performance*
Town Hall, Reading
Nelson's Mirror, *performance*
Now Festival, Nottingham
Big Map, *outreach project*
Whitechapel Gallery, London
Tree Man, *performance*
various sites in South London
Resting and Nesting, *installation*
Morden Hall, London

1993
Perfection, *performance*
South Bank Centre, London; Cafe Gallery,
London
Live Art in Schools, *publication*
Arts Council of England
A Slice of Life, *performance*
Royal Academy, London
In Transit, *performance*
Camerawork, London and various sites
No Hamburger Uniform,
video/performance
Mid-Pennine Arts, Burnley; Little Theatre,
Northwich; Media Centre, Leigh

1993–94
Here One Minute, *performance*
Royal Academy, London; Whitechapel
Gallery, London; Tate Gallery, London;
Adelphi University, New York; GFT,
Glasgow;

1994
Enterprise Rent-a-car, *residency &
performance*
Sculpture Space, Utica, New York
Samples of the Modern World,
residency and performance
Sculpture Centre, Oronsko, Poland
Fond Memories, *assemblage*
New Burlington Gallery, London
Coat Melon, *performance*
Cafe Gallery, London

1994–95
Mentations, *performance*
Articule, Montreal; Bond Gallery,
Birmingham; YYZ, Toronto; The Showroom,
London

1995
Tap Ruffle and Shave 1, *installation &
video*
McLellan Galleries, Glasgow

1996
Jumbo Rumba, *performance*
Colchester Arts Centre
Tap Ruffle and Shave 2, *installation &
performance*
South Bank Centre, London; Firstsite,
Colchester
I Never Done Enough Weird Stuff,
performance
National Review of Live Art, Glasgow

1997
Aggravation, *installation & video*
Bluecoat Gallery, Liverpool (with University
of the Third Age and Video Positive 97)
Ventilation, *performance*
De La Warr Pavilion, Bexhill-on-Sea
Infiltration, *residency and performance*
Mead Gallery, Warwick Arts Centre
Tap Ruffle and Shave 3, *installation*
Museum of Science and Industry,
Manchester
Celestial Chamber, *installation*
Science Museum, London

1998
Art Man Max, *performance*
Colchester Arts Marketing Exchange
Max Hombre, *performance*
Le Arie del Tempo, Genoa, Italy
Tap Ruffle and Shave 4, *installation & performance*
Laing Art Gallery, Newcastle-upon-tyne
Done, *performance*
Cleveland Performance Festival, Ohio
Enhanced performance, *publication* (edited
by Deborah Levy)
Firstsite, Colchester

ISBN 0 9529070 5 4

British Library Cataloguing in Publications Data
Data available

Library of Congress Cataloguing in Publications Data
Data available

Enhanced performance has been supported by the
Combined Arts Department, Arts Council of England
through its Critical Texts initiative, and Wimbledon
School of Art

Published by
firstsite
The Minories, 74 High Street, Colchester, CO1 1EU
T (01206) 577067, F (01206) 577161

Firstsite is funded by Eastern Arts Board, Colchester
Borough Council and Essex County Council

Distributed by
Black Dog Publishing Ltd
PO Box 3082, London NW1, UK
T (0171) 380 7500, F (0171) 380 7453
E ucftlil@ucl.ac.uk

Photography
Kippa Matthews: cover; Gary Kirkham: pp.4, 92–94;
Derek Jarman: p.6; Mavis Taylor: p.10; Sally Morgan:
p.19; John Kippin: p.23; Alex Graham: pp.28–29; Peter
McCallum: pp.38, 68; Wendy Workman: pp.43–45;
Vincent: pp.47–48; Edward Woodman: pp.51, 57,
98–99; Sheila Burnett: p.59; Ellen Marwood: p.62; Jo
Stockham: p.65; Jerome Ming: pp.71–73; Amy Robins:
pp.74, 85, 88, 91; Egil Kurdol: p.81; Jo Neil: pp.82–83;
Jim Hamlyn: pp.85 (inset), 87 (top); Sarah Lockwood:
p.87 (bottom); Simon Arnand: p.97; Richard Layzell: pp.
8, 12–17, 20–22, 26–27, 30, 33, 37, 39, 53, (left), 54, 61,
70, 76–78, 89

Designed by Phil Baines

Richard Layzell would like to thank Phil Baines, Bronac
Ferran, Michael Ginsborg, Richard Hicks, Tom Kelly,
Owen Layzell, Deborah Levy, Colin Painter, Debbie
Reeves and Katherine Wood

WIMBLEDON | SCHOOL OF ART